"Anyone who loves the game knows You are the Ref.
Paul Trevillion's brilliant art has been around for generations
– only the other day I was clearing out my attic and found
boxes and boxes of Shoot! magazine, obsessively collected
in my youth. In this book Paul has managed to combine my
two greatest passions: art and football. I hope his work will
continue to inspire many more generations to come."

David James

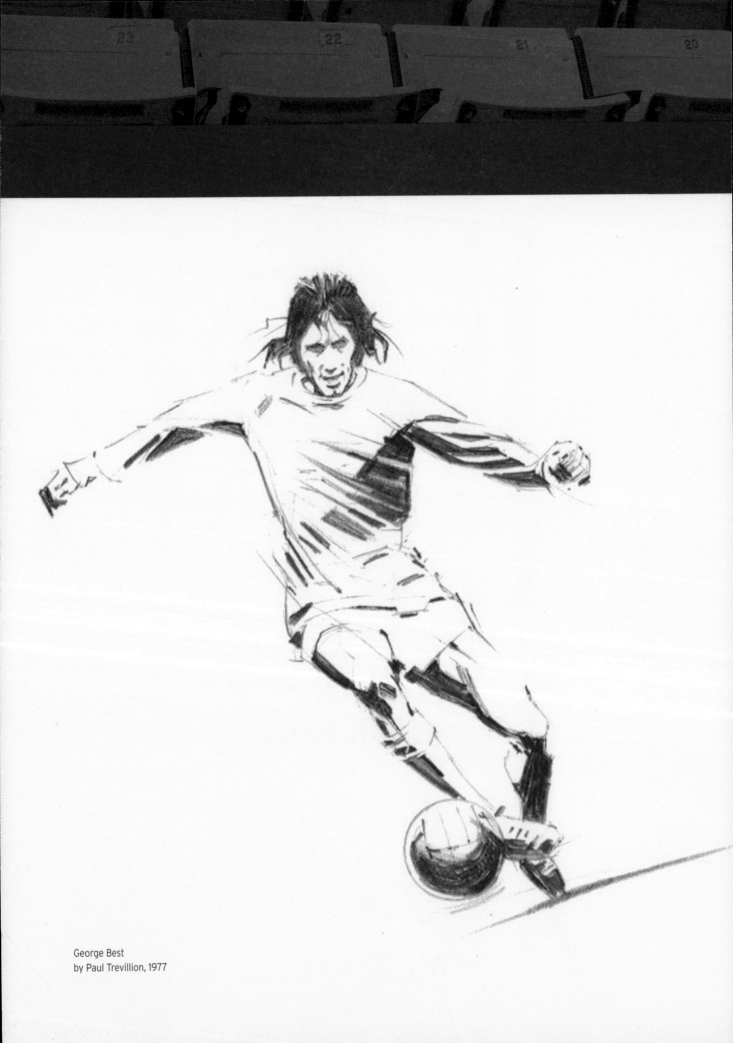

George Best
by Paul Trevillion, 1977

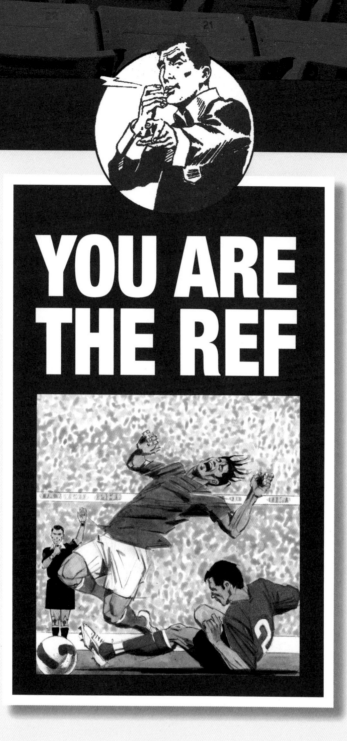

YOU ARE THE REF

Edited by David Hills and Giles Richards

TheObserver

Published by Observer Books 2010

2 4 6 8 10 9 7 5 3 1

First published in Great Britain in 2010 by
Observer Books
Kings Place
90 York Way
London N1 9GU

www.guardianbooks.co.uk

A CIP catalogue record for this book
is available from the British Library

ISBN 978-0-85265-148-3

Designed and set by www.carrstudio.co.uk

Edited by David Hills and Giles Richards
Contributors: Mal Davies, Philip Cornwall, Anna Kessel, Charlie Nutbrown, Steven Bloor

Printed and bound in Italy by Graphicom

PICTURE CREDITS

Photographs: Tom Jenkins/Guardian p5, p107, p112, p116, p117, p118, p120, p122, p123
Neal Simpson/Empics Sport, p5, p121
Lorna Roach/Observer p7

CONTENTS

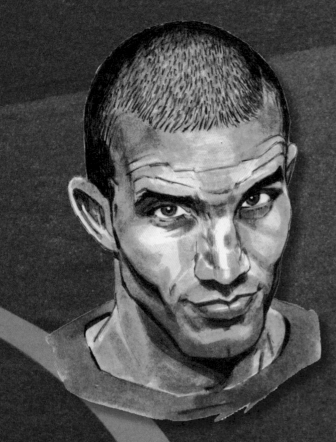

FOREWORD

David James

felt pleased with myself – then saw the ref giving the goal. I remember storming over towards the linesman with my arms outstretched trying to think of something smart to say, failing, and storming back again. I was fuming.

I've faced plenty more tough moments since then – goalline decisions, tight penalty calls – and that feeling of injustice sticks with you. But I've also grown up quite a bit. The longer you play the game, one thing becomes obvious: for every wrong decision, referees make 50 good ones which go unnoticed. They are under huge pressure from players on the pitch, from managers, and from all the scrutiny that accompanies a live televised game. I've since taken a leaf out of Nigel Martyn's book and now always shake the referee's hand to congratulate him after a match.

It would help if everybody felt a responsibility to learn the laws of the game. Players of my generation were never encouraged to learn them: we spent more time at Watford being taught how to use a knife and fork than how offside works. And plenty of top level players still struggle. Last time I tried a You Are The Ref question on our dressing room ("how many people are allowed to stand in a Premier League technical area?") only one player got it right. (It's one, by the way.)

Today most academy boys complete a basic referee course to help them learn the laws, but they never actually complete the experience by overseeing a match. I found out just how hard that is when I refereed my first match, in Malawi, a few years ago. My head was spinning just trying to get the basic decisions right, and that was without television cameras following my every move. I hope this book encourages more people to understand the Laws of the game, and to appreciate what it takes for referees to do their job.

But for me this book is as much about the art as it is about football. Anyone who loves the game knows You Are The Ref. Paul Trevillion's brilliant work has been around for generations – only the other day I

As a kid I used to read You Are The Ref religiously. I still remember some of the classic questions about flags on the halfway line (when they still had them) and alien objects finding their way into the match. I was a proper geek back then, obsessing over the Laws of the game, memorising the stats and facts – round goalposts, oval goalposts, the width of the lines painted on the pitch. I loved all that stuff.

That's why it used to wind me up so much when referees got decisions wrong. Even at under-10 level I felt robbed. And my league debut – Watford versus Millwall, August 1990 – was probably one of the worst. My future nemesis Teddy Sheringham shot, I saved on the line and

was clearing out my attic and found boxes and boxes of Shoot! magazine, obsessively collected in my youth. Attempting to produce a drawing to be included in such an iconic collection wasn't easy. But in my imagination Paul is always pitchside working on his pictures – so I placed him bang in the middle of the action where he belongs, football's ultimate "outside agent".

I finished the drawing ahead of an away game – tucked up in bed with a cup of tea, all the pre-match tension gone, just me and my picture. It reminded me how important art is in my life. In this book Paul has managed to combine my two greatest passions: art and football. I hope his work will continue to inspire many more generations to come.

YOU ARE THE REF

The artist Paul Trevillion runs onto the field of play, positions his easel on the penalty spot and proceeds to draw a picture of the goal and goalkeeper. An opposing player shoots from distance and hits Paul Trevillion on the back. The ball deflects into the net. Do you a) Allow the goal? b) Disallow the goal and restart with a drop ball from the point of contact with Paul Trevillion? c) Ask for Paul's autograph before telling him to leave the field?

2018

INTRODUCTION

As a player runs in and takes a penalty in blustery conditions, a plastic carrier bag, caught by a gust of wind, wraps itself around his face. The keeper, in hysterics, makes no attempt to stop the ball. It rolls into the net. What is your decision?

You Are The Ref, drawn by sports artist Paul Trevillion and written by top football referees, began life back in 1957. Featuring a series of testing refereeing dilemmas, it puts you in the spotlight and asks: what decision would you make?

The series – based on an idea Paul had for Spurs magazine The Lilywhite in 1952 – made its debut in The People newspaper as **Hey Ref**, and by the late 50s and early 60s, with Paul also drawing for Roy of the Rovers, the feature took on a new larger format in the Roy annuals, under the name If You Were The Ref.

But it wasn't until 1969, when the strip moved to Shoot! magazine, that it picked up its most famous name. Over the next two decades, You are The Ref, written first by Stan Lover, head of the London Referees' Association, then by Clive "The Book" Thomas and finally by Keith Hackett, became a genuine cult hit.

When Paul moved to work in America in the 90s the strip seemed to have disappeared forever – but, after a gap of nearly 15 years, Paul and Keith reunited in January 2006 to revive the strip for The Observer newspaper. You Are The Ref was reborn – ready to entertain and aggravate a whole new generation.

This book follows the 2006 title **You Are The Ref: 50 years of Paul Trevillion's Cult Classic cartoon strip**, which covered the history of the strip in all its forms – and the 2009 book **You Are The Umpire: The Ultimate Illustrated Guide to the Laws of Cricket**, a critically acclaimed collection of The Ref's cricketing offshoot.

This new collection combines the best strips published in The Observer since 2006, featuring some of Paul's favourite players and managers, plus brand new material never seen before, including his top 15 all-time World Cup heroes. And at the back – your complete guide to the laws, what it takes to be a top referee, and lots more.

Taking in all football's most controversial and debatable laws, the quirks and popular misconceptions, You Are The Ref will test your knowledge to the limits.

And that plastic bag? Find out more on page 93.

THE REFEREE: KEITH HACKETT

The voice of You Are The Ref since 1981, Keith Hackett has been synonymous with refereeing for decades: first as one of England's top officials, and then as General Manager of the Professional Game Match Officials Limited — the body in charge of the nation's referees.

He started refereeing as a teenager in 1960, and 13 years later was on the Football League list. He refereed the 1981 FA Cup final between Tottenham and Manchester City, as well as the replay, and five years later the 1986 League Cup final between Oxford United and QPR — the last ever Milk Cup final. He refereed at Euro 88 and that year's Olympic Games in Seoul.

After retiring in 1994 he worked as an assessor before being appointed successor to Philip Don as General Manager of PGMOL, where he drove through improvements in the use of technology, fitness and training, worked around the world with Uefa and Fifa, and spoke out repeatedly on the need for goalline technology.

"For nearly 30 years now I've hardly been able to step outside without people asking me about You Are The Ref. One guy came over recently and asked me to sign a giant book of newspaper cuttings — he said he'd been collecting the strips since he was a boy. I've never felt older. But it's been such a privilege to be part of it for so long — this book is a great tribute to Paul's brilliant art, and his irrepressible, boyish enthusiasm.

"Over the years the strip has really grown into a big part of British football culture. It's true that we do plenty of light-hearted questions in the strips (one young lad sent me a very involved question last year about aliens landing during a penalty shoot-out - I'm still thinking about that one) — but the strip has also had a serious impact, too.

"In the broadest terms, it has helped educate on the laws, and on the challenges and rewards of being an official. But more specifically it has also, as a focus for debate, made a substantial difference. For instance, one question from a YATR reader on offside prompted me to ask the International Football Association Board to review the law, as a result of which changes were made and new guidance issued to officials, players and managers.

"But this isn't a dry reference book. I find so much of Paul's work brilliantly evocative, bringing back vivid memories from my career as an official, and from my life as a football fan: that stunning save by Gordon Banks, Pelé's 1970 Brazil side, Paul Gascoigne's tears and so much more. I hope you enjoy the book — and that it moves some readers to consider a life in refereeing. It's hard, intense, challenging work — but it's also one of the very best jobs in the world."

THE ARTIST: PAUL TREVILLION

Born in 1934 in Love Lane, in London's Tottenham, Paul Trevillion was always going to be an artist. He was drawing for comics including Eagle and TV21 when he was still at school, and as an adult his work has appeared in almost every UK newspaper. Famous for classic series including Roy of the Rovers, he's also the author and illustrator of more than 20 books, and illustrated the Gary Player Golf Class, which appeared in over 1,000 newspapers worldwide.

Paul, who spent a large part of his career in the US, is acclaimed as the finest proponent of comic art realism — an expert in accuracy and movement. Disney animator Milt Neil said it took "20 Disney drawings to produce the movement Trevillion captures in one".

During his career Paul has met and drawn an extraordinary list of sporting greats: Pelé, Jack Nicklaus, Sugar Ray Robinson — and many of the modern generation, from Wayne Rooney to Tiger Woods.

Away from art, he has had a full, proudly different life. Among the highlights: a stand-up career alongside Tommy Cooper and Norman Wisdom; a record deal; he's been crowned world speed-kissing champion (25,009 in two hours); had coffee with, then drew, Winston Churchill; devised a split-handed putting technique; caused uproar by drawing Evonne Goolagong nude for The Sun; invented sock tags, made famous by Don Revie's Leeds United team; and dressed up as DJ Bear, the Panda of Peace, in the 1980s — to pacify football hooligans and spread love in the game.

"It's been really wonderful to have had the chance to revive The Ref after all this time, and to do this series of books. I was so humbled by the reaction to our You Are The Umpire book, and I'm not normally big on humble — so I hope people will enjoy this one just as much! Working on it with Keith and the boys at The Observer has been brilliant, and it's a real treat for me to see my work in this format.

"I'm always amazed by how many people will still stop me to talk about The Ref and Roy of The Rovers. They're quite a double act — up there with Hope & Crosby and Morecambe & Wise, I like to think! But the fact that the strips have captured the imagination of so many different generations is what pleases me most.

"I hope it inspires people to become involved, too — in refereeing, but also in art. My advice to young artists has always been simple. Never follow the crowd: find a space in art for yourself and make it your own, and whatever you do, live for the moment. As a boy from the Blitz, I never said to my school friends "see you tomorrow" because you might not see them again. I learnt as a youngster to make every moment count — and that's how I've always lived my life since."

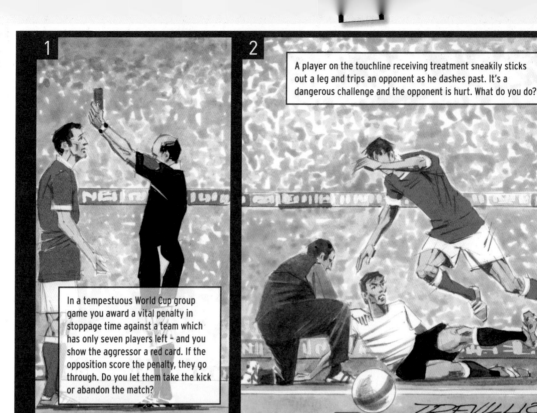

1

In a tempestuous World Cup group game you award a vital penalty in stoppage time against a team which has only seven players left – and you show the aggressor a red card. If the opposition score the penalty, they go through. Do you let them take the kick or abandon the match?

2

A player on the touchline receiving treatment sneakily sticks out a leg and trips an opponent as he dashes past. It's a dangerous challenge and the opponent is hurt. What do you do?

TREVILLION

Keith Hackett

1) A game must not *start* with fewer than seven players. However, the opinion of the International FA Board is that a match *should* not continue – as opposed to *must* not continue – if there are fewer than seven players in either team. It could become farcical. However, the taking of a stoppage time penalty would not be a farcical situation. So you should allow the kick to be taken and, as soon as the result of the kick is known, abandon the game and report the full facts to the authorities.

2) Stop play. The sneaky challenge did not use excessive force, although the opponent was hurt. It was reckless. So caution (yellow card) the player for an act of unsporting behaviour. Restart play with a direct free-kick at the point where the offence occurred.

3) Yes. As with free-kicks, opponents must comply with a minimum distance. At a throw-in the Law states: "All opponents must stand a minimum two yards from the point at which the throw-in is taken." So you should first ask the player to respect the required distance, and if he does not, then show him a yellow card for delaying the restart.

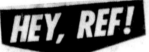

You Are The Ref artist Paul Trevillion – a football fan for seven decades – has selected his 15 all-time favourite World Cup icons. He explains his choice...

"John Charles makes my top 15 because he was genuinely world-class in both the positions he played. He was never sent off and never cautioned because he just didn't need to use his weight to be a force. He had a delicate touch, a tremendous shot and could really hammer the ball with his head. A joy to watch, and possibly the best all-rounder ever to play the game."

The portrait of Charles (left) was published in Weekly Sporting Review in 1958. The "Hey, Ref!" cartoon appeared the same year in The People. (The answer: It's a goal - if, after discussion with your linesmen, you agree the goal was properly scored.)

3

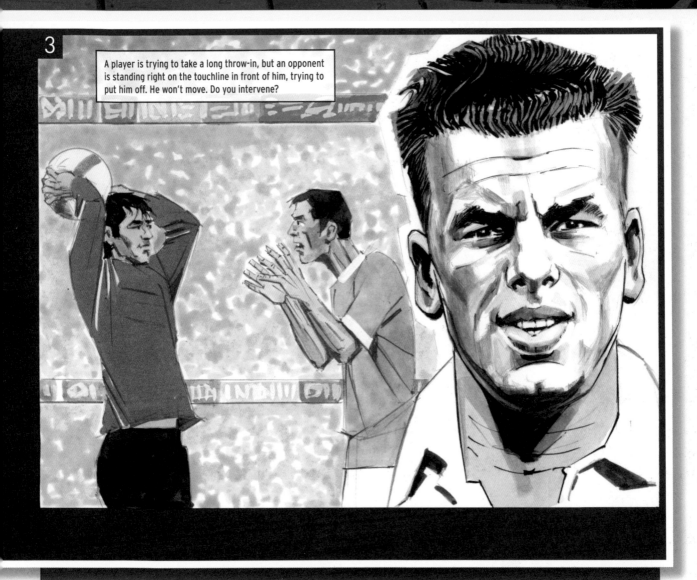

A player is trying to take a long throw-in, but an opponent is standing right on the touchline in front of him, trying to put him off. He won't move. Do you intervene?

JOHN CHARLES

Full name: William John Charles

Born: 27 December 1931, Swansea

Major clubs: Leeds, Juventus, Roma, Cardiff, Hereford

Country: Wales

Position: Centre-forward/centre-back

The list of British players who have thrived abroad isn't a long one, but Wales' Charles remains arguably Britain's greatest export, and Wales' most illustrious player. Though principally a prolific centre-forward, Charles was equally capable of playing in defence, making him one of the few players capable of giving world-class performances in such different positions.

He made his debut for Leeds as a centre-back in 1949 and remained a defender during his early career. He was tried out as a striker in 1952-53, and the following season scored an astonishing 42 goals. During his nine years with Leeds he hit 150 goals in 297 league appearances, a remarkable feat considering he spent half that time at the back.

His form in Yorkshire prompted Juventus to bid £65,000 for him – then a British transfer record. Moving abroad was a rare decision for a British player, but Charles was a huge hit in Italy, scoring 93 goals in 155 matches and winning three Italian titles. Nicknamed Il Gigante Buono (the Gentle Giant), Charles was voted in 1997 the greatest non-Italian ever to play for Juve.

After five years in Turin he returned to Leeds, but failed to settle, and moved back to Italy with Roma. However, injuries disrupted his spell, and he returned to the UK, first with Cardiff and later as player-manager with Hereford and Merthyr Tydfil.

In all, he made 38 appearances for Wales, scoring 15 times, and led the side to the 1958 World Cup in Sweden. Cruelly, injury kept him out of the quarter-final where Wales lost 1-0 to the eventual winners Brazil, the goal scored by Pelé. Charles died in 2004.

Kaká

Full name:
Ricardo Izecson
dos Santos Leite

Born: 22 April
1982, Brasilia,
Brazil

Major clubs:
São Paulo, Milan,
Real Madrid

International:
Brazil

Position:
Midfielder

Kaká, so-called
because his little
brother Rodrigo
couldn't pronounce
Ricardo when they
were small, is one
of the greats of his
generation. The

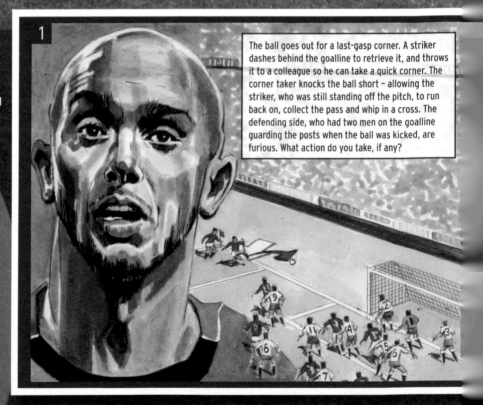

A goalkeeper punches the ball clear at his near post, but gets his boot snagged in the netting. His foot is hopelessly tangled – he watches helpless as a striker taps the ball into the unguarded goal. What do you award?

midfielder signed his first professional deal with São Paulo aged 15 and moved to Milan in 2003 for just under £8m. His progress was rapid, and he won the Ballon d'Or for European Footballer of the Year and Fifa's World Player of the Year award in 2007. In 2009 Manchester City, under rich and ambitious new ownership, bid over £100m for him – but Kaká responded by dismissing the offer, saying he wanted to "grow old" at Milan. He signed for Real Madrid for £68.5m five months later. The Brazilian is particularly well-known for his strong religious beliefs –

Stephen Ireland

Full name: Stephen James Ireland

Born: 22 August 1986, Cobh,
Republic of Ireland

Major clubs: Manchester City

International: Republic of Ireland

Position: Midfielder

Ireland may have made himself famous
with his off-field activities – his tattoos,
tabloid stories and a goal celebration
which involved dropping his shorts to
reveal Superman underpants – but he is
also rated as one of the Premier League's
best attacking midfielders. Starting at
hometown club Cobh Ramblers in Ireland,
he joined Manchester City at the age of
15 and made his debut in September 2006
against Bolton. He developed steadily
into an integral part of the line-up, and

The ball goes out for a last-gasp corner. A striker dashes behind the goalline to retrieve it, and throws it to a colleague so he can take a quick corner. The corner taker knocks the ball short – allowing the striker, who was still standing off the pitch, to run back on, collect the pass and whip in a cross. The defending side, who had two men on the goalline guarding the posts when the ball was kicked, are furious. What action do you take, if any?

in 2009 was named City's player of the year, earning a lucrative new contract. His international career – which began at U15 level for Ireland – has also been marked by controversial moments, mostly famously in 2007 when he withdrew from the squad days before a vital game claiming his grandmother had died. It turned out not to be true: Ireland eventually admitted he wanted to go home because

2

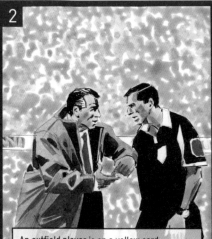

An outfield player is on a yellow card. His team, 4-0 up, have made all three substitutions, but his manager is worried that the player is still being reckless and is destined to be sent off. He calls you over and says he wants to withdraw the player, and voluntarily go down to 10 men. You know his side have a massive relegation six-pointer the following week. What is your decision?

3

A player takes a throw-in. He completes it legally, but you and the opposition notice that both his feet are in the field of play, with just the back of each heel touching the line. Opponents protest. Do you play on, or give a foul throw?

Keith Hackett

1) This is the goalkeeper's problem, not yours. He hasn't been fouled or impeded – he has become caught in the net as a result of his own actions, so he's just unlucky – the opposition have done nothing wrong; it's a goal even if the goalkeeper is injured. It has happened so fast that you wouldn't have had time to assess whether or not to stop the game for a serious injury anyway.

2) The fact that you believe the manager is attempting to protect his side for the forthcoming crucial relegation match isn't relevant. You simply have to follow the laws of the game, and a manager is perfectly entitled to reduce his own team in this way.

3) Ignore the complaints from opponents: it's a valid throw. As long as part of each foot is in contact with the touchline then the throw is legal. It's your job as referee to watch the player's hands to make sure he is throwing in the correct way, and it's your assistant's job to watch his feet, to make sure he is behind, or touching, the touchline. The main throw-in offences referees have to watch out for are illegal one-handed throws, and ballboys only making towels available to the home side.

prompted in part by his remarkable recovery from a spinal fracture suffered in an accident as a teenager – a recovery he says "I owe to Jesus". He famously wore a T-shirt bearing the slogan "I belong to Jesus" at the 2002 World Cup, and lists his favourite music as gospel and his favourite book as the Bible. He also donates part of his huge salary to a church. In 2008 Time magazine named Kaká in the Time 100 list of the world's most influential people.

2

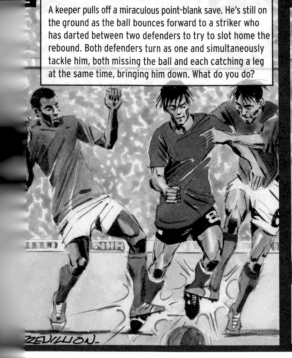

A keeper pulls off a miraculous point-blank save. He's still on the ground as the ball bounces forward to a striker who has darted between two defenders to try to slot home the rebound. Both defenders turn as one and simultaneously tackle him, both missing the ball and each catching a leg at the same time, bringing him down. What do you do?

3

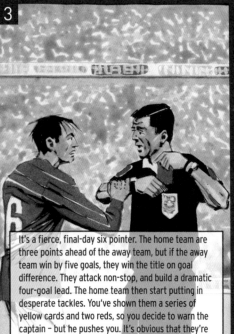

It's a fierce, final-day six pointer. The home team are three points ahead of the away team, but if the away team win by five goals, they win the title on goal difference. They attack non-stop, and build a dramatic four-goal lead. The home team then start putting in desperate tackles. You've shown them a series of yellow cards and two reds, so you decide to warn the captain – but he pushes you. It's obvious that they're trying to get the game abandoned. What do you do?

Keith Hackett

1) Take no action – play on. For the purposes of judging an offside, the player who retrieved the ball is considered to be on the goalline near the corner flagpost. So he is effectively level with the two players on the posts when the ball was kicked, and is therefore onside.

2) Send off the player you believe to be the worst offender, and award a penalty. Both players are guilty here – but there is only one offence to punish. Had they both punched the striker simultaneously then there would clearly be two offences and two red cards. However, their combined action has resulted in one offence being committed, namely the denying of an obvious goalscoring opportunity. So while your instinct may be to dismiss both, in practice you would only dismiss whichever player you believe to have been most at fault. One offence, one red card.

3) You cannot alter your approach because of what you suspect. Send off the captain for pushing you – considered an assault. Continue to referee the game in a fair and firm manner. If, as a result, the home team are reduced to six players, whether by the number of red cards or by injuries, you cannot restart the game. The game is abandoned and the home club are reported to the authorities. A very foolish way to try to secure the title.

his girlfriend had had a miscarriage, but he thought the grandmother story would get him home faster. It led to an extended absence from the Ireland squad. "Things happen to me that make me look ridiculous," Ireland said. "They become the main part of me and I have to change that image. I think I am close."

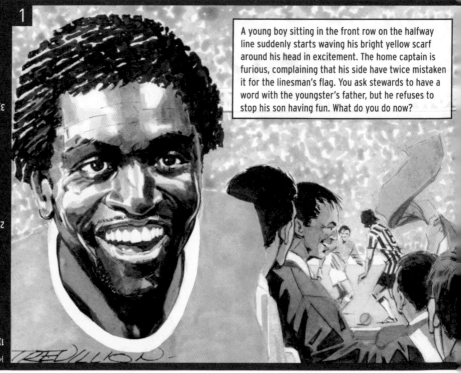

A young boy sitting in the front row on the halfway line suddenly starts waving his bright yellow scarf around his head in excitement. The home captain is furious, complaining that his side have twice mistaken it for the linesman's flag. You ask stewards to have a word with the youngster's father, but he refuses to stop his son having fun. What do you do now?

Keith Hackett

1) Stop wasting everyone's time. Tell the captain to make sure his players concentrate on the game and play to the whistle. Neither you nor they should be worrying about kids waving scarves. At professional level you will be alerted to any signal from an assistant by the buzzer on the flag: when your assistant presses it, the receiver on your arm vibrates. So there's no need for anyone to worry about confusing flag signals.

2) Stop the game. Allow the physio to come on to attend to the injured player. The trainer can inspect the injury then treat the injured player off the field of play. Referees are reminded on a regular basis to treat head injuries with extreme caution and to stop the game if any doubt exists about the safety of a player. You may suspect the player of gamesmanship here, but you can't take risks with a potential head wound.

3) d) Something else. You should stop the game, order the teams to switch then restart the second half and play the full 45 minutes, not 40 minutes, plus any stoppage time. Then report the matter, and yourself, to the authorities. Good referees use a notebook to record who kicked off to avoid situations like this.

Despite all the goals – 46 in 104 games – Arsenal's fans never fully embraced the Togo striker, regularly criticising his unpredictable form and his apparent lack of loyalty to the club. Before his departure to Manchester City in 2009 for £25m, Adebayor had spent a year linking himself with lucrative moves to other clubs including Milan and Barcelona. In October 2008 he had attempted to reassure Arsenal fans, saying: "Money is killing football: people are making their decisions based on money. If I made my decisions because of money, I would not be at Arsenal. I'm at Arsenal for love." But when he moved to Manchester the following year, he did so on a contract

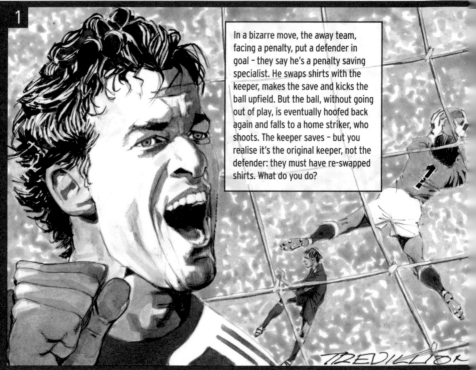

In a bizarre move, the away team, facing a penalty, put a defender in goal – they say he's a penalty saving specialist. He swaps shirts with the keeper, makes the save and kicks the ball upfield. But the ball, without going out of play, is eventually hoofed back again and falls to a home striker, who shoots. The keeper saves – but you realise it's the original keeper, not the defender: they must have re-swapped shirts. What do you do?

Keith Hackett

1) They are allowed to swap shirts and change places at any time when the ball is out of play, having notified you, even after the award of a penalty. But they cannot exchange places and shirts when the ball is in play and without notifying you. The player with the keeper's jersey is the only player allowed to handle the ball. So you need to wait until the ball is next out of play, then show both players the yellow card for not notifying you of the change back of positions and waiting until the ball is next out of play. Restart play in the appropriate manner.

2) This isn't an ideal situation, so you need to be sure of the facts. First of all, the player is the assistant physio. So check to see if the physio him or herself is present, and if so, call him/her on to treat the player instead. If not, you have to prioritise care of players, so you should allow the assistant to carry on. Clubs do use an injury to players to pass on tactics, and the referee cannot intervene.

3) Speak to the team captain and warn him that if they continue to carry out their protest, you will abandon the game at 3-0 and report the facts to the competition.

Michael Ballack signed for Chelsea on a free transfer from Bayern Munich in 2006 and quickly became an integral part of the club's expensively successful side. A solid, tough but creative midfielder, he was brought up in what was then East Germany and made his professional debut in 1995 for his local side Chemnitzer FC, six years after the fall of the Berlin Wall. He won the Bundesliga in his debut season for Kaiserslautern in 1998. Since then, via moves to Bayer Leverkusen, Bayern and then Chelsea, he has won countless personal

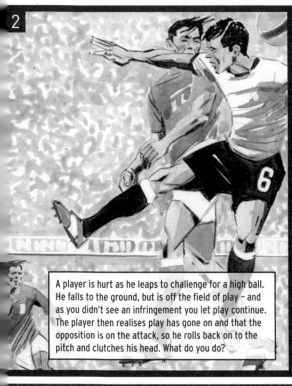

2

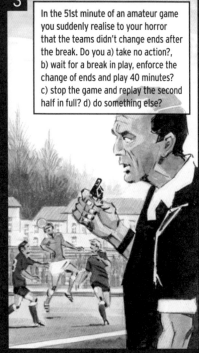

3

In the 51st minute of an amateur game you suddenly realise to your horror that the teams didn't change ends after the break. Do you a) take no action?, b) wait for a break in play, enforce the change of ends and play 40 minutes? c) stop the game and replay the second half in full? d) do something else?

A player is hurt as he leaps to challenge for a high ball. He falls to the ground, but is off the field of play – and as you didn't see an infringement you let play continue. The player then realises play has gone on and that the opposition is on the attack, so he rolls back on to the pitch and clutches his head. What do you do?

Emmanuel Adebayor

Full name:
Emmanuel Adebayor

Born: 26 February 1984,
Lomé, Togo

Major clubs:
Metz, Monaco, Arsenal,
Manchester City

International: Togo

Position: Striker

worth £170,000 a week. He marked his first game against his old club, in September 2009, with a goal and a controversial celebration in front of the Arsenal fans, and a stamp on his former team-mate Robin van Persie; he was charged by the FA for both incidents and later made a public apology. But despite all the controversy and his

perceived inconsistency, Adebayor's power, touch and scoring record have marked him out as one of the game's most potent forwards: hard to play against because he is impossible to predict. He was named African Football of the Year in 2008, and has been a regular scorer at international level.

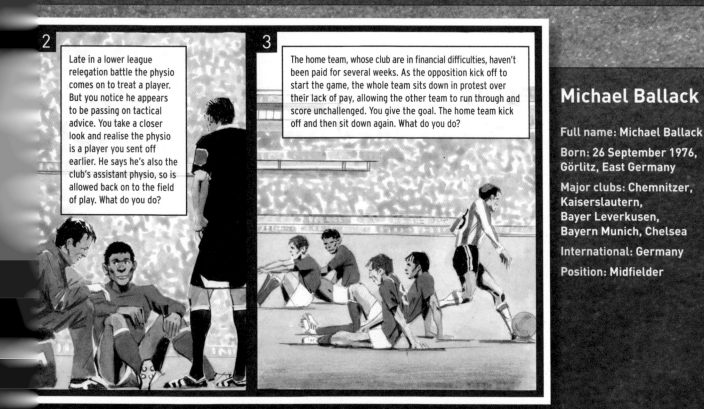

2

Late in a lower league relegation battle the physio comes on to treat a player. But you notice he appears to be passing on tactical advice. You take a closer look and realise the physio is a player you sent off earlier. He says he's also the club's assistant physio, so is allowed back on to the field of play. What do you do?

3

The home team, whose club are in financial difficulties, haven't been paid for several weeks. As the opposition kick off to start the game, the whole team sits down in protest over their lack of pay, allowing the other team to run through and score unchallenged. You give the goal. The home team kick off and then sit down again. What do you do?

Michael Ballack

Full name: Michael Ballack

Born: 26 September 1976,
Görlitz, East Germany

Major clubs: Chemnitzer,
Kaiserslautern,
Bayer Leverkusen,
Bayern Munich, Chelsea

International: Germany

Position: Midfielder

and team awards, and played in the Champions League final, and in European Championships and World Cups for Germany. He first captained his country in 2004 and is among the top scorers in the history of the national team, despite his position. The same year he

was named in Fifa's list of the hundred greatest living players. In 2008 he said the move to London would be his last. "I am at a huge club in the best league in the world. In 20 years' time I want to say that I was at Chelsea, and it is there that I ended my career."

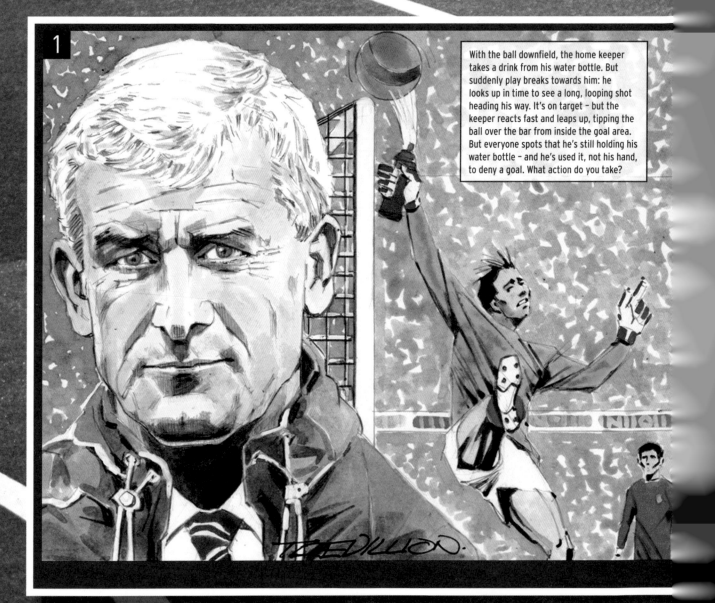

1

With the ball downfield, the home keeper takes a drink from his water bottle. But suddenly play breaks towards him: he looks up in time to see a long, looping shot heading his way. It's on target – but the keeper reacts fast and leaps up, tipping the ball over the bar from inside the goal area. But everyone spots that he's still holding his water bottle – and he's used it, not his hand, to deny a goal. What action do you take?

Mark Hughes

Full name: Leslie Mark Hughes

Born: 1 November 1963, Wrexham, Wales

Major clubs as player: Manchester United, Barcelona, Bayern Munich, Chelsea, Southampton, Everton, Blackburn

Major sides as manager: Wales, Blackburn, Manchester City

International: Wales

A Manchester United icon taking over at Manchester City was never going to be a smooth transition – but any uncertainty Mark Hughes felt quickly faded with the multi-million-pound investment of City's new owners in September 2008. A year before moving to Eastlands, Hughes had been doing a steady, unspectacular job at Blackburn. But, three months after arriving he suddenly became the richest manager in world football, able to make an unsuccessful £100m bid for Kaká, and to sign a string of talented players for enormous fees on enormous contracts. But then, 18 months and £200m later, the dream ended as suddenly as it began, with an unceremonious mid-match sacking.

It was a remarkable spell in a remarkable career. As a player Hughes had been a consistent and potent striker for a series of top clubs, winning two Premier League titles, four FA Cups and three League Cups. He made 72 appearances for Wales and scored 16 goals, his reputation securing him the national manager's job in 1999. He remained in charge until 2004, narrowly missing out on qualification for Euro 2004, then cemented his growing reputation as a coach at Blackburn, rebuilding the side in his image: tough and uncompromising, capable of European qualification. At City, despite some fine performances and steady progress, he was ultimately undone by his lack of instant success, and by a perceived lack of glamour. His dismissal in December 2009, announced moments after a win over Sunderland, was hugely controversial. He left with his reputation as one of the game's most promising British managers intact, and his personal ambition as strong as ever.

2

Deep into the minimum five minutes stoppage time, the away team snatch what has to be the winner. You check your watch, which reads 49:13. Then, straight from the kick off, the home team win a dangerous free-kick and a chance to equalise. You check the time again: 49:13. Your watch has stopped. You then check your other watch, and that reads 52:32. You realise that you should have blown for full time before the goal. What do you do?

3

It's a windy day, with the odd bit of litter swirling around the pitch. Late in the game a forward strokes a shot past the keeper but the ball rolls into a carrier bag that has blown on. It slows the ball down enough for the keeper to dive and grab the handle of the bag before the ball crosses the line. He then picks the ball up and boots it upfield. What do you do?

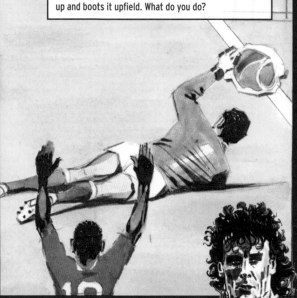

Keith Hackett

1) Caution the goalkeeper for unsporting behaviour and restart play with a indirect free-kick on the six-yard line parallel to the goal line at the point nearest to where he "handled" the ball. It is not a red card because the bottle is considered an extension of the goalkeeper's hand - keepers are allowed to handle the ball inside their penalty area.

2) Blow for fulltime. Report the facts to the competition, which will then decide if it should order a replay. Clearly not the best piece of refereeing ever... But it's not entirely your error – one of your assistants should have told you once you had played six minutes (a minimum of five minutes allows you to play up to 5:59).

3) Stop play and award a dropped ball from where the ball made contact with the plastic bag. If the contact took place inside the goal area (six-yard box), then the dropped ball is on the six-yard line that is parallel to the goalline at a point nearest to where the contact occurred. This is not the same as question one. The plastic bag is an outside agent – the moment the ball makes contact with it, play is dead – so the fact the keeper subsequently picked the bag up is irrelevant.

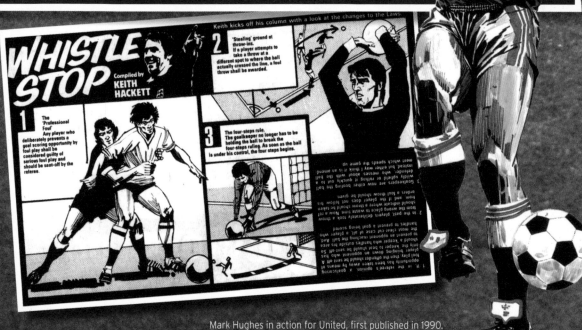

Mark Hughes in action for United, first published in 1990. "Whistle Stop" was one of the formats Paul Trevillion and Keith Hackett created for Shoot! magazine in the 1980s.

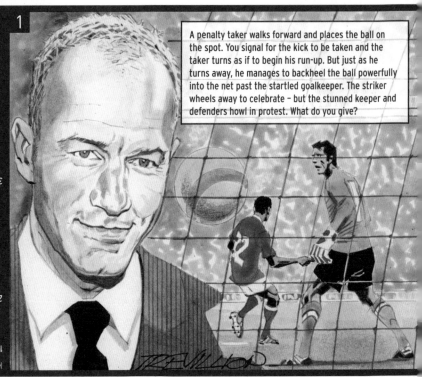

1

A penalty taker walks forward and places the ball on the spot. You signal for the kick to be taken and the taker turns as if to begin his run-up. But just as he turns away, he manages to backheel the ball powerfully into the net past the startled goalkeeper. The striker wheels away to celebrate – but the stunned keeper and defenders howl in protest. What do you give?

Keith Hackett

1) Give the goal. You have signalled for the kick to be taken and the player has kicked the ball. Nowhere in the laws does it say a player cannot backheel a penalty towards goal.

2) Players should always play to the whistle – but in the case of a head injury, use common sense. With all head injuries you must stop play immediately and call for treatment. Restart play with a dropped ball. In this case, the defender was simply quicker than your whistle. You should explain to the complaining attackers that the defender was reacting to the seriousness of their colleague's injury, and that you were about to whistle anyway.

3) Stand by your decision. Tell your assistant that you have made the call and do not need his input. Really, this is poor teamwork. Before kick-off, you should have made clear to your assistants when their input is needed for penalty area incidents. If you have seen the incident and acted upon it, you do not need their input. If you feel you do need help with the decision, you will look to your colleagues and request it. The chain of command should be clear. At the top levels of the game, this sort of mess is rare because of the communication system: officials can discuss incidents openly without flags being waved.

One of England's finest strikers, with one of England's most iconic goal celebrations, Shearer at his peak was impossible to play against. Powerful and aggressive – sometimes too much so – he had explosive shooting and heading ability, and set records for his goals tally. His career began with Southampton in 1988 where he hit a hat-trick on his professional debut against Arsenal, aged 17. Four years later he became the £3.6m focal point of Blackburn's expensive overhaul, forming a superb partnership with Chris Sutton. That move came a few months after he scored on his England debut. In 1994 he was named the Football Writers' Footballer of the Year; in 1995 his 34 goals helped win

David Moyes

Full name: David William Moyes

Born: 25 April 1963, Glasgow, Scotland

Major clubs as player:
Celtic, Cambridge Utd, Bristol City, Shrewsbury, Dunfermline, Preston

Major sides as manager:
Preston, Everton

Voted manager of the year in 2003, 2005 and 2009 by the League Managers Association, Moyes is one of the British game's top managerial talents: admired for his discipline, ruthlessness and for pushing the players and clubs in his charge to the top end of their potential. As a player himself he was unspectacular: a no-nonsense centre-back, starting his 550-game career at Celtic and ending it at Preston, where he would take his first job in management. It was a role he had been preparing for throughout his playing career, taking his coaching badges early and studying the coaches and managers around him. His choice of inspiration says a lot about his style: "When I was a player at Celtic and Alex Ferguson was manager at Aberdeen, I'd sit on the bench at Celtic just watching him. I was just so struck by the intensity, the passion, the drive." His first break at Preston was as a coach, then

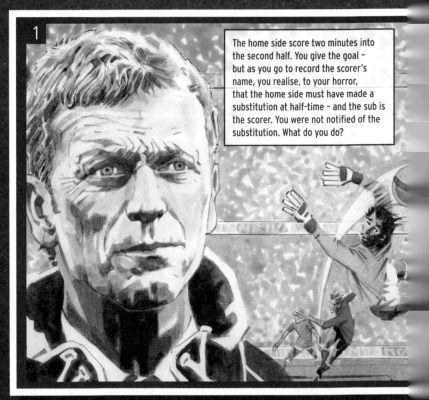

1

The home side score two minutes into the second half. You give the goal – but as you go to record the scorer's name, you realise, to your horror, that the home side must have made a substitution at half-time – and the sub is the scorer. You were not notified of the substitution. What do you do?

as assistant manager, before he was finally given the job outright in January 1998. He made a quick impact, saving Preston from relegation, and taking them to the play-offs the next season. In the

2

Two players leap for a high ball near the penalty spot. They collide in mid-air and, as they land, the defender notices the striker's head is bleeding. Without waiting for you to intervene, the defender picks the ball up and signals to the touchline for attention. The surprised attacking team appeal for a penalty. What do you do?

3

An attacker bursts into the box, tussles with a defender and falls. The defender is furious, accusing the forward of diving – but you give the penalty and book the defender for a reckless challenge. But then you see your assistant flagging wildly: he tells you it was definitely a dive. What do you do?

Alan Shearer

Full name:
Alan Shearer

Born: 13 August 1970, Newcastle upon Tyne, England

Major clubs as player: Southampton, Blackburn, Newcastle

Major sides as manager: Newcastle

International: England

Position: Striker

Blackburn the league title and him the PFA Player of the Year award. He was consistently the top flight's top scorer, and won the golden boot at Euro 96 with England. His £15m move to hometown club Newcastle after the tournament was a world record, and he went on to captain club and country. He amassed 63 England caps and scored 30 goals, before standing down from the national team after Euro 2000. He retired from playing in 2006 having broken Jackie Milburn's 49-year-old record of 200 Newcastle goals, securing cult status at the club. He went on to work for the BBC until a brief stint in 2009 as manager of Newcastle, when he failed to save them from relegation.

2

You've made a string of controversial decisions. The home crowd are getting more and more upset with you and start chanting, "You don't know what you're doing". After a prolonged period of chanting you become aware that all the coaching staff and players on the home bench are on their feet too, enthusiastically joining in. How do you handle it?

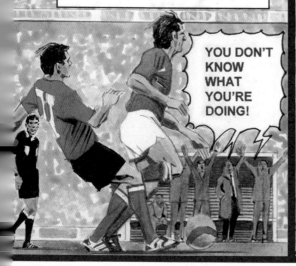

YOU DON'T KNOW WHAT YOU'RE DOING!

3

A scuffed shot takes a wicked deflection off a pitch sprinkler nozzle which has somehow popped up out of the ground just outside the six yard box. The ball's change of direction completely wrong-foots the goalkeeper – it ends up flying into the net. What do you give?

Keith Hackett

1) You've given the goal, but the game hasn't restarted, so you can now change your decision. Disallow the goal, show the sub a yellow card for entering the field of play without permission, then instruct him to leave the field so that the substitution procedure can be completed correctly. Restart play with an indirect free-kick to the opposing team from anywhere in the six-yard box. The subbed player, like all other players, had left the field at half-time with your permission, so no need to caution him.

2) Go to the technical area and speak to the senior person occupying the bench – usually the manager – and send him to the stand for irresponsible behaviour. Inform him that you are reporting the matter to the authorities, then warn the other occupants of the bench that if there's no improvement in their behaviour you'll be issuing appropriate sanctions for misconduct.

3) Disallow the goal, get the groundsman to deal with the sprinkler, then restart play with a dropped ball where the contact was made just outside the goal area. The sprinkler isn't part of the fabric of the game (like a corner flagpost, goal post, crossbar, nets, etc) – it has just popped up, so must be treated as an "outside agent".

following two seasons he won Preston promotion to Division One, then to the Division One play-offs – catching Everton's attention. Moyes moved to Goodison to take over a relegation-threatened side from Walter Smith in March 2002. Three years later Everton finished fourth, then in 2009 the club reached the FA Cup final and had a second successive fifth place.

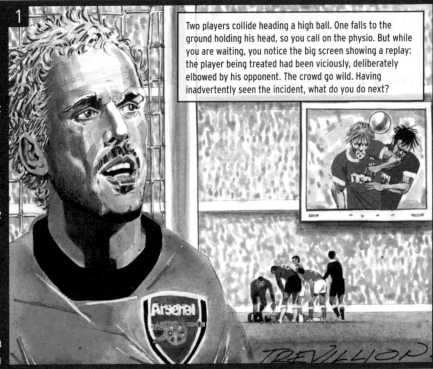

1 Two players collide heading a high ball. One falls to the ground holding his head, so you call on the physio. But while you are waiting, you notice the big screen showing a replay: the player being treated had been viciously, deliberately elbowed by his opponent. The crowd go wild. Having inadvertently seen the incident, what do you do next?

Keith Hackett

1) As hard as it may be, no, you cannot take any action. You are not allowed to use the big screen in the decision-making process (and the screen should not have shown the incident). You should, though, communicate with your assistants to seek their view on the challenge – but if they've seen nothing wrong, that is the end of the matter. The situation would later be looked at by the FA, who could take it further if they were satisfied that none of the match officials had witnessed the elbowing.

2) a) Order a retake. You must first warn the goalkeeper not to move off his line again and then have a firm word with the kick-taker, too: you are the ref, not him. The taker has no excuse for not taking the kick, because the advantage is always with him: if the goalkeeper had saved his kick illegally, you would order a retake. But if he had scored, you would allow the goal. Either way, the law is enforced.

3) No goal. The home player in the offside position has an unfair advantage, so must be penalised, as stated in law, "the moment the ball touches or is played by one of his team", "Played on", hasn't existed in the laws of the game since 1978.

TREVILLION

For so long in the shadow of other goalkeepers at his two biggest clubs, Almunia finally earned first-choice status at Arsenal in 2008-09 when Jens Lehmann left for VfB Stuttgart. It was a late breakthrough for a player who started his senior career in Osasuna's reserves in 1997. His time at Celta Vigo was spent out on loan: first at Recreativo Huelva, where he was again mostly on the bench, then in more active spells at SD Eibar and Albacete. It was there that he caught Arsenal's attention, and signed for them for an undisclosed fee in July 2004.

Marouane Fellaini

Full name: Marouane Fellaini-Bakkioui

Born: 22 November 1987, Etterbeek, Belgium

Major clubs: Standard Liège, Everton

International: Belgium

Position: Midfielder

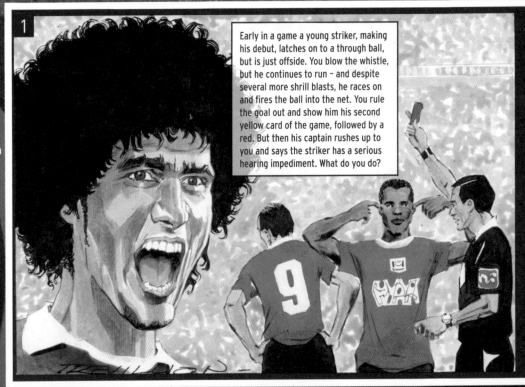

1 Early in a game a young striker, making his debut, latches on to a through ball, but is just offside. You blow the whistle, but he continues to run – and despite several more shrill blasts, he races on and fires the ball into the net. You rule the goal out and show him his second yellow card of the game, followed by a red. But then his captain rushes up to you and says the striker has a serious hearing impediment. What do you do?

TREVILLION

Famed for his often explosive hair-styles, most notably the giant afro, Fellaini, a Belgian international of Moroccan descent, made an instant impact when he signed for Everton in September 2008 for £12m. Strong, skilful and renowned for his stamina and athleticism, he rapidly became a cult hero among fans, many of them kitted out in replica wigs. "That pleases me," Fellaini said in 2009. "If my hair makes people happy, then that's good." His career began at Anderlecht's academy, and via a series of other youth-level clubs he joined Standard Liège where he signed his first professional contract aged 17. He played 84 times for the club, scoring 11 goals, his style and strength attracting

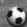

2 At a penalty shootout, the away team's players are convinced that the home keeper is moving off his line before kicks. So at the next kick, the taker deliberately stops just before striking the ball – and sure enough, the keeper has sprung off his line. Do you a) Order a retake? b) Rule that the penalty has been missed? c) Ban the taker from taking any further kicks? d) Something else?

3 A home team player passes back towards a team-mate – but the ball strikes the heel of an opponent and flies forward to the home team's star striker, who is in an offside position. The striker races away unchallenged and scores – but the keeper insists he was offside. The striker says he was "played on". What is your decision?

Manuel Almunia

Full name:
Manuel Almunia Rivero

Born: 19 May 1977, Pamplona, Spain

Major clubs: Osasuna, Sabadell, Celta Vigo, Arsenal

Position: Goalkeeper

He started as understudy to Lehmann, largely limited to FA Cup and League Cup appearances, but an injury and loss of form by Lehmann gave him a chance in 2007-08, and Almunia took it. The animosity between the pair was famous and kept the press entertained, but in 2009 Almunia sought to smooth it over. "I want to thank Lehmann for pushing me this far. We have normalised our relationship. Players need psychological pressure if they are to become better." He is eligible to play for both Spain and England.

2 In a midweek FA Cup replay, the visitors, a non-League side, are 6-0 down with 89 minutes played. Because of a bad injury earlier in the second half, there will be at least 10 minutes of stoppage time – but the minnow's captain asks you to waive it. He says they can't win, they have a long journey home and a big game on Saturday. The home captain nods his consent. What do you do?

3 Minutes before the start of a key game at a lower-league ground, one of your assistants points out to you that the goalposts at one end have a square profile, while those at the other end have a round profile. What do you do now?

Keith Hackett

1) The red card stands. The team should have informed you before kick-off that they had a player with a serious hearing problem. As it is, you're not to know either way – you could be being deceived by the captain. By sticking to the laws, you'll have at least made sure that next week's referee will be informed before kick-off. It's an interesting scenario. Many years ago I had the privilege of refereeing an international between two sides of deaf players representing England and Scotland. I had to carry a whistle and a flag and use both to signal every decision. It was amazing how the players reacted almost instantly each time: there was no dissent, just the odd smile from them at my expense... It was a terrific match, too, and a great experience.

2) Ignore the request. Both halves must be of equal duration. Only if the conditions worsened or it got too dark would you abandon the game early – you'd then send a report to the competition who could let the score stand or order a replay.

3) Goalposts need to be square, rectangular, round or elliptical in shape. So play the game. The different shapes will be the same for both teams, except in different halves.

scouts from Manchester United, Real Madrid, Bayern Munich and a host of Europe's other top clubs. But it was David Moyes who moved first, Everton agreeing the lucrative deal and a five-year contract. Fellaini made his debut in a win at Stoke in September 2008, and at the end of his first season he was named the club's young player of the season.

PAOLO ROSSI

Full name: Paolo Rossi

Born: 23 September 1956, Prato, Italy

Position: Striker

Country: Italy

Clubs: Como, Vicenza, Perugia, Juventus, Milan, Hellas Verona

The only man to win the World Cup, the Golden Ball and the Golden Boot at the same tournament, Paolo Rossi was a natural scorer. A slight figure, he was a predatory and clinical finisher, scoring 20 goals in 48 internationals.

A product of the Juventus youth system, Rossi was sent out to gain experience at Vicenza in 1976, scoring 21 goals in his debut season and helping them into the top flight. The following year his 24 goals fired Vicenza to second spot, prompting the club to pay a then-Italian record 2.612m lire for him. He left in 1979 when they were relegated, joining Perugia, where he was engulfed in a betting scandal which nearly ruined his career, resulting in a two-year ban. He always maintained his innocence.

The ban could have destroyed him – but instead he made a miraculous return to grace at the 1982 World Cup. Rossi had made his international debut in 1977, and impressed at the World Cup the following year, scoring three goals and setting up two. His ban ended only a couple of weeks before the 1982 World Cup but the striker, now back at Juventus, was selected regardless. At first it seemed the tournament had come too soon as Rossi failed to score in the opening four games. But in the fifth, a second-round group match against Brazil, he sprung to life, scoring a poacher's hat-trick in a 3-2 victory. Two more goals came in the semi against Poland and he added his sixth in Italy's 3-1 win over West Germany in the final. Later that year he was named European Footballer of the Year and he went on to win the European Cup and two Italian Championships with Juve. He finished his career with AC Milan and Hellas Verona.

In 2009 he was named vice-president of Lega Pro side Pescina Valle del Giovenco.

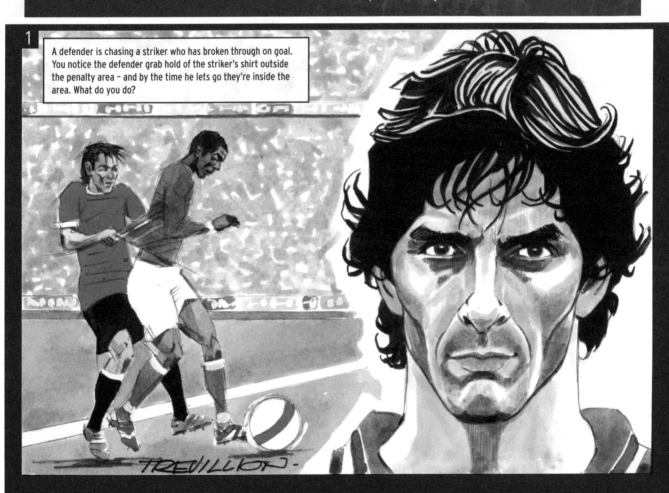

1

A defender is chasing a striker who has broken through on goal. You notice the defender grab hold of the striker's shirt outside the penalty area – and by the time he lets go they're inside the area. What do you do?

Paul Trevillion explains his choice:

"Paolo Rossi was fast and menacing. He had the ability to disappear for periods in a game, then suddenly appear in an unexpected place at the same time as the ball and, with the defence floundering, score another goal. Nobody could pin him down: he was close to impossible to mark out of a game."

Paolo Rossi, drawn for Umbro for the USA 94 World Cup

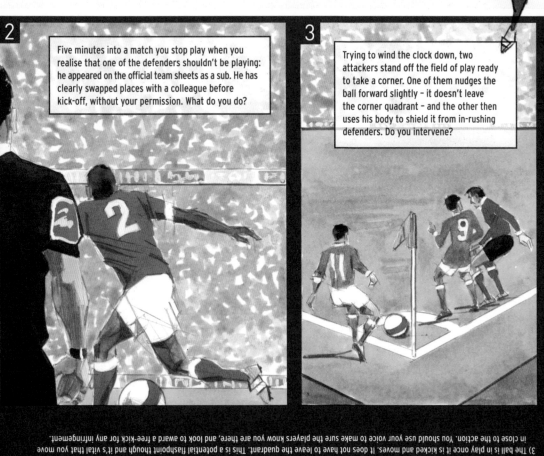

2 Five minutes into a match you stop play when you realise that one of the defenders shouldn't be playing: he appeared on the official team sheets as a sub. He has clearly swapped places with a colleague before kick-off, without your permission. What do you do?

3 Trying to wind the clock down, two attackers stand off the field of play ready to take a corner. One of them nudges the ball forward slightly – it doesn't leave the corner quadrant – and the other then uses his body to shield it from in-rushing defenders. Do you intervene?

1) Apply advantage. Award a penalty and then determine if the defender has denied the forward an obvious goalscoring opportunity. If so, then you must show a red card to the defender. If other defenders are close to the action then show a yellow card for unsporting behaviour.

2) Show the defender a yellow card for coming on to the field without your permission. Restart play with an indirect free-kick to the opposing team from the place the ball was when play was stopped - and, afterwards, report the matter to the authorities.

3) The ball is in play once it is kicked and moves. It does not have to leave the quadrant. This is a potential flashpoint though and it's vital that you move in close to the action. You should use your voice to make sure the players know you are there, and look to award a free-kick for any infringement.

Keith Hackett

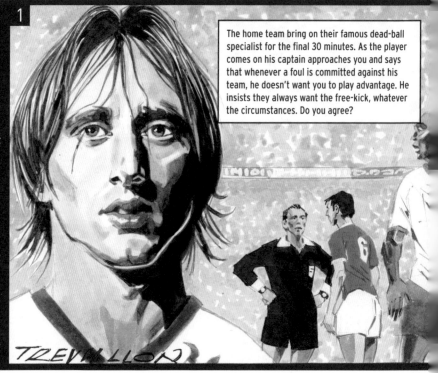

1

The home team bring on their famous dead-ball specialist for the final 30 minutes. As the player comes on his captain approaches you and says that whenever a foul is committed against his team, he doesn't want you to play advantage. He insists they always want the free-kick, whatever the circumstances. Do you agree?

1) No. Only the referee can officiate and apply the laws of the game. The captain does not decide how you referee the game and therefore his request would be denied. I would also suggest that he gets on with playing the game and leaves the business of officiating to you.

2) Dismiss the goalkeeper. He has clearly committed a serious offence from which his team have benefited and, given the circumstances, his actions have denied an obvious goalscoring opportunity, so he must be shown the red card. Have the defending team choose someone to take over in goal and restart play with an indirect free-kick at the point inside the penalty area where he dropped his shorts.

3) Again you must dismiss the goalkeeper. However, as with the previous circumstances a team must have a goalkeeper and so, before restarting play, another player needs to go in goal and put on a distinguishing coloured jersey. Otherwise the game would have to be abandoned. Having blown for the initial offence on the goalkeeper you would restart play with a direct free-kick to the defending team.

Keith Hackett

TREVILLION

It is his range of skills which makes Luka Modric so valuable: he has positional awareness, pace and composure – so he can win the ball, keep it and use it. His talent became obvious during his time as a left-sided playmaker at Dinamo Zagreb, and in Croatia's national team, prompting Juande Ramos to pay £16.5m to take him to Spurs in 2008. At first the big move appeared to have turned sour: he made his debut in a 2-1 defeat to Middlesbrough on the opening day of the season, the first loss in a terrible run which led to Ramos' sacking. But under Harry

Phil Brown

Full name: Philip Brown

Born: 30 May 1959, County Durham, England

Major clubs as player: Hartlepool, Halifax, Bolton, Blackpool

Major sides as manager: Derby, Hull

Whatever else he does in his career, Brown will always be remembered for his on-pitch teamtalk on Boxing Day 2008, when he reacted to a poor first-half performance by his Hull side at Manchester City by keeping the players on the pitch at half-time and dressing them down in front of the fans. It drew widespread criticism, but Brown's self-belief was unshaken. "The way we performed in the first half was unacceptable. The way I performed at half-time certainly wasn't unacceptable. It was totally acceptable." As a player Brown was a right-back, playing over 600 league games in 18 years in the lower divisions. As a manager it took him just three years to reach the highest level: taking Hull to the top flight for the first time in the club's 104-year history in

1

In the dying minutes of a game, with the home team 1-0 up, the ball goes out for a home throw. But no home player makes any effort to retrieve the ball to continue the game. No one is close to where the ball went out, so no individual player is obviously time wasting. What do you do?

2008. He had previously moved into coaching at Bolton, and took his first management job at Derby in 2005, but lasted just seven months before he was dismissed. He joined Hull as a coach in October 2006, and was named manager in January 2007, taking them to that historic

2

A striker is onside and clean through on goal, so the goalkeeper decides to try diversionary tactics – turning his back on the striker and dropping his shorts. Astonished by what he is seeing, the attacker briefly hesitates and turns to you in bewilderment. The keeper quickly turns round, pulls up his shorts and picks up the loose ball. What do you do?

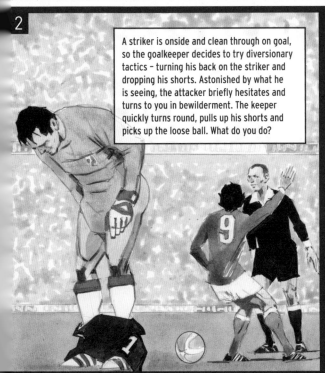

3

An attacking player slides in hard on a goalkeeper in the penalty area. You blow for a free-kick to the defending team. The goalkeeper, shaken up but unharmed, picks himself up and punches the opposing player in the face. What do you give and how does play resume?

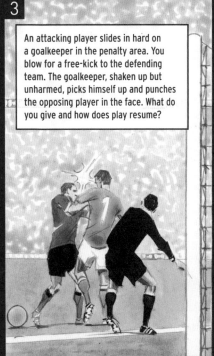

Luka Modric

Full name: **Luka Modric**

Born: **9 September 1985, Zadar, Croatia**

Major clubs: Dinamo Zagreb, Tottenham

International: Croatia

Position: Midfielder

Redknapp Modric was given a more flexible and advanced role and began to recapture the form that earned him the move. He made his senior Croatia debut in a friendly against Argentina in March 2006, and was a star of Euro 2008. Slaven Bilic called him "the best midfielder in the world" while the press dubbed him "the Croatian Cruyff" – all adding plenty of pressure for the years to come. "It is very flattering," said Modric in 2008. "But I'll have to play at the top for a long, long period before I can think of myself in such company."

2

You give a free-kick just outside the penalty area. Three forwards huddle round the ball. But when you blow for the kick to be taken, one of the three startles everyone by suddenly dashing forward, head down, pretending to be a bull. He charges at the wall, which splits. At the same time, one of the other forwards fires the ball through the gap into the net. What do you give?

3

The under-pressure home manager makes a controversial substitution, provoking more boos and jeers from the home fans. You allow the change and the fourth official holds up his board. But before the player involved starts to leave the field, the home captain dashes over and shouts that the substitution is "crazy". He says, as captain, he's overruling it and that you should play on. What do you do?

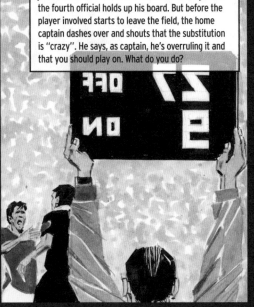

Keith Hackett

1) You can't allow this situation to go on – just because there isn't anyone obvious to caution, that doesn't stop you taking firm action. As referee you are the sole timekeeper, and you must make that very clear to everyone involved. So stop your watch, then call the home captain over and inform him that you're aware of what his team are doing, and issue him with a very public warning. Make sure that the away side are also aware that you're on top of it, and that you'll play on until midnight if it needs be. Don't caution the captain, though, because if no one took the throw even after the yellow card, you'd then have to send him off. So what should you do if they still refuse to take the throw? Simple: abandon the game. The full facts would be reported to the authorities, the club would be fined, and the game could be replayed or the result awarded to their opponents.

2) Disallow the goal, show the bull a yellow card and award a retaken free-kick. It's inventive, and pretty entertaining, but it's also a deliberate act of unsporting behaviour.

3) The captain is wrong – the laws make no allowance for captains overruling their managers.

promotion. His first season in the Premier League, apart from the pitch teamtalk, was eventful: there were some fine results against some big clubs and some awful ones, too, and a series of misconduct charges and fines. Then, when they stayed up on the final day, he picked up a microphone and led the fans in a rendition of a version of the Beach Boys song Sloop John B. "I'm proud, I'm passionate," he said in 2009. "I might not always get things right, but I'm not going to change."

Paul Trevillion explains his choice:

"Dalglish had such an astute tactical brain. Nobody spotted gaps quicker or hit first-time passes better, so he always had a commanding influence. When a team-mate found himself in difficulties, he could rely on Dalglish having read the situation and positioned himself to receive the ball. But there was much more to him as well: he could score goals out of nothing."

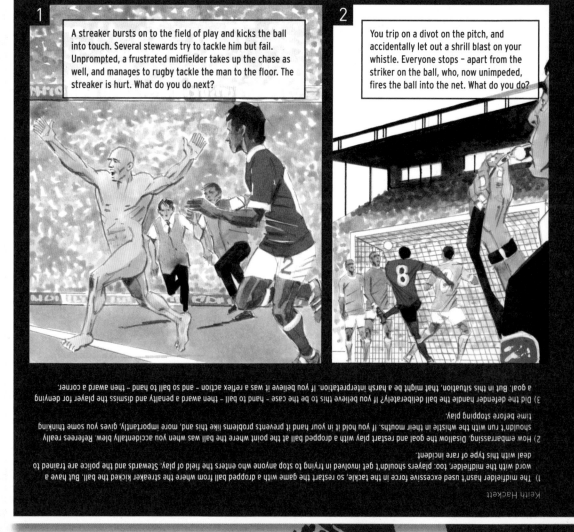

1 A streaker bursts on to the field of play and kicks the ball into touch. Several stewards try to tackle him but fail. Unprompted, a frustrated midfielder takes up the chase as well, and manages to rugby tackle the man to the floor. The streaker is hurt. What do you do next?

2 You trip on a divot on the pitch, and accidentally let out a shrill blast on your whistle. Everyone stops – apart from the striker on the ball, who, now unimpeded, fires the ball into the net. What do you do?

1) The midfielder hasn't used excessive force in the tackle, so restart the game with a dropped ball from where the streaker kicked the ball. But have a word with the midfielder, too: players shouldn't get involved in trying to stop anyone who enters the field of play. Stewards and the police are trained to deal with this type of rare incident.

2) How embarrassing. Disallow the goal and restart play with a dropped ball at the point where the ball was when you accidentally blew. Referees really shouldn't run with the whistle in their mouths. If you hold it in your hand it prevents problems like this and, more importantly, gives you some thinking time before stopping play.

3) Did the defender handle the ball deliberately? If you believe this to be the case – hand to ball – then award a penalty and dismiss the player for denying a goal. But in this situation, that might be a harsh interpretation. If you believe it was a reflex action – and so ball to hand – then award a corner.

Keith Hackett

KENNY DALGLISH

Full name: Kenneth Mathieson Dalglish

Born: 4 March 1951, Glasgow

Major clubs: Celtic, Liverpool

Country: Scotland

Position: Striker

One of Scotland's true greats, Dalgish was a prolific deep-lying forward. After making his debut for Celtic in 1971 he soon established himself as the preeminent player for club and country, and became Celtic's captain in 1975. But in 1977, after 167 goals in just 269 appearances and having won four Scottish League titles, he moved to Liverpool for a British record £440,000.

Bought to replace the departed Kevin Keegan, Dalglish scored 31 goals in his debut season, including the winner against Bruges in the 1978 European Cup final. He became an Anfield hero, and was the key figure in one of the most dominant sides in European football.

With Scotland he went to three World Cups (1974, 1978, 1982) and his 102 caps remains a record, while his 30 goals for his country is a tally equalled only by Denis Law.

In 1985 he became Liverpool player-manager, replacing Joe Fagan, and continued in this dual role until February 1991, when he retired for health reasons. During his time as manager at Anfield he won three English Leagues and two FA Cups – adding to the six Leagues and three European Cups he won as a player. In October 1991 he took up the managerial position with Blackburn where, backed by Jack Walker's money, he won the Premier League in 1995 – becoming only the third man (after Herbert Chapman and Brian Clough) to win the League with two different clubs. He later had brief and less successful spells with Newcastle and Celtic, and in 2009 returned to Liverpool to work with the academy and as an ambassador for the club.

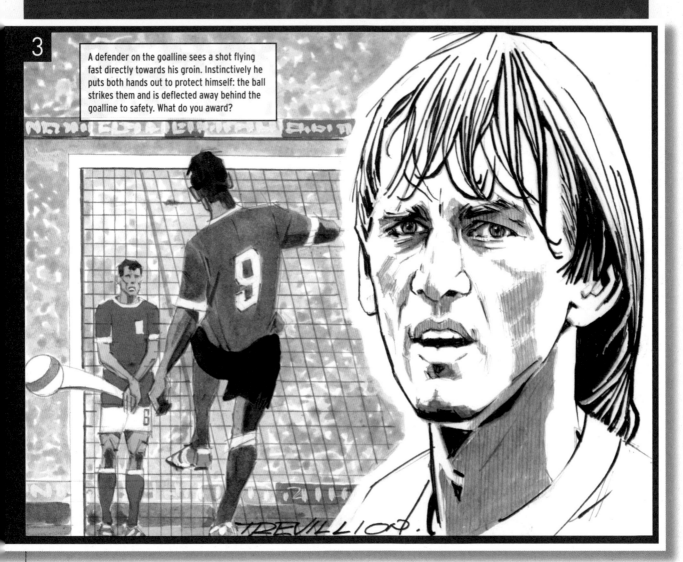

3 A defender on the goalline sees a shot flying fast directly towards his groin. Instinctively he puts both hands out to protect himself: the ball strikes them and is deflected away behind the goalline to safety. What do you award?

TREVILLION.

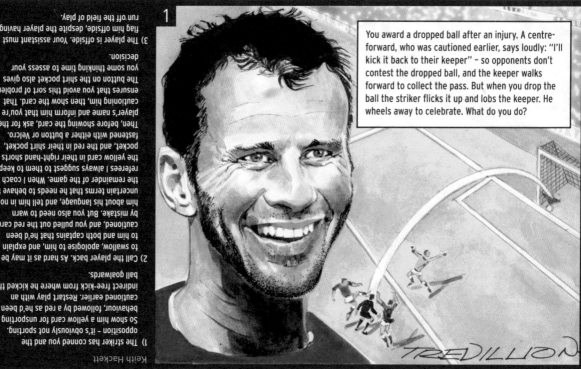

You award a dropped ball after an injury. A centre-forward, who was cautioned earlier, says loudly: "I'll kick it back to their keeper" – so opponents don't contest the dropped ball, and the keeper walks forward to collect the pass. But when you drop the ball the striker flicks it up and lobs the keeper. He wheels away to celebrate. What do you do?

Keith Hackett

1) The striker has conned you and the opposition – it's obviously not sporting. So show him a yellow card for unsporting behaviour, followed by a red as he'd been cautioned earlier. Restart play with an indirect free-kick from where he kicked the ball goalwards.

2) Call the player back. As hard as it may be to swallow, apologise to him, and explain to him and both captains that he'd been cautioned, and you pulled out the red card by mistake. But you also need to warn him about his language, and tell him in no uncertain terms that he needs to behave for the remainder of the game. When I coach referees I always suggest to them to keep the yellow card in their right-hand shorts pocket, and the red in their shirt pocket, fastened with either a button or Velcro. Then, before showing the card, ask for the player's name and inform him that you're cautioning him, then show the card. That ensures that you avoid this sort of problem. The button on the shirt pocket also gives you some thinking time to assess your decision.

3) The player is offside. Your assistant must flag him offside, despite the player having run off the field of play.

TREDILLION

the game's most celebrated players, Giggs has spent his whole
at the highest level, winning an unmatched haul of personal
am honours, and passing Bobby Charlton's Manchester United
ances record. But it could have been so different: as a boy Giggs
cked up by Manchester City's school of excellence and might

have stayed but for a personal intervention by Alex Ferguson, who
visited Giggs, then aged 14, at home to offer him schoolboy forms. Giggs
worked his way up through United's famously productive youth team
and by 1991-92 was a first-team regular, becoming the new Premier
League's original teen pin-up, and earning praise from some special

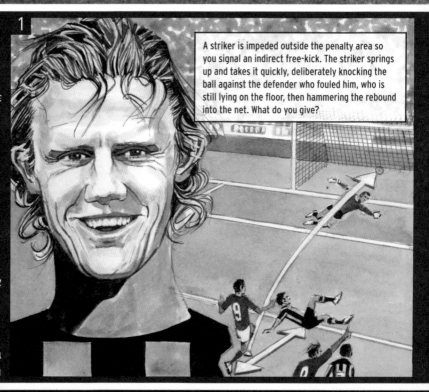

A striker is impeded outside the penalty area so you signal an indirect free-kick. The striker springs up and takes it quickly, deliberately knocking the ball against the defender who fouled him, who is still lying on the floor, then hammering the rebound into the net. What do you give?

Keith Hackett

1) If you're satisfied that the player lying on the ground isn't injured and the player taking the free-kick has positioned the ball correctly, then play on: the attacking team shouldn't be penalised if they take a quick free-kick. Allow the goal to stand.

2) Act quickly and decisively. If you decide that both of these challenges are more than reckless, and the players are using excessive force and endangering each other's safety, then you have to show two red cards. Your next decision is how to restart play: who was the most guilty? If it's the defender, award a penalty, if it's the attacker, award a direct free-kick. If you really can't decide, restart with a dropped ball. You need to be well-positioned, with a good viewing angle. Whatever you give, you're not going to be the most popular person on the field of play, so show courage – one of the key qualities of any top referee.

3) Yes – don't let him play on. The player is guilty of unsporting behaviour, so stop play and issue a caution. You could argue that the player, in using his shirt like this to cushion the ball, is guilty of deliberate hand ball. Restart play with a direct free-kick.

James
lard

tober
am,

:
gh,
am,

al:

ively
much as
owess,
ter
who
reak

football until the age of 20, suffered what could have
ending injury in September 2006, dislocating his
earing cruciate ligaments. But despite 16 frustrating
the game he recovered so strongly that he earned an

England call-up in 2008. Bullard made his name at Peterborough in 2001, his form
earning him a £275,000 move to Wigan in January 2003, followed by a £2.5m switch
to Fulham in 2006. The injury cut him down when he was in peak form, winning
plaudits for industrious performances, fine goals and blistering free-kicks. Fulham

2

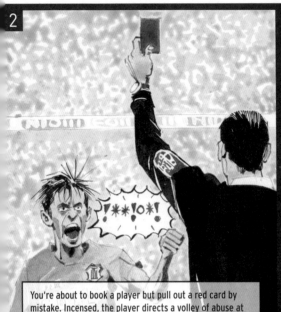

You're about to book a player but pull out a red card by mistake. Incensed, the player directs a volley of abuse at you as he turns to walk off. You then realise what you have done. This abuse deserves a red card – but he wouldn't have abused you but for your mistake. What do you do?

3

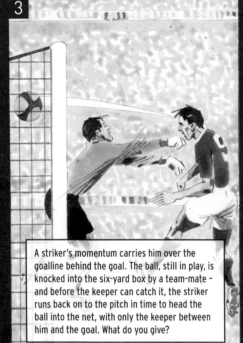

A striker's momentum carries him over the goalline behind the goal. The ball, still in play, is knocked into the six-yard box by a team-mate – and before the keeper can catch it, the striker runs back on to the pitch in time to head the ball into the net, with only the keeper between him and the goal. What do you give?

Ryan Giggs

Full name:
Ryan Joseph Giggs

Born: 29 November 1973, Cardiff, Wales

Major clubs: Manchester United

International: Wales

Position: Midfielder

observers: "One day," said George Best in 1992, "they might even say that I was another Ryan Giggs." In a career of famous moments, his strike against Arsenal in the 1999 FA Cup semi-final replay was arguably his finest: dribbling past opponents from the halfway line and smashing the ball past David Seaman. The celebration was iconic, too: whipping off his shirt and waving it round his head. This was a rare moment of extroversion from a reserved character. Among the praise heaped on him, perhaps the most memorable was from Ferguson: "When he runs he can leave the best defenders in the world with twisted blood." At international level he played 64 times for Wales, scoring 12 goals.

2

The ball breaks loose in the away team's penalty area. One player from either team lunges in high to get it, with both feet off the ground. Neither makes contact with the ball but both make contact with each other. The crowd shouts for a penalty – both sets of players surround you. What do you do?

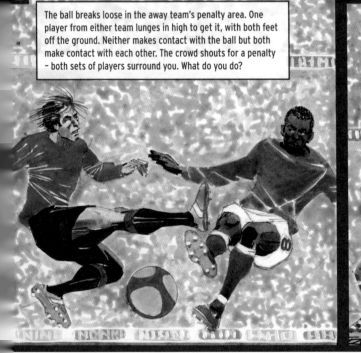

3

A cunning striker, waiting for a high looping ball to drop, decides to tug his shirt out of his shorts and, using both hands, stretch it out like a blanket to cushion the ball. It works – the ball drops to his feet and he plays on. Do you intervene?

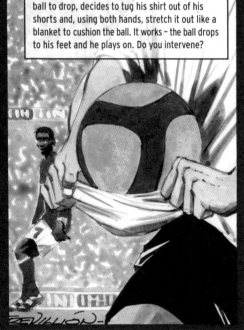

missed him badly and when he returned in January 2008 his impact was vital in saving them from relegation. Disagreements over a new contract led him to join Hull for £5m in January 2009 – but his start there was disastrous, injuring the same knee on his debut. Throughout both injuries, though, he retained his infectious enthusiasm and sense of humour. His goal celebration at Manchester City in November 2009 – mimicking manager Phil Brown's notorious on-pitch team-talk delivered there the previous season (see page 24) – was, said Brown, "classic comic timing".

Shay Given

Full name: Seamus John James Given

Born: 20 April 1976, Lifford, Republic of Ireland

Major clubs: Newcastle, Manchester City

International: Republic of Ireland

Position: Goalkeeper

One of the Premier League's most consistent goalkeepers, Given spent 12 years at Newcastle before joining Manchester City in 2009. He first moved into English football in 1994 having failed to make the breakthrough at his boyhood club, Celtic, and arrived at Kenny Dalglish's Newcastle in 1997 via Blackburn and loan spells at Swindon and Sunderland – winning the First Division title with the latter. Given's time at St James' Park was famously eventful: the keeper the one reliable, calm constant as the club around him lurched from the highs of a title challenge under Sir Bobby Robson and European football to the lows under a series of failing managers

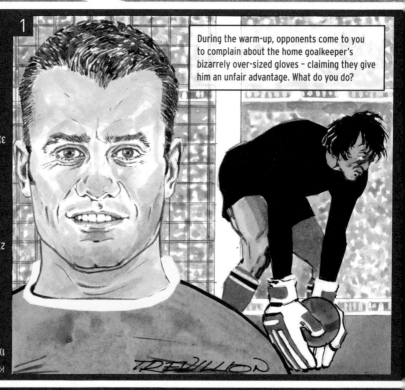

During the warm-up, opponents come to you to complain about the home goalkeeper's bizarrely over-sized gloves – claiming they give him an unfair advantage. What do you do?

Keith Hackett

1) Dismiss the complaints. As odd as it may seem, there's nothing in the laws to regulate the size of gloves: they simply need to be safe – so you'd base your decision on that. There are various rules about gloves – including the condition in some competitions that they can only carry one logo – but nothing to do with size.

2) Ignore what you've overheard. You're within your rights to change your decision before the restart, but can you really trust the player's comment – particularly when you don't have any corroborative evidence from your assistants? You need to be absolutely certain to overrule such a crucial decision, and hearsay doesn't add up to much – so to stand by your original call.

3) Make a representative from the home club remove the muck, and make the pitch, in your opinion, fit for play. You do have to consider any danger or risk to players, which includes issues around hygiene, but really, this is an overreaction from the top-flight players. In my career I've had to have all sorts removed from pitches before games: I remember vividly having to get a shovel out myself to move one cow pats before one Sunday match...

Lionel Messi

Full name: Lionel Andrés Messi

Born: 24 June 1987, Rosario, Argentina

Major clubs: Barcelona

International: Argentina

Position: Winger

One of the finest players of his generation, Messi is a unique talent. By the age of 21 the Argentinian had already been nominated for the European Footballer of the Year and Fifa World Player of the Year awards, and been named by Diego Maradona as "my successor". He joined Barcelona as a boy in 2000, his family tempted to Spain by the club's promise to fund his expensive treatment for growth hormone deficiency. He developed rapidly, and made his debut in 2004 at the age of 17, becoming La Liga's youngest ever player, and winning the title in his first season. By 2006-07 "Leo" was a regular, finishing with 14 goals in 26 league games, and breaking through into Argentina's senior team. In 2008-09 he scored an incredible 38 goals as Barça won the league, Copa del Rey and Champions League treble; he headed the second goal in the Champions League final, against Manchester United. In April 2007 he scored

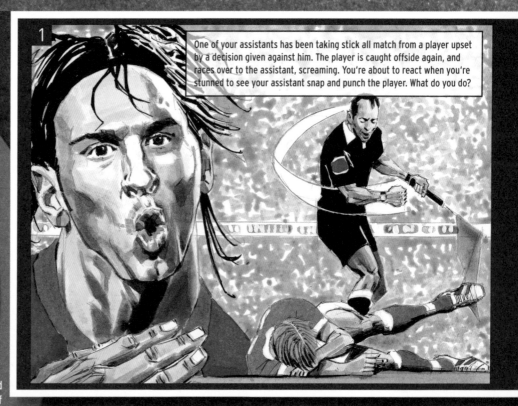

One of your assistants has been taking stick all match from a player upset by a decision given against him. The player is caught offside again, and races over to the assistant, screaming. You're about to react when you're stunned to see your assistant snap and punch the player. What do you do?

2

You've given an indirect free-kick just outside the area. The ball flies across and a striker leaps at it, appearing to flick it into the net. You give the goal. But as both sides line up for the restart, you overhear the striker laughing and confessing to a team-mate that he didn't touch the ball. What do you do?

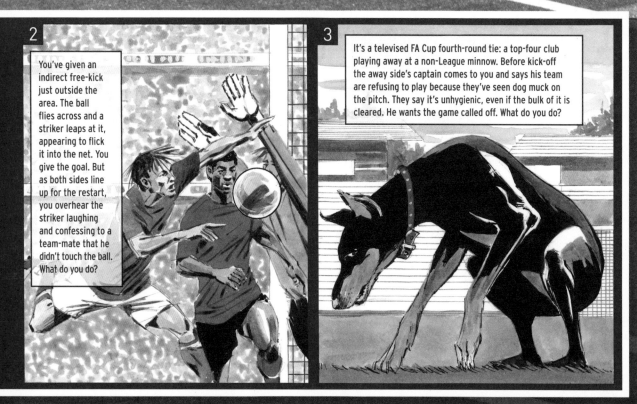

3

It's a televised FA Cup fourth-round tie: a top-four club playing away at a non-League minnow. Before kick-off the away side's captain comes to you and says his team are refusing to play because they've seen dog muck on the pitch. They say it's unhygienic, even if the bulk of it is cleared. He wants the game called off. What do you do?

against a backdrop of boardroom instability. He left in early 2009 before they were relegated, joining City for £5.9m. "I just felt that I should be at a club challenging for honours. You have a short career, and I

didn't want to finish and later regret not taking this opportunity." At international level, Given made his debut in 1996, playing in the 2002 World Cup, and ranks among Ireland's most celebrated players.

2

It's a bitterly cold day and the home side's star striker misses a sitter. In a fit of anger he rips his gloves off and hurls them to the ground. The opposition keeper laughs, picks them up and throws them to the crowd. The striker is enraged, and demands you book the keeper. What do you do?

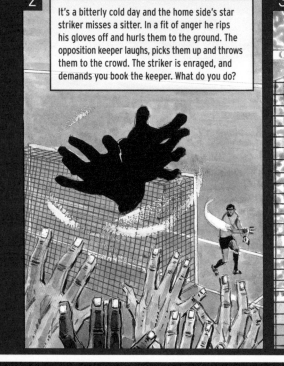

3

As a high ball loops into the box a striker raises his arm in what looks like a deliberate attempt to deflect the ball into the net with his hand. The keeper is distracted and adjusts his position – but the attacker doesn't make contact and the ball flies into the net. The keeper is furious. What do you give?

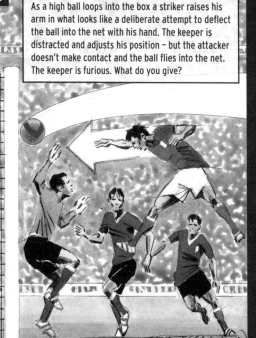

1) Send your colleague off the field of play, and replace him with the fourth official. You then have to find someone to take over the fourth official duties – which could involve a PA request to fans to see if there's a qualified referee in the crowd. If there's no response, the match assessor could get involved. You should also consider what action to take against the player: depending on the level of abuse you heard, you could dismiss him too. Then leave the authorities to deal with both individuals after the game.

2) Tell the striker to calm down, get another pair of gloves from his kitman, and have a quiet word with the keeper, who hasn't broken any laws. With any conflict, try to get your body in between the two individuals concerned, and take the heat out of the situation quickly.

3) It's a goal. The attacker hasn't committed an offence – you can't make a decision based on his intent. It's up to the goalkeeper to be sharper.

Keith Hackett

a scintillating goal against Getafe in a Copa del Rey semi-final, a goal which mirrored Maradona's long, defender-humiliating dribble against England in the 1986 World Cup. In September 2009 he was handed an

enormous new contract at Barça, with a buy-out clause of £225m. Barça president Joan Laporta said: "This contract is about his qualities as a man and a footballer – for everything he gives to the game."

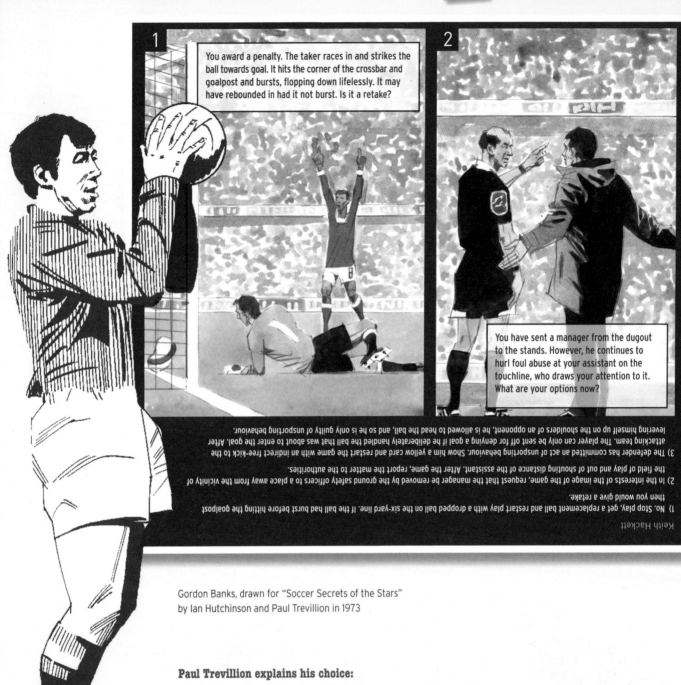

Keith Hackett

1) No. Stop play, get a replacement ball and restart play with a dropped ball on the six-yard line. If the ball had burst before hitting the goalpost then you would give a retake.

2) In the interests of the image of the game, request that the manager be removed by the ground safety officers to a place away from the vicinity of the field of play and out of shouting distance of the assistant. After the game, report the matter to the authorities.

3) The defender has committed an act of unsporting behaviour. Show him a yellow card and restart the game with an indirect free-kick to the attacking team. The player can only be sent off for denying a goal if he deliberately handled the ball that was about to enter the goal. After levering himself up on the shoulders of an opponent, he is allowed to head the ball, and so he is only guilty of unsporting behaviour.

Gordon Banks, drawn for "Soccer Secrets of the Stars"
by Ian Hutchinson and Paul Trevillion in 1973

Paul Trevillion explains his choice:

"The hallmark of a great goalkeeper is concentration: no other player can be out of the game for such long periods. When Banks found his concentration wavering, he would slap his thighs and pinch himself to stay alert. I'll always remember him talking about one game which his team won 5-0, where he was redundant: 'My thigh was blue with pinchmarks.'"

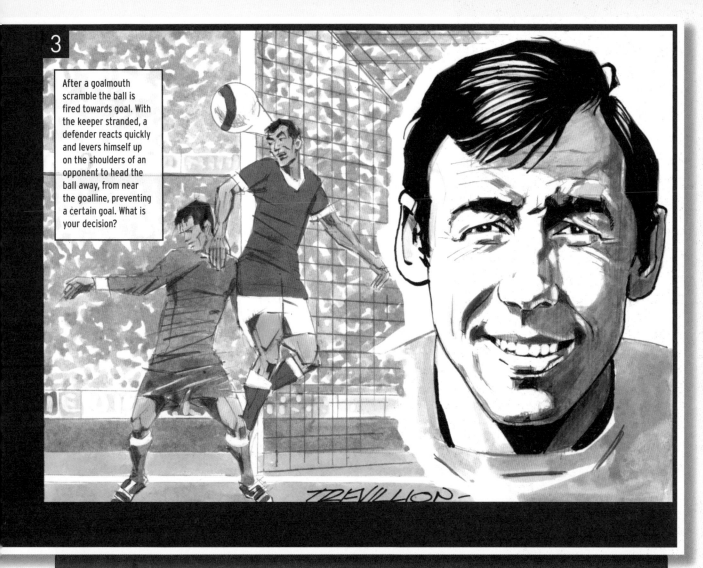

3 After a goalmouth scramble the ball is fired towards goal. With the keeper stranded, a defender reacts quickly and levers himself up on the shoulders of an opponent to head the ball away, from near the goalline, preventing a certain goal. What is your decision?

GORDON BANKS

Full name: Gordon Banks

Born: 30 December 1937, Sheffield

Major clubs: Chesterfield, Leicester, Stoke

Country: England

Position: Goalkeeper

Only Lev Yashin and Dino Zoff can challenge Banks' claim on the title of all-time finest goalkeeper. He spent his club career primarily with Leicester and Stoke, but it is for his feats at international level that he is best remembered.

He made his England debut in 1963, and by the World Cup three years later was unchallenged as Alf Ramsey's first-choice keeper. He kept clean sheets in the first four matches of the tournament, and though his goal was finally breached in the semi-final by a Eusébio penalty, England won 2-1 to reach the epic final against West Germany.

Four years later, with Banks ill, England were knocked out in the quarter-final as West Germany won revenge, but Banks produced the individual moment of his career during a group stage match against Brazil. Pelé leapt high to meet Jairzinho's cross and thundered a header down towards Banks' right post. So sure was the Brazilian that he had scored that he began to celebrate – only to watch bewildered as Banks flew down and backwards and somehow scooped the ball over the bar with his thumb. Pelé later said it was the greatest save he had ever witnessed.

Banks' career was cruelly and suddenly ended in 1972 when a car crash cost him the sight in his right eye. Forced to retire he became a scout and then manager of Telford United and – after a brief return to football in Ireland and America – entered the commercial side of the game.

Peter Crouch

Full name: Peter James Crouch

Born: 30 January 1981,
Macclesfield, England

Major clubs:
QPR, Portsmouth, Aston Villa,
Southampton, Liverpool, Tottenham

International: England

Position: Striker

Famous internationally thanks largely to his
distinctive appearance and style, and owner of
more nicknames than any other professional
of his generation (Crouchy, Crouchinho,
Crouchigol, Coathanger and many others), the
6ft 7in Crouch is a unique package. The tallest
player ever to represent England, making his
debut in 2005, he is naturally dangerous and
prolific in the air, but also capable of excellent
close control and powerful shooting. His range
of skills, which became obvious when he joined
QPR in 2000, resulted in a string of multi-
million pound-transfers, but also in a succession of managers unsure of
how to use him best. He began his career in Tottenham's youth system
and went on to play for five other Premier League clubs before arriving

back at Spurs in 2009 for around £10m. Famously self-effacing, Crouch
has always been a cult hero: at Liverpool, where he was top scorer in all
competitions in 2006-07 and appeared in the 2007 Champions League

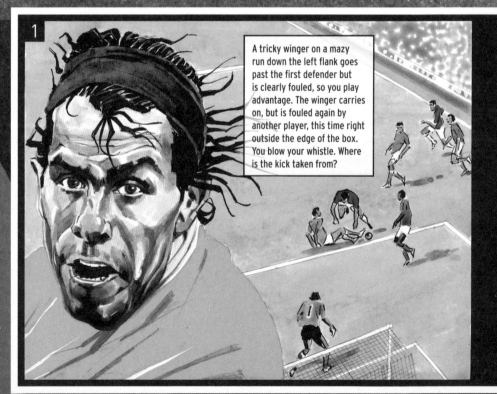

1 At a ground renowned for its atmosphere,
a manager has trouble communicating with
his players on the pitch. At the start of the
second half he appears with a megaphone,
which he uses to instruct his team. His
opposite number complains that this is an
unfair advantage. Do you intervene?

Carlos Tevez

Full name:
Carlos Alberto Tevez

Born: 5 February 1984,
Buenos Aires, Argentina

Major clubs: Boca Juniors,
Corinthians, West Ham,
Manchester United,
Manchester City

International: Argentina

Position: Striker

Explosive and full of quality, Tevez's
ability is unquestioned – but his
football career may end up being
most notable for matters off the
field. The controversy dates back to
his move to Corinthians in December
2004, where investment group
MSI took ownership of his rights.
In August 2006, he moved, with
team-mate Javier Mascherano, to
West Ham. While Mascherano quickly
moved on, Tevez helped save the club from relegation at Sheffield
United's expense. It later emerged that the transfers had breached
Premier League rules on third party ownership, resulting in West
Ham being fined £5.5m, and paying £20m in compensation to United.

1 A tricky winger on a mazy
run down the left flank goes
past the first defender but
is clearly fouled, so you play
advantage. The winger carries
on, but is fouled again by
another player, this time right
outside the edge of the box.
You blow your whistle. Where
is the kick taken from?

Tevez, meanwhile, moved to Manchester United on an extended loan
deal – another move complicated by ownership issues. Once at United he
was a hit with fans, but after protracted contract talks over a permanent
move in 2009, he did the unthinkable: becoming the first player for a

2

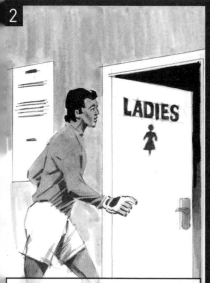

At half-time in a non-League game you notice one of the goalkeepers going into the ladies' toilet. You approach the manager, who admits the keeper is female. The opposition manager demands that you abandon the game. What do you do?

3

An attacker breaks into the penalty area and is one-on-one with the keeper, who promptly brings him down. It's a clear penalty and sending-off. But before you blow your whistle, a defender, tracking back, smashes the ball into his own net, claiming you can't now send off his colleague as a goalscoring opportunity hasn't been denied. What action do you take?

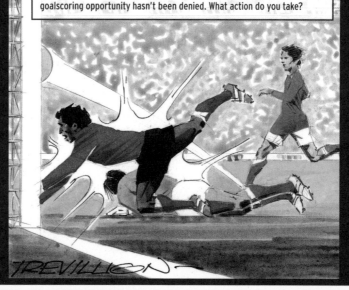

TREVILLION

Keith Hackett

1) Yes. Tell the manager to stop using it – he has a duty to act responsibly. If he doesn't stop, remove him from the technical area and the vicinity of the field of play. This isn't too different from using radio communication systems between the coach and the players.

2) Abandoning the game would be an extreme reaction, and very embarrassing for the player involved. However, you can't let things stay as they are. So you should have the keeper substituted, then report all the facts to the authorities after the game. Females over the age of 12 are not allowed to play in open-age male football.

3) Play has not been stopped for the foul, so allow the goal to stand. The defender's ruse has worked. Caution the keeper for unsporting behaviour and restart play with a kick-off. However, if you judged that the foul was serious foul play then you could still send the keeper off – but not for "DOGSO".

final, the fans immortalised him in song: "He's big, he's red, his feet stick out the bed, Peter Crouch, Peter Crouch." And after being handed his England senior breakthrough by Sven-Göran Eriksson,

Crouch was selected for the 2006 World Cup squad – pioneering his famous robot dance goal celebration in the build-up to the tournament.

2

During a penalty shoot-out the keeper tries to second-guess the striker, and dives to his left. As he dives he tears his hamstring and lets out an almighty scream. The startled striker slips and skies the penalty over the bar. What happens next?

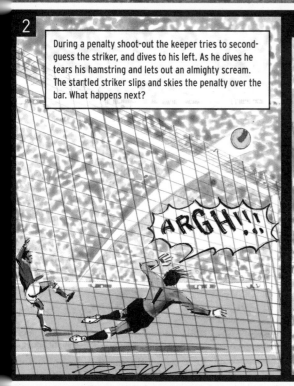

ARGH!!!

TREVILLION

3

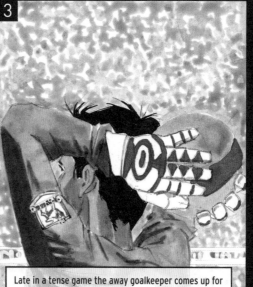

Late in a tense game the away goalkeeper comes up for a corner. The defence clear it out of play for a throw – and to everyone's surprise, the keeper dashes over to take it. Quickly he launches a long, legal throw into the box – and a striker heads it in. What do you give?

Keith Hackett

1) The kick is taken outside the edge of the penalty area, where the second foul is committed. Once the advantage has been played. The phase of play that allowed the second foul took place. The kick is committed the second foul. Don't ignore that first foul. You may still wish to take disciplinary action over it. But the second foul is the "live" one.

2) Record the kick as a miss. The kick taker needs to concentrate better than this. There are all sorts of potential distractions to overcome during a shoot-out. The injured keeper can be replaced for the rest of the shoot-out (though an injured outfield player can't be).

3) It's a goal. The goalkeeper is allowed to take this or any other throw if he wants to, so long as his action is legal. The fact that he is wearing gloves makes no difference. Outfield players wearing gloves can take throws, and so can goalkeepers.

decade to move from United to Manchester City. Apart from collecting controversial transfers, the Argentina star is also known for fronting a band with his brother Diego, and for the distinctive scarring to his neck – the result of a childhood accident which left him in intensive care for

two months. When he joined Boca Juniors aged 17 the club offered to fund cosmetic surgery, but Tevez refused. "These scars are part of who I am," he said in 2009. "It was a generous offer, but they are part of my story."

David Beckham

Full name: David Robert Joseph Beckham

Born: 2 May 1975, London, England

Major clubs: Manchester United, Real Madrid, Los Angeles Galaxy, Milan

International: England

Position: Midfield

Always at the top of polls of the world's most famous contemporary sportsmen – neck and neck with Tiger Woods – Beckham defines top level modern football. His story can be split in two: his career in football, and what he has built outside it: the endorsements, the wealth, the glamour, Mrs Beckham, charity work and his ambassadorial status as England's first choice front man for any World Cup or Olympic bid. So big is the Beckham brand that his achievements as a footballer are sometimes lost.

His career honours list is what playground dreams are made of: England captain, a star of European Championships and World Cups, a multiple title and cup winner. The signs of what he would become were obvious from an early age. He joined Manchester United aged

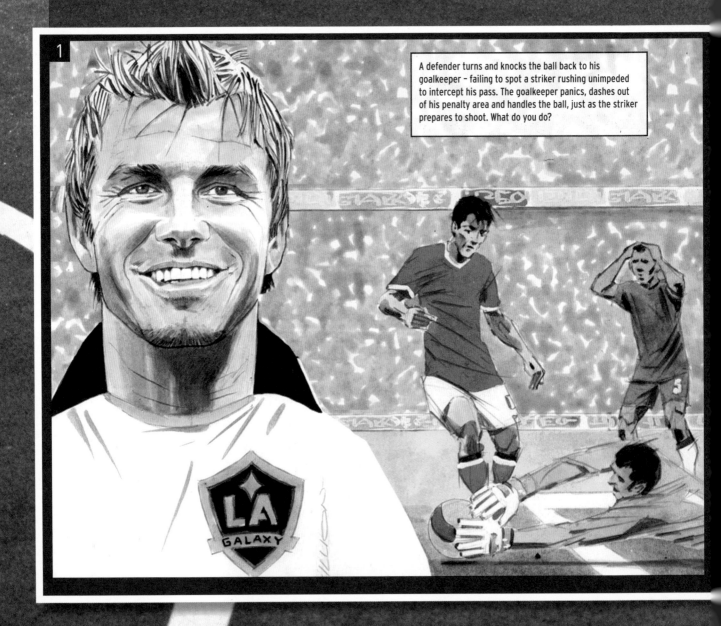

1

A defender turns and knocks the ball back to his goalkeeper – failing to spot a striker rushing unimpeded to intercept his pass. The goalkeeper panics, dashes out of his penalty area and handles the ball, just as the striker prepares to shoot. What do you do?

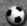

14 after trials at Leyton Orient, Norwich and a spell at Tottenham's School of Excellence, and attracted plenty of attention in United's famously successful youth system. But it was on 17 August 1996 that he found his first taste of worldwide fame: scoring from the halfway line against Wimbledon at Selhurst Park. Among many other notable moments in his career were highs like his stunning free-kick winner for England against Greece in 2002 World Cup qualifying, and real lows like his red card in the 1998 World Cup against Argentina. In late 2009 Kaká dismissed suggestions that Beckham's career was winding down, and called on Fabio Capello to keep him at the heart of England's squad. "He is simply one of the most intelligent players I have ever played alongside. There is no one else like him."

2

A long clearance is punted upfield. A striker, in an offside position, watches bemused as it flies over his head. But then he decides to jog after the ball – which prompts the opposition goalkeeper to advance. But he advances too far: the ball takes a wicked bounce, flies over him and drops into the net. What is your decision?

3

A mouthy player who has been showing dissent throughout and has already been booked is subbed. He storms off the field of play, and as he does so, turns and aims a torrent of foul verbal abuse at you. Neither the subbed player, nor his replacement, is on the field of play. What do you do?

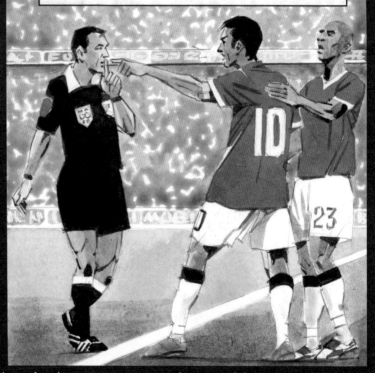

TREVILLION

Keith Hackett

1) A goalkeeper handling outside his box is not an automatic red card. You must be clear that he has denied an obvious goalscoring opportunity – and in this case, as no other defenders are close enough to play the ball, he has. It's a red card: re-start with a direct free-kick.

2) Award a goal. To be declared offside the striker must be "active" – and here he is not. Jogging forward is not a clear distraction to the goalkeeper, whose job it is to stop the ball going into his net. He has simply advanced too far and been caught out by the bounce.

3) Show the abusive player a straight red card. The substitution has not taken place, so the sub is not allowed on to the field of play. Re-start the game in the appropriate way with the team involved reduced to 10 players – unless they want to continue the substitution by taking another player off.

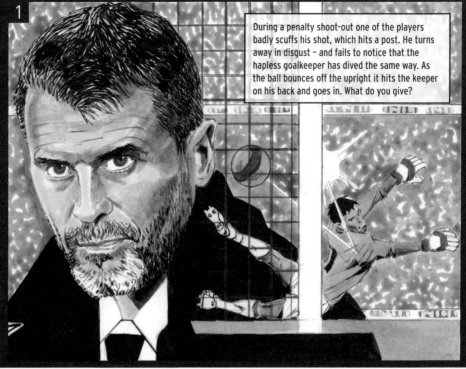

1

During a penalty shoot-out one of the players badly scuffs his shot, which hits a post. He turns away in disgust – and fails to notice that the hapless goalkeeper has dived the same way. As the ball bounces off the upright it hits the keeper on his back and goes in. What do you give?

Keith Hackett

1) It's a goal. You have to wait for the ball to finish its course before making a decision. Here, the ball clearly hit the upright, then the keeper, then went in.

2) Award a penalty and send off the defender for denying a goal. You should also caution the attacker for unsporting behaviour: this is your call, not his. In a game that's all about goals being scored, handling the ball on the line is among the most serious offences. It's not a situation where playing advantage makes sense, so you should have blown your whistle the moment the defender handled it.

3) Stop play, award a penalty and show the defender a second yellow card, followed by a red, for his reckless tackle. But this isn't great refereeing; you've waited too long before making a decision. You should decide within two to three seconds whether or not to call play back for any offence. In this instance you should have whistled before the offender had made up the ground to clear the ball – which would have saved a lot of controversy.

Keane – famously enigmatic – was one of the finest midfielders of his generation, and one of the most controversial. During his 18-year playing career, largely at Nottingham Forest and Manchester United, he grew into an aggressive, uncompromising leader – captain of United from 1997 to 2005. But it was a career also notable for indiscipline: the first of his 11 red cards was for stamping on Crystal Palace's Gareth Southgate in an FA Cup semi-final in 1995, and the worst single incident an assault on Alf-Inge Haaland in 2001, in revenge for a tackle four years earlier. His regular confrontations with Arsenal captain Patrick Vieira were infamous, as were outbursts at colleagues at club and

Harry Redknapp

Full name: Henry James Redknapp

Born: 2 March 1947, London, England

Major clubs as player: West Ham, Bournemouth, Seattle Sounders

Major sides as manager: Bournemouth, West Ham, Portsmouth, Southampton, Tottenham

One of football's most colourful and quotable managers, Redknapp's career list of trophies won is short – but his reputation for squad building and flowing football has won him some big jobs. The father of former England midfielder Jamie, who played under him at Bournemouth and Southampton, and the uncle of Frank Lampard, Redknapp's own playing career featured 149 top-flight games for West Ham, and 101 appearances in four years at Bournemouth. It was at US club Seattle Sounders from 1976-79 that he began to move into coaching, but his first management job didn't come until 1983 when he took over at Bournemouth. After surviving a car crash in Italy in 1990 he

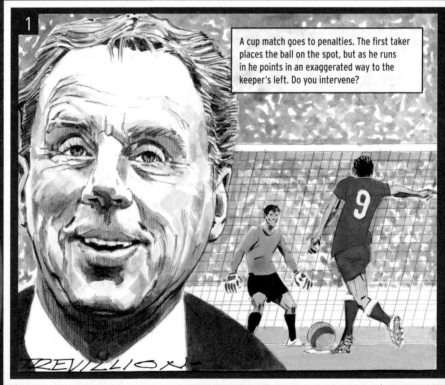

1

A cup match goes to penalties. The first taker places the ball on the spot, but as he runs in he points in an exaggerated way to the keeper's left. Do you intervene?

TREVILLION

spent a year out of football, before returning to West Ham as assistant to Billy Bonds in 1991. He took the main job in 1994, rejuvenating the club and staying until 2001. Subsequent jobs have all been at the top level - with his moves from Portsmouth to arch rivals Southampton and back again

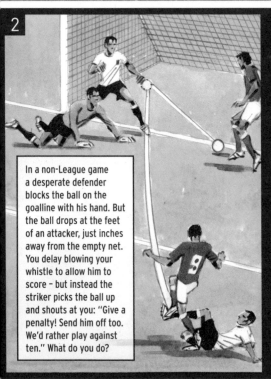

2 In a non-League game a desperate defender blocks the ball on the goalline with his hand. But the ball drops at the feet of an attacker, just inches away from the empty net. You delay blowing your whistle to allow him to score – but instead the striker picks the ball up and shouts at you: "Give a penalty! Send him off too. We'd rather play against ten." What do you do?

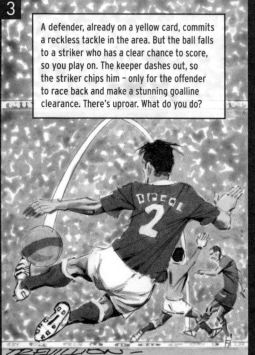

3 A defender, already on a yellow card, commits a reckless tackle in the area. But the ball falls to a striker who has a clear chance to score, so you play on. The keeper dashes out, so the striker chips him – only for the offender to race back and make a stunning goalline clearance. There's uproar. What do you do?

international level – including his decision to walk out on his country before the 2002 World Cup having verbally attacked manager Mick McCarthy, and his famous comments on United's restless home fans for coming to games "just for a few drinks and probably the prawn sandwiches... they don't realise what's going on out on the pitch". After

retiring he moved into management, first at Sunderland, taking the club from near the bottom of the Championship into the Premier League in his first season, and later at Ipswich. "There's enough people out there with no ambitions who are happy to go through the motions in life," he said in 2008. "I'm an ambitious man."

Roy Keane

Full name:
Roy Maurice Keane

Born: 10 August 1971, Cork, Republic of Ireland

Major clubs as player: Nottingham Forest, Manchester United, Celtic

Major sides as manager: Sunderland, Ipswich

International: Republic of Ireland

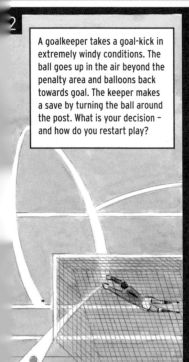

2 A goalkeeper takes a goal-kick in extremely windy conditions. The ball goes up in the air beyond the penalty area and balloons back towards goal. The keeper makes a save by turning the ball around the post. What is your decision – and how do you restart play?

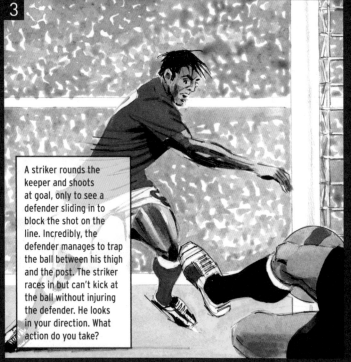

3 A striker rounds the keeper and shoots at goal, only to see a defender sliding in to block the shot on the line. Incredibly, the defender manages to trap the ball between his thigh and the post. The striker races in but can't kick at the ball without injuring the defender. He looks in your direction. What action do you take?

1) Yes – it's unsporting behaviour. Wait to see what happens from the kick: if it goes in, caution the player and order the kick to be retaken. If not, rule it as a miss/save, then caution the player.

2) It's an indirect free-kick to the attacking team. Once the ball has passed out of the penalty area it is in play and the kicker isn't allowed to touch it a second time unless it has been played by another player. The keeper has touched it again inside his own goal area, so the kick is taken from the six-yard goal area line which runs parallel to the goalline, at the nearest point to where the keeper handled for the second time.

3) It's a dropped ball. There's a clear risk that the defender could be injured or that there could be a flare-up. So, step in quickly. Stop play and restart the game with a dropped ball on the six-yard goal area line that is parallel to the goalline at the nearest point to the incident.

Keith Hackett

the most controversial. His record in the transfer market is famously prolific, with some fine signings, some average ones, and some notorious, expensive flops. Discussing the number of player compilation videos sent to him by hopeful agents, Redknapp revealed:

"I tape over most of them with Corrie or Neighbours. They can make anyone look good. I signed Marco Boogers for West Ham off a video. He was a good player but a nutter. They didn't show that on the video."

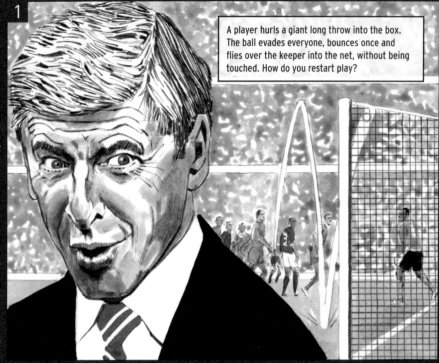

1

A player hurls a giant long throw into the box. The ball evades everyone, bounces once and flies over the keeper into the net, without being touched. How do you restart play?

Keith Hackett

1) It's a goal-kick. You cannot score directly from a throw, so effectively the throw-taker has hurled the ball directly out of play. So logically, it's a goal-kick, regardless of the fact that it ended up in the net.

2) A free-kick to the defending team. As the artwork shows, the ball has been dislodged from the keeper's possession by the over-enthusiastic actions of his former colleague. So regardless of the friendly intent, it would clearly be wrong to allow the goal in this situation. Use a mixture of common sense and the laws: the goalkeeper has been impeded, so give the free-kick.

3) Yes. Let the substitution go ahead because there's also nothing in the laws to prevent playing in furry trousers – and there's no reason for you to intervene because the trousers are clearly not dangerous to either the player or his opponents. It's not exactly ideal, though. You should monitor the situation in case problems do occur with the player – at which point you'd have the authority to have him removed from the game, even if the side have used all their substitutes.

Wenger's record is remarkable: Arsenal's most successful and longest-serving manager, the first non-British manager to win the Double, and, in 2004, the architect of Arsenal's extraordinary undefeated season. As a player he was mediocre, never reaching great heights, but it was while at RC Strasbourg in 1981 that he qualified as a manager. Two years later he became assistant at Cannes. Though his first senior job was at Nancy in 1984, his career took off when he joined Monaco in 1987, managing big name players including Glenn Hoddle and Jürgen Klinsmann. After 18 months in Japan with Nagoya Grampus Eight, he moved to London in 1996 to replace Bruce Rioch at Arsenal, and went on to rebrand the club,

Emile Heskey

Full name:
Emile William Ivanhoe Heskey

Born: 11 January 1978,
Leicester, England

Major clubs: Leicester, Liverpool, Birmingham, Wigan, Aston Villa

International: England

Position: Striker

A powerful, solid target man who, at his best, is impossible to contain, Heskey's ability and attitude have taken him to the highest levels of club and international football. Born in Leicester he started with his hometown club in 1994 before joining Liverpool for £11m in 2000. At Anfield and through subsequent moves to Birmingham, Wigan and Aston Villa he proved his strength and ability to hold up the ball and link play, and responded positively to criticism about his lack of goals, and about falling over too easily. It was criticism which peaked after an expensive defensive mistake for England at Euro 2004:

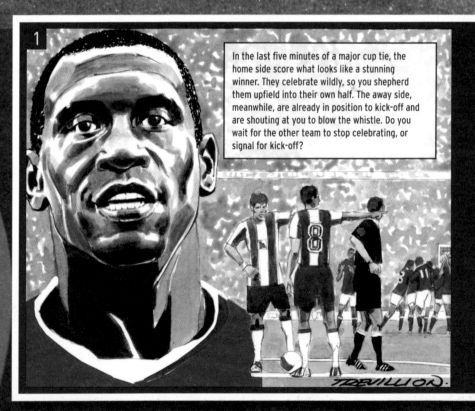

1

In the last five minutes of a major cup tie, the home side score what looks like a stunning winner. They celebrate wildly, so you shepherd them upfield into their own half. The away side, meanwhile, are already in position to kick-off and are shouting at you to blow the whistle. Do you wait for the other team to stop celebrating, or signal for kick-off?

TREVILLION.

barracked by fans, he was dropped from Sven-Göran Eriksson's squad, and was written off as an international striker. But, via strong performances at club level, he worked his way back into the squad in 2007 under

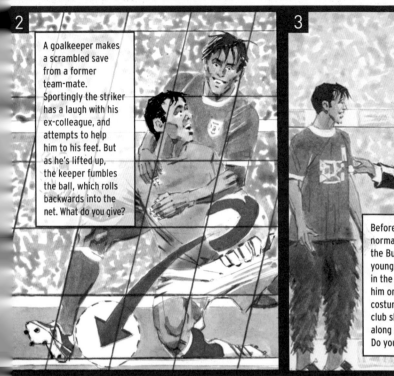
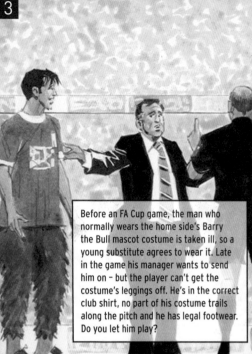

2

A goalkeeper makes a scrambled save from a former team-mate. Sportingly the striker has a laugh with his ex-colleague, and attempts to help him to his feet. But as he's lifted up, the keeper fumbles the ball, which rolls backwards into the net. What do you give?

3

Before an FA Cup game, the man who normally wears the home side's Barry the Bull mascot costume is taken ill, so a young substitute agrees to wear it. Late in the game his manager wants to send him on – but the player can't get the costume's leggings off. He's in the correct club shirt, no part of his costume trails along the pitch and he has legal footwear. Do you let him play?

Arsène Wenger

Full name:
Arsène Wenger

Born: 22 October 1949, Strasbourg, France

Major clubs as player: Mulhouse, ASPV Strasbourg, RC Strasbourg

Major sides as manager: Nancy, Monaco, Nagoya Grampus Eight, Arsenal

winning a string of honours. Famous among rival fans for responding to questions from journalists about indiscretions by Arsenal players with "I did not see the incident", he also attracted criticism for running battles with Sir Alex Ferguson and José Mourinho, and for failing to develop English talent. But the man who appointed him at Arsenal,

David Dein, summed up his impact: "He's highly intelligent; cool and calm; a great tactician; knows a lot about medicine and injuries... even the development of our training ground is Arsène's brainchild, right down to the teacups. To me he's a miracle worker. He has revolutionised our club."

2

A striker is onside, clean through on goal, and goes round the keeper. But as he does so, a colleague, also onside, sprints in ahead of him and shapes to slot the ball into the net. The striker is furious at the attempted poaching of his goal, so shoves his team-mate away and scores the goal himself. What do you give?

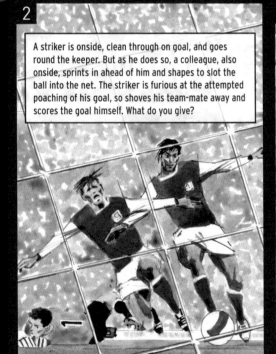

3

You are refereeing a League One match where the home side play very loud music after they score. But after they hit their second goal there's a technical fault. The music is stuck on a loop and they can't turn it off. What do you do?

1) Signal for kick-off. It's their fault for not concentrating. The procedure for restart is this: a) all players must be in their own half of the field of play; b) The opponents must be at least 9.15m (10 yards) from the ball until it is in play; c) the ball must be stationary on the centre mark. To start the game, you give a signal, and the ball is in play as soon as it is kicked and moves forward. If either team deliberately delays the restart, you can caution the offenders.

2) Allow the goal. An unusual one – I'd also take the opportunity to have a quiet word with each player.

3) Allow the game to continue. Football isn't a quiet experience. I've refereed in front of crowds of over 100,000 people: at times it can be difficult in games like that to make your whistle heard, but you have to carry on. So in this situation, that should be part of your reasoning. As long as it's within the competition regulations that the team can play music when a goal is scored, you should just put up with the problem and allow the game to continue. But I'd report the matter to the authorities.

Keith Hackett

Steve McClaren, impressing with his drive and hunger to succeed and remaining a regular under Fabio Capello. "It's a strange sport," Heskey said after the recall. "You can have so many ups and downs, and it's about how you cope with them. When I was dropped I never gave up. I've always had self-belief, and I wanted to get back in – I always knew I would eventually."

A goalkeeper leaps to collect a looping ball on the edge of his penalty area, but as he catches it he's accidentally knocked outside the area by a team-mate. What do you do?

TREVILLION

EUSÉBIO

Full name: Eusébio da Silva Ferreira

Born: 25 January 1942, Lourenco Marques, Portuguese East Africa/Mozambique

Major club: Benfica

Country: Portugal

Position: Forward

Eusébio had the kind of scoring rate that it is hard to believe will ever be seen again: 727 goals in 715 games. A frighteningly powerful forward with a thunderous right foot, Eusébio was also a skilled and deft creator, and ready to pounce on any half-chance. He is rated as Portugal's all-time greatest player.

After starting his club career with Sporting Clube de Lourenço Marques in Portuguese East Africa, he moved to Benfica aged 18, and became their record goalscorer. In 1962 he scored twice as Benfica trounced Real Madrid 5-3 in the European Cup final, though Eusébio and his side were subsequently beaten finalists in three campaigns. But his goals helped Benfica to a more complete dominance at home as they won 11 league titles and five cups during his career. In 1965 he was voted European Footballer of the Year and, three years later, became the inaugural winner of the Golden Boot award.

For his country he scored 41 goals in 64 appearances, including nine in the 1966 World Cup, making him the tournament's top scorer, as Portugal made it to the semi-finals.

After leaving Benfica he played for five North American clubs and enjoyed spells in Mexico with Monterry, and, back in Portugal, with Beira-Mar and União de Tomar.

Despite being considered a Portuguese legend – he was voted by the Portuguese Football Federation as the key player in their history - Eusébio also deserves to be remembered as the first world-class Africa-born player.

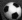

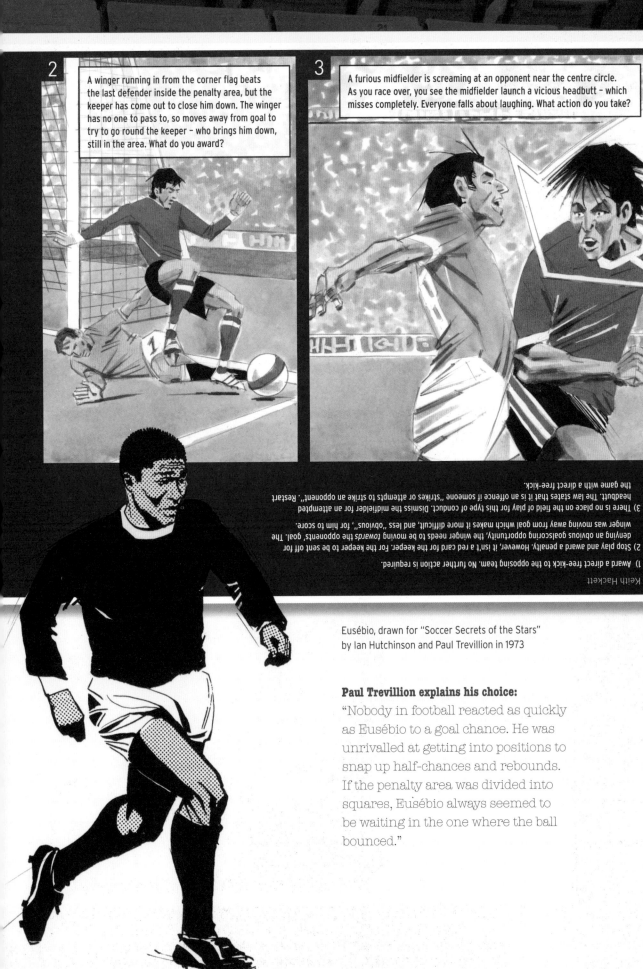

2

A winger running in from the corner flag beats the last defender inside the penalty area, but the keeper has come out to close him down. The winger has no one to pass to, so moves away from goal to try to go round the keeper – who brings him down, still in the area. What do you award?

3

A furious midfielder is screaming at an opponent near the centre circle. As you race over, you see the midfielder launch a vicious headbutt – which misses completely. Everyone falls about laughing. What action do you take?

1) Award a direct free-kick to the opposing team. No further action is required.

2) Stop play and award a penalty. However, it isn't a red card for the keeper. For the keeper to be sent off for denying an obvious goalscoring opportunity, the winger needs to be moving *towards* the opponents' goal. The winger was moving away from goal which makes it more difficult, and less "obvious", for him to score.

3) There is no place on the field of play for this type of conduct. Dismiss the midfielder for an attempted headbutt. The law states that it is an offence if someone "strikes or attempts to strike an opponent". Restart the game with a direct free-kick.

Keith Hackett

Eusébio, drawn for "Soccer Secrets of the Stars" by Ian Hutchinson and Paul Trevillion in 1973

Paul Trevillion explains his choice:

"Nobody in football reacted as quickly as Eusébio to a goal chance. He was unrivalled at getting into positions to snap up half-chances and rebounds. If the penalty area was divided into squares, Eusébio always seemed to be waiting in the one where the ball bounced."

Rio Ferdinand

Full name: Rio Gavin Ferdinand

Born: 7 November 1978, Peckham, London, England

Major clubs: West Ham, Leeds, Manchester United

International: England

Position: Defender

A pivotal player for club and country, Ferdinand has had a relentlessly high-profile career. It began at West Ham where, after making his full debut in 1996, he developed into a fine all-round defender: dominant, comfortable on the ball and resolute under pressure. He won his first cap the following year aged 19, then the youngest defender to play for England. In 2000 Leeds, then at their peak, paid £18m for him, a world record for a defender at the time, and two years later he completed another record transfer, valued at over £30m, to Manchester United. He has won a string of personal and club honours, including a Premier League and Champions League double in 2008. His life off the pitch has been colourful – his own TV show, record

label and other commercial projects – and controversial: he missed a drugs test in 2003, resulting in an eight-month ban from football, and he has also been attacked for low moments such as his conviction for drink driving, making a homophobic remark during

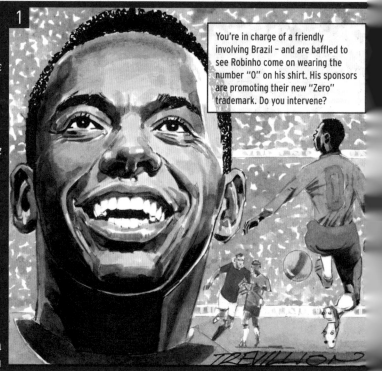

1

The away side try a new corner routine. The taker pauses and indicates he'll let a colleague take the kick instead – but as the colleague jogs over, the original player gently brushes the ball with his foot. The ball moves very slightly, but doesn't leave the quadrant. The home side haven't noticed – and when the colleague arrives to take the kick, he surprises everyone by turning, sprinting with the ball into the area and firing it into the net. There's uproar. What do you give?

Robinho

Full name: Robson de Souza

Born: 25 January 1984, São Vicente, Brazil

Major clubs: Santos, Real Madrid, Manchester City

International: Brazil

Position: Forward

Among the ranks of players tipped as "the new Pelé" during his youth, Robinho turned professional in 2002 with Santos, and had an eye-catching first season, scoring 10 goals as the club won

the Campeonato Brasileiro, a feat they repeated in 2004. His form drew scouts from across Europe, with a £24m bid from Real Madrid accepted in July 2005. At Real he shone, scoring 14 goals in his debut season and winning the title in his second and third, earning nominations for the

European Footballer of the Year Ballon d'Or and Fifa's World Player of the Year. But in the summer of 2008 his Real career collapsed dramatically: president Ramón Calderón attempted to use him as bait in a failed deal for Manchester United's Cristiano Ronaldo, convincing Robinho he was

1

You're in charge of a friendly involving Brazil – and are baffled to see Robinho come on wearing the number "0" on his shirt. His sponsors are promoting their new "Zero" trademark. Do you intervene?

Keith Hackett

1) No, allow him to continue. As long as his name has this number on the team sheet, there's nothing in the laws that stops him having the number 0. All you need to know is his number and name so you can take disciplinary action. Not so long ago competition rules required shirts to be numbered 1 to 11, and a player could be numbered 7 one week and number 8 the next. But now a player can have any number from 0 to 100, but must keep that shirt all season. With the large squads at the top level now it helps boost shirt sales. In most lower leagues, though, the competition rules will determine the numbers – often 1 to 11 – and the size and colour of those numbers.

2) Yes, there's no problem here – play on. A player can use the base of the corner flag post in exactly the same way he can use the goal post. The only time you'd intervene would be with a player using the crossbar to pull himself up to head the ball clear.

3) No, there's no offence: the ball hasn't yet entered the field of play, so you can allow it to be retaken. Even if it had entered play, the throw had not been completed, so you would order a retake anyway.

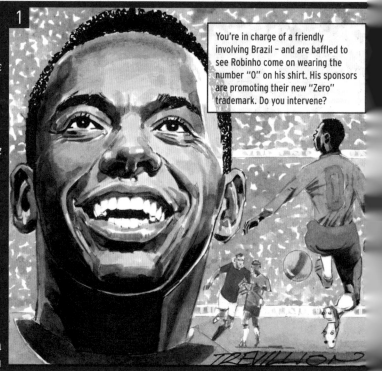

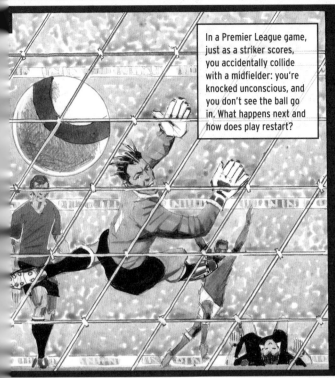

In a Premier League game, just as a striker scores, you accidentally collide with a midfielder: you're knocked unconscious, and you don't see the ball go in. What happens next and how does play restart?

3

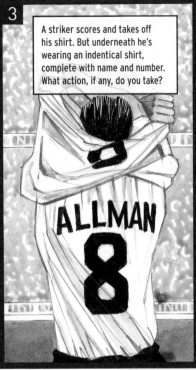

A striker scores and takes off his shirt. But underneath he's wearing an indentical shirt, complete with name and number. What action, if any, do you take?

ALLMAN 8

Keith Hackett

1) Give the goal. It's a clever routine: the ball is in play when it is kicked and moves – it doesn't have to leave the quadrant.

2) The goal is awarded, so long as neither of your assistants saw an infringement before the ball went in. In the Premier League the fourth official is a national list referee and so takes over the whistle. And if there is one, a volunteer with relevant experience is then taken from the crowd to act as the new fourth official.

3) Book him – it's a cautionable offence whatever he's wearing underneath. I'm often asked why this law exists. There are a few reasons. One of them is crowd incitement: there's a famous old clip of a player running to the fans and taking off his shirt in celebration – it caused a crowd surge that led to fatalities. Other issues include preventing players showing political slogans, and the fact that it's a global game: in some countries the removal of the shirt is considered offensive.

a radio interview, and kicking a female Chelsea steward by mistake in 2008. But he spoke in 2009 of his growing personal maturity as a senior figure in the game. "I've been in football a long time now, and I've begun acting like a big brother to the younger guys. It only seems like yesterday when I was being talked to by the likes of Iain Dowie and Ian Wright at West Ham. I'm now in the same period of my career as they were back then. You evolve into a different person."

2

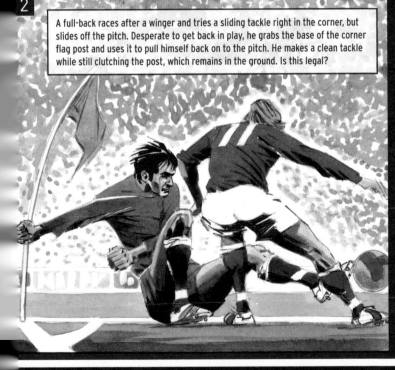

A full-back races after a winger and tries a sliding tackle right in the corner, but slides off the pitch. Desperate to get back in play, he grabs the base of the corner flag post and uses it to pull himself back on to the pitch. He makes a clean tackle while still clutching the post, which remains in the ground. Is this legal?

3

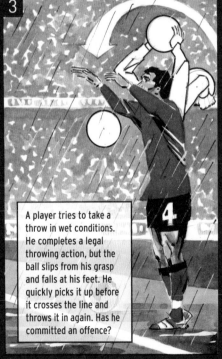

A player tries to take a throw in wet conditions. He completes a legal throwing action, but the ball slips from his grasp and falls at his feet. He quickly picks it up before it crosses the line and throws it in again. Has he committed an offence?

unwanted. This led eventually to a shock £32.5m, £160,000-a-week transfer to Manchester City. The move drew fierce criticism for a lack of ambition, with Brazilian press referring to "the wrong Manchester" and Pelé calling his decision "not normal" – but Robinho insisted it wasn't a financial decision. "It's not nice to hear Pelé being critical. But I can take it. I am used to good things, and bad things, being said about me." He made his Brazil debut in July 2003, shone in the 2007 Copa America, and helped them win the 2009 Confederations Cup.

PAT JENNINGS

Full name: Patrick Anthony Jennings

Born: 12 June 1945, Newry

Major clubs: Watford, Tottenham, Arsenal

Country: Northern Ireland

Position: Goalkeeper

Composed and brave, Pat Jennings was one of the finest keepers of his era, renowned for his positional sense and his skill in one-on-ones. Aged 18 he joined Watford, in the English Third Division, where a successful season caught the attention of Spurs, who signed him for £27,000.

In 1973 he was voted Footballer of the Year by the Football Writers' Association, and in 1976 won the PFA players' award – both rare honours for a goalkeeper, speaking volumes about his outstanding quality. During his time at Spurs he won the FA Cup, the Uefa Cup and two League Cups.

In 1977, after 13 years at White Hart Lane, Jennings crossed north London and joined Arsenal, Spurs' great rivals. Aged 32, Spurs had considered Jennings past his peak, but he went on to spend eight successful seasons with Arsenal, winning another FA Cup in 1979. Despite his lengthy association with Tottenham, Jennings became a hero at Highbury, and remains one of the few players to be remembered with affection by both sets of fans. On retiring he returned to Tottenham as a goalkeeping coach.

At international level he made his debut aged 18 in the same match as fellow Northern Ireland legend George Best. Jennings went on to make a record 119 appearances for his country, and during his 22 year international career featured in two World Cups (1982 and 1986) and a then-record six World Cup qualifying stages. His final cap was earned, on his 41st birthday, in a 3-0 defeat to Brazil in the 1986 World Cup.

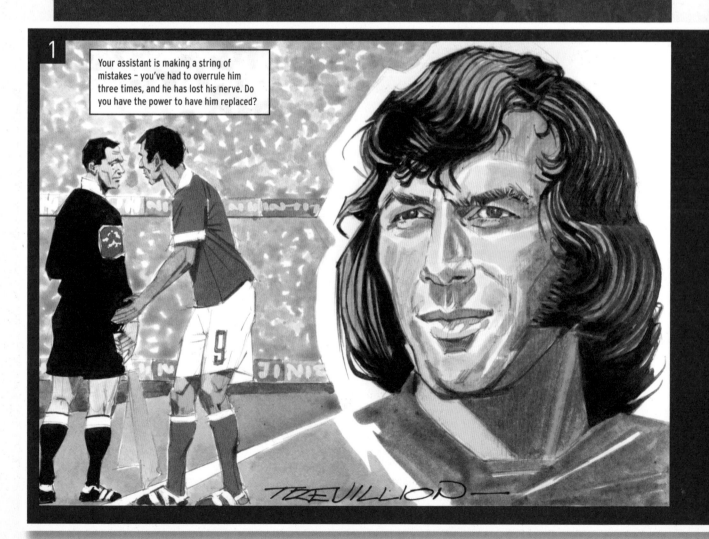

1

Your assistant is making a string of mistakes – you've had to overrule him three times, and he has lost his nerve. Do you have the power to have him replaced?

Paul Trevillion explains his choice:

"Jennings offered forwards absolutely no encouragement. He didn't give away silly goals, he was unflappable under pressure, he kept out shots he had no right to get close to, and he could pluck out crosses from the air with one hand. He was the most consistent keeper I have ever been lucky enough to watch."

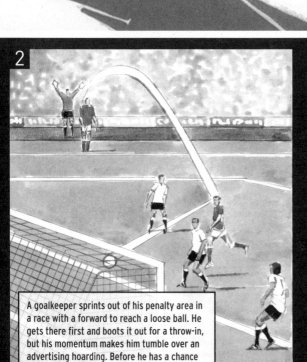

2

A goalkeeper sprints out of his penalty area in a race with a forward to reach a loose ball. He gets there first and boots it out for a throw-in, but his momentum makes him tumble over an advertising hoarding. Before he has a chance to get back into play, the opposition take a quick throw and score. What do you give?

3

You are shocked to see a defender bend down and pick up the ball in his own penalty area near the penalty mark. As you run up to him, he protests that he heard a whistle – and players from both sides agree, saying the noise came from the crowd. You didn't hear it, and neither did your assistants. What do you do?

1) Manage the situation sensibly. Approach the assistant and give him some words of encouragement and tell him you will take on some of his duties. Ask him to just award ball in and out of play decisions, and that offside decisions are yours. If he doesn't wish to continue then you can call on the services of the fourth official. After the game, report what happened to the authorities.

2) A goal – assuming the throw-in has been taken correctly. The same decision would be given if the player wasn't the goalkeeper. If, though, you thought the keeper was seriously injured, you would stop play immediately.

3) Use common sense: restart with a dropped ball near the penalty mark. However, before the restart, ask for a stadium announcement to request the spectator involved stops using the whistle.

Keith Hackett

Dimitar Berbatov

Full name: Dimitar Ivanov Berbatov

Born: 30 January 1981, Blagoevgrad, Bulgaria

Major clubs: CSKA Sofia, Bayer Leverkusen, Tottenham, Manchester United

International: Bulgaria

Position: Striker

A distinctive, enigmatic figure for club and country, Berbatov's languid style often disguises his fantastic skill as a striker. He began his professional career at CSKA Sofia aged 17 in 1998. Three years later he was signed by Bayer Leverkusen where he made a major impact, and appeared in the Champions League final in 2002 against Real Madrid. In 2006 Tottenham beat a host of rivals to bring him to England for £10.9m – making him then the most expensive Bulgarian player ever – where his subtlety and style quickly impressed. He scored on his debut against Sheffield United and went on to establish himself as key to the side's attacking threat in the Premier League and Uefa Cup, winning their player of the year award in 2007. But at the start

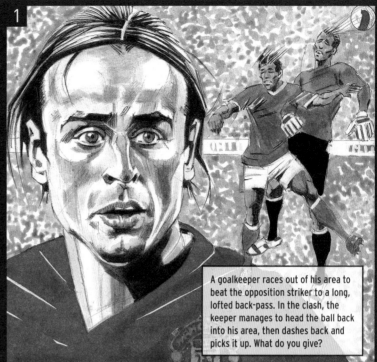

1

A goalkeeper races out of his area to beat the opposition striker to a long, lofted back-pass. In the clash, the keeper manages to head the ball back into his area, then dashes back and picks it up. What do you give?

Keith Hackett

1) Penalise the goalkeeper for handling the ball from a deliberate back-pass. His header outside the area makes no difference. Give an indirect free-kick from the point where the keeper handled it.

2) Play on. But it's an immensely difficult situation. Intent is no longer in the laws of the game – so the fact that the defender did not intend to bring the defender down is irrelevant. Instead, the question you have to ask is whether the defender could have avoided the collision if he had taken more care – was it down to carelessness? If your answer was yes then you would give a direct free-kick or penalty, with a possible red card if an obvious goalscoring opportunity had been denied. But if the incident isn't down to carelessness, and is obviously a complete accident like this one, let play continue.

3) The defenders are right – the laws state that, in this instance, after treatment, an injured player must leave the field of play.

Theo Walcott

Full name: Theo James Walcott

Born: 16 March 1989, London, England

Major clubs: Southampton, Arsenal

International: England

Position: Forward

Walcott, for a long time the most talked-about teenager in the English game, spent his formative years in Swindon's youth system, but joined Southampton aged 11. His speed and skills quickly attracted scouts from bigger clubs, but five years later, aged 16 and ready for his first professional contract, he chose to stay with Southampton. He went on to become the club's youngest ever first-team player at 16 years and 143 days, coming on as a sub in a 0-0 draw with Wolves, before making his full debut on 18 October 2005 away to Leeds. But he didn't stay long. Sold to Arsenal in January 2006 for a fee potentially rising to £12m, he made his Premier League debut on 19 August that year, having spent the close-season with the England squad at World Cup 2006. A surprising choice,

1

You've given an indirect free-kick just outside the box. A defender stands two yards away to stop it being taken quickly – but the taker spots the keeper out of position, so deliberately plays the ball off the defender's leg and fires the rebound into the net. He wheels away to celebrate. What do you give?

TREVILLION

Keith Hackett

1) Yes, give the goal. The defending side are being penalised, so it's right to give the call in favour of their opponents. You should then book the defender for failing to retreat the correct distance.

2) You haven't stopped play by raising your arm – players must play to the whistle. Give the goal. One of the skills a top referee must have is an ability to read this, to see if an advantage develops for a few seconds in a situation like the game and delay blowing the whistle this case, you've done well to spot the advantage. English referees have a terrific reputation for allowing the game to flow by applying advantage. Recent figures show the average number of free-kicks awarded in Premier League games is 25, compared to 40 plus in other major leagues abroad.

3) No – play on. The ball didn't cross the line, and the keeper has used his hand to block it. If, though, you'd spotted that the keeper had actually pushed the net up to block the ball, that would have been considered use of an "outside agent". In that situation, you'd award a dropped ball on the six-yard line.

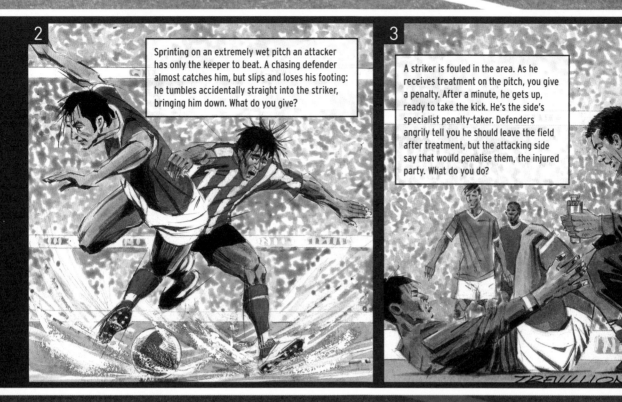

2

Sprinting on an extremely wet pitch an attacker has only the keeper to beat. A chasing defender almost catches him, but slips and loses his footing: he tumbles accidentally straight into the striker, bringing him down. What do you give?

3

A striker is fouled in the area. As he receives treatment on the pitch, you give a penalty. After a minute, he gets up, ready to take the kick. He's the side's specialist penalty-taker. Defenders angrily tell you he should leave the field after treatment, but the attacking side say that would penalise them, the injured party. What do you do?

of 2008-09, amid a war of words between Spurs and Manchester United over allegations of "tapping up", Berbatov demanded, then completed, a move to Old Trafford for £30.75m. Talking in 2009 about his laid-back style, which has always drawn criticism when he is not scoring, he

denied suggestions he should put more effort into his game: "I'm a relaxed guy. I play the way I do and can't change. I watch games and see guys who panic on the ball and look so nervous. But I sometimes know what I want to do even before the ball comes to me - so I stay calm."

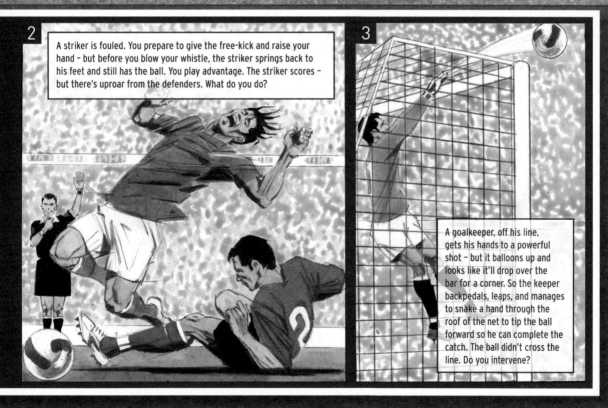

2

A striker is fouled. You prepare to give the free-kick and raise your hand – but before you blow your whistle, the striker springs back to his feet and still has the ball. You play advantage. The striker scores – but there's uproar from the defenders. What do you do?

3

A goalkeeper, off his line, gets his hands to a powerful shot - but it balloons up and looks like it'll drop over the bar for a corner. So the keeper backpedals, leaps, and manages to snake a hand through the roof of the net to tip the ball forward so he can complete the catch. The ball didn't cross the line. Do you intervene?

he didn't make an appearance during the tournament, but was named the BBC's Young Sports Personality of the Year, and subsequently went on to establish himself as a key part of Arsène Wenger's side. After a lean time with England due in part to injury, he scored a hat-trick in the 4-1 win in Croatia and looks destined to have a long future at

international level. In 2009 he spoke of his ambition. "Cristiano Ronaldo only needs to walk on to the pitch to have defenders scared straight away. That's the message I want to send out. I want left-backs to see my name on the team-sheet and be afraid before we've even kicked off."

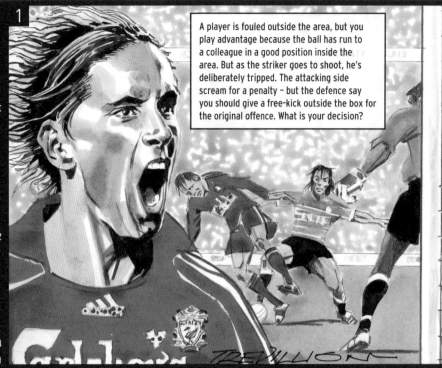

A player is fouled outside the area, but you play advantage because the ball has run to a colleague in a good position inside the area. But as the striker goes to shoot, he's deliberately tripped. The attacking side scream for a penalty – but the defence say you should give a free-kick outside the box for the original offence. What is your decision?

Keith Hackett

1) Award a penalty. You've shown courage and skill by applying an advantage so close to the area – and that passage of attacking play has resulted in a clear penalty. The advantage is with the attacking side, and the penalty decision reflects that. You must also decide if the foul denied an obvious goalscoring opportunity.

2) If the police haven't already intervened, send both physios out of the technical area and advise them they will be reported to the FA. Both clubs would have a doctor present, and they, plus paramedics, would cover the physios. At a lower level, though, while you'd send the physios off and report them, you would still have to allow them on to the field if needed as they are likely to be the only people qualified to treat injuries.

3) Play has not restarted, so retract the red card. Ask the other players who made the comment. If one owns up, send him off. If no one owns up, play on and report the comment. If they failed to provide it, action would then be taken against the club as a whole.

One of the game's top contemporary strikers, and a player recognised as having the ability to command a first-team spot in all the world's biggest club sides, Torres's glamorous image belies his toughness and strength. A product of Atlético Madrid's youth system which he joined aged 11, he made his first team debut in 2001, and went on to score

75 goals in 174 League games there. After rumours of possible moves to Chelsea and Newcastle, he joined Liverpool in 2007 in a deal worth around £25m, and scored on his Anfield debut against Chelsea. He ended the season with 29 goals in all competitions and was shortlisted for the PFA's Player of the Year award. As his prolific form continued,

David Bentley

Full name:
David Michael Bentley

Born: 27 August 1984, Peterborough, England

Major clubs: Blackburn, Tottenham

International: England

Position: Winger

For a long time considered a player with huge potential and raw talent, but also a suspect attitude, Bentley began his career at Arsenal aged 13. He went on to make just one first-team appearance in the league before spending two seasons on loan at Norwich and Blackburn, joining the latter on a full-time basis in January 2006. It was at Ewood Park that he really made an impact, with strong, skilful performances and fine goals earning his first international cap in September 2007, and a new, long-term contract. The Rovers chairman, John Williams, said: "David is widely regarded

A superstar wantaway midfielder has spent the summer trying and failing to leave his club. He's furious with his manager – so, in the first home game of the season, launches a bizarre protest, racing towards his goal with the ball in an attempt to score an own goal. His captain sees what's happening, chases after him and violently fouls him in their own penalty area before he can shoot. What do you do, and how does play restart?

as one of the best young footballers in the country. This deal underpins our ambition." But a year after signing the contract Bentley made clear he wanted to move to a bigger club, and in July 2008 joined Spurs for £15m. High expectations soon faded as he struggled to find any consistency, and

2

With play in progress, you're suddenly made aware of a disturbance in the technical area. You turn in time to see the two physios engaged in a furious fight. They exchange blows before being dragged apart. What action do you take?

3

In a melee you hear a player shout "f***ing cheat" at you. You show him a straight red – but as he protests you realise he has a totally different accent to the voice that swore. Other players protest and you suddenly realise it was one of these voices that made the comment – but in the mayhem you're not sure which one. What action, if any, do you take?

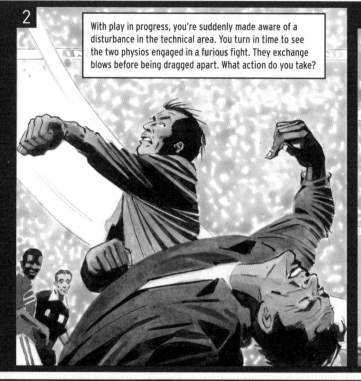

Fernando Torres

Full name: Fernando José Torres Sanz

Born: 20 March 1984, Madrid, Spain

Major clubs: Atlético Madrid, Liverpool

International: Spain

Position: Striker

stories spread of a £50m bid by Chelsea for him in 2008, but Torres stated he wouldn't consider moving again: "It is an honour to be linked to clubs like Barcelona, Chelsea and Arsenal – but I am not thinking about a change. I want to continue playing for Liverpool for many years to come." He finished in third place on the Fifa World Player of the Year award list in 2008 behind Cristiano Ronaldo and Lionel Messi, and earned high praise from Liverpool's manager, Rafa Benítez: "Given the money that some clubs pay for a player, he was cheap. He is one of the world's best." Torres made his Spain debut against Portugal in 2003, and scored the winner in the Euro 2008 final against Germany.

2

A player is being abused by fans as he tries to take a corner. In a rage he turns, aims a foul gesture at them and storms off, straight down the tunnel, before taking the kick. You've taken no action and he has already disappeared. Can his side bring on a sub? How do you restart play?

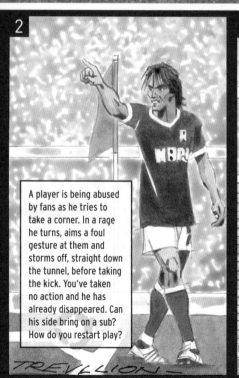

3

A young forward dashes up to you to complain that the goalkeeper is breaking the rules by bouncing the ball before taking his kicks. He says each bounce counts as releasing the ball, and you should take action. Is he right?

Keith Hackett

1) A bizarre set of circumstances, but your action is clear. First, the captain has committed an act of violent conduct so you should show him the red card. Second, play is restarted with an indirect free-kick to the opposition from the point where the offence was committed. Third, the actions of the midfielder are beyond your control. It is up to his manager to remove him from the game.

2) Make it clear to the team's manager that the player has been sent off, and do not allow a sub to replace him. The foul gesture means the player is dismissed in line with Law 12, offence number six. And even if you didn't consider the player's gesture to the crowd to be a seriously offensive one, it would still be a bookable action, which would still result in a dismissal: this first yellow card would immediately be followed by a second for the offence of leaving the field of play without permission. So the player is sent off either way.

3) No. The law states that a goalkeeper is considered to be in control of the ball while in the act of bouncing it on the ground or tossing it into the air. So the goalkeeper has not committed an offence. Play on.

he began drawing criticism for a perceived "big-time" attitude. After he was charged with drink-driving in the summer of 2009, crashing his Porsche into a lamppost, Bentley was given a stark warning by his manager, Harry Redknapp: "He needs to lose this image that has grown around him. He doesn't need to be spending his time in nightclubs, he needs to concentrate on football. He needs to look at players like Luka Modric, who just get on with their jobs."

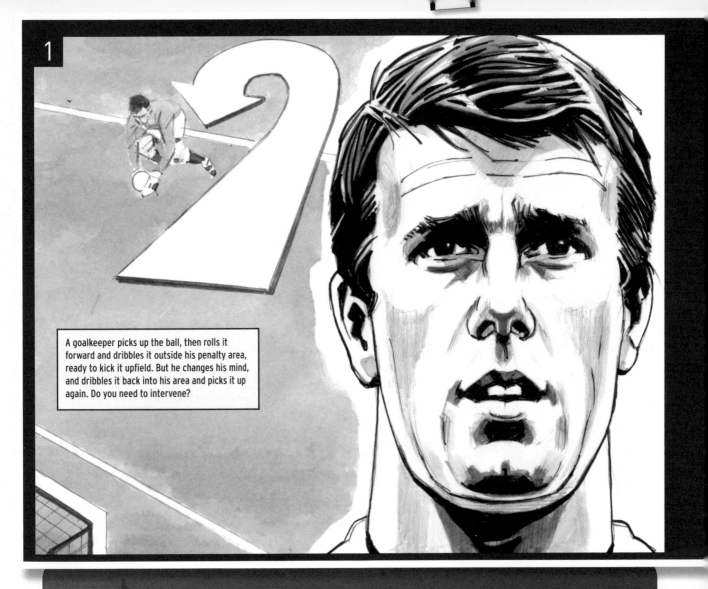

A goalkeeper picks up the ball, then rolls it forward and dribbles it outside his penalty area, ready to kick it upfield. But he changes his mind, and dribbles it back into his area and picks it up again. Do you need to intervene?

GEOFF HURST

Full name: Sir Geoffrey Charles Hurst

Born: 8 December 1941, Ashton-under-Lyne

Major clubs: West Ham, Stoke City, West Bromwich Albion

Country: England

Position: Striker

Despite 252 goals in 499 games for West Ham and a great England career, Hurst's World Cup final hat-trick will always be remembered as his finest hour. At the start of the 1966 World Cup he was just five months and five games into his England career, and wasn't selected for the first three games of the tournament. When Jimmy Greaves was injured, though, he came into the team for the quarter-final against Argentina. He scored and subsequently played well enough in England's 2-1 victory over Portugal in the semi to retain his place.

In the final, Helmut Haller opened the scoring for West Germany, but Hurst levelled with a thumping header past a static goalkeeper. Martin Peters and Wolfgang Weber exchanged goals in the second half to send the game to extra time – the 30 minutes that would define Hurst's career. His second, infamous, goal was a swivel and shot which thumped off the crossbar and down, with the linesman determining it had landed over the line. The third, hat-trick goal is another piece of football history: West Germany had swarmed forward in search of an equaliser, but Bobby Moore won the ball and sent it upfield to Hurst. England fans, convinced the match was won, charged on to the field, while Hurst – in an attempt, he later claimed, to put the ball into the Wembley stands – let loose an unstoppable shot that squeezed into the top left-hand corner of the German goal. As he ran, BBC commentator Ken Wolstenholme tracked his progress: "And here comes Hurst. He's got... some people are on the pitch, they think it's all over. It is now!"

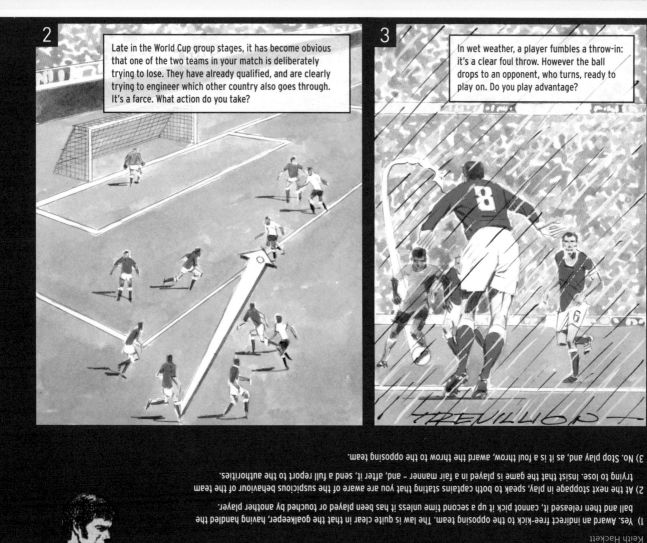

2 Late in the World Cup group stages, it has become obvious that one of the two teams in your match is deliberately trying to lose. They have already qualified, and are clearly trying to engineer which other country also goes through. It's a farce. What action do you take?

3 In wet weather, a player fumbles a throw-in: it's a clear foul throw. However the ball drops to an opponent, who turns, ready to play on. Do you play advantage?

3) No. Stop play and, as it is a foul throw, award the throw to the opposing team.

2) At the next stoppage in play, speak to both captains stating that you are aware of the suspicious behaviour of the team trying to lose. Insist that the game is played in a fair manner – and, after it, send a full report to the authorities.

1) Yes. Award an indirect free-kick to the opposing team. The law is quite clear in that the goalkeeper, having handled the ball and then released it, cannot pick it up a second time unless it has been played or touched by another player.

Keith Hackett

Paul Trevillion explains his choice:

"Tall, strong, commanding and deceptively quick, he had perfect timing. When he went up for a ball in the air, his jump was instinctive, timed to perfection. He also had two good feet and when he hit the ball it really went – timing again. A deadly goalscoring machine, and a real World Cup hero for any Englishman!"

Left, Hurst controls a ball, and right, in England kit – first published in Match magazine in 1990

John Terry

Full name:
John George Terry

Born: 7 December 1980, London, England

Major club: Chelsea

International: England

Position: Defender

John Terry has never been far from controversy: his image tarnished by off-field incidents and on-pitch indiscipline. However, he also ranks among the top defenders of his era, brave, resolute and central to the success of a trophy-laden Chelsea side. Terry won the Chelsea captaincy after mentor Marcel Desailly retired and led the side to the most successful period in the club's history. Through all the upheaval that followed Roman Abramovich's arrival, Terry was one of the few constants, and quickly came to represent the club, styling himself as "Mr Chelsea". It was a passion never more obvious than when he led the team into the Champions League final against Manchester United in 2008, missed a potentially game-winning kick in the penalty shoot-out and broke down in tears.

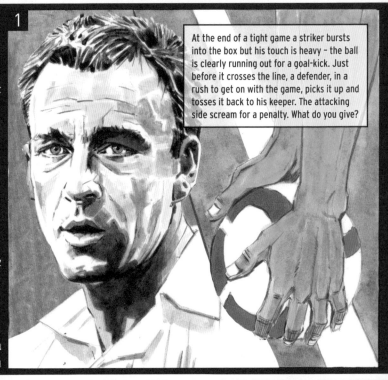

1

At the end of a tight game a striker bursts into the box but his touch is heavy – the ball is clearly running out for a goal-kick. Just before it crosses the line, a defender, in a rush to get on with the game, picks it up and tosses it back to his keeper. The attacking side scream for a penalty. What do you give?

Keith Hackett

1) The defender cannot assume what is about to happen: he has handled the ball while it is still live. It may seem harsh, but the law is clear: you must show him the yellow card for unsporting behaviour and award a penalty.

2) You cannot award a retake. However, if you agree that the dinosaur's action constituted deliberate outside distraction, then you should report the incident to the authorities after the game. I'd hope most referees wouldn't allow this to happen in the first place: you need to be vigilant at penalties to make sure the kick is taken fairly. In this case, ideally, if there is time before the kick is taken, you must intervene and stop play, and make sure the mascot moves away. The player is also within his rights to stop his run-up and ask you to deal with the dinosaur.

3) You cannot reverse your decision, and nor should you. It is the player's responsibility to keep his shirt on, so the second caution stands and he is sent off. He may like to have a word or two with his colleague after the game...

Bacary Sagna

Full name:
Bacary Sagna

Born: 14 February 1983, Lens, France

Major clubs: Auxerre, Arsenal

International: France

Position: Right-back

A France international of Senegalese descent, Sagna is as well-known for his hair as his performances for Arsenal at right-back. "My hair style goes back years, to when I was still playing up front as a boy. It was a bet with my dad, who said I could have my hair how I wanted it if I scored in the next game. I scored two so went out and had braids put in. It's been the same ever since." Sagna's professional career began with Auxerre, where his style, speed and versatility attracted attention from Arsenal's extensive scouting network. After three full seasons he agreed to move to London for a

1

During a top-flight game, an away team player dashes up to you in a fury, complaining that when he went up for a header, his opponent's long bleached dreadlocks caught him in the eye. He says they're dangerous, and the player shouldn't be allowed to play on with his hair "all over the place". What do you do?

Keith Hackett

1) Take no action. There's nothing in the laws of the game to cover this particular point, and if, in your judgment, the dreadlocks don't represent a danger to other players, you should not intervene.

2) Disallow the goal. No other player has touched the ball, so re-start play with an indirect free-kick. That should cheer the keeper up.

3) You cannot disallow the goal. You'll have to put up with all the criticism because you've made a serious mistake in not allowing the player back on. Fortunately this shouldn't happen in the professional game because of the combination of the fourth official and the communication system. The rule about having to leave the field after receiving treatment is one that I would love to see changed. A few seasons ago, Thierry Henry was injured from a challenge which resulted in a penalty. Having received treatment, he was then forced to leave the field of play – so Henry, Arsenal's penalty taker, couldn't take the kick. What a nonsense.

2

It's a penalty to the away side. Just as the kick is about to be taken, the home side's official mascot suddenly jumps up behind the net, dancing. The penalty-taker misses and turns to you in outrage, pointing at the green dinosaur. Do you take any action?

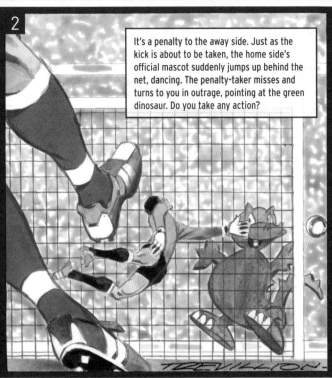

3

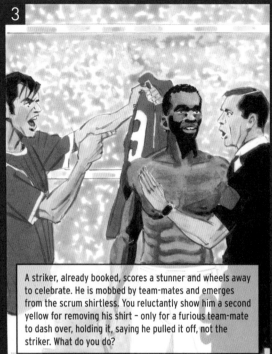

A striker, already booked, scores a stunner and wheels away to celebrate. He is mobbed by team-mates and emerges from the scrum shirtless. You reluctantly show him a second yellow for removing his shirt – only for a furious team-mate to dash over, holding it, saying he pulled it off, not the striker. What do you do?

He was handed the England captaincy by Steve McClaren in 2006, leading the team during its failure to qualify for Euro 2008. But he retained the captaincy under Fabio Capello, and led a revitalised team to 2010 World Cup qualification, after which he spoke of his relief: "Not qualifying for Euro 2008 was the biggest down in my career. It was churning in my stomach for a long time. I wake up in the night thinking about it. When you are captain of your country you carry the weight of everything on your shoulders."

2

In an under-12 game, a striker takes a penalty that beats the keeper, but rebounds off the bar. The striker scores direct from the rebound. The goalkeeper starts crying and says it is "so unfair". What do you do?

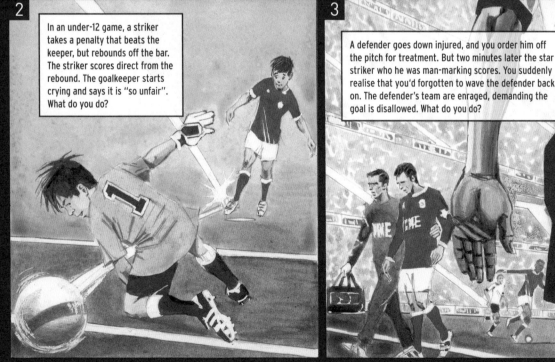

3

A defender goes down injured, and you order him off the pitch for treatment. But two minutes later the star striker who he was man-marking scores. You suddenly realise that you'd forgotten to wave the defender back on. The defender's team are enraged, demanding the goal is disallowed. What do you do?

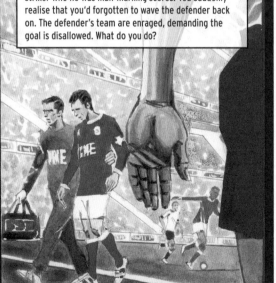

fee rising to over £7m, and made his Premier League debut in a 2-1 win over Fulham in 2007. He scored his first goal for them in a defeat to Chelsea in March 2008, and that season was named in the PFA Team of the Year, Arsène Wenger praising the ease with which he fitted into his side as "tremendous". He won his first full France cap in August 2007, and went on to secure a regular place in their first-choice team.

1

You are refereeing a top Premier League clash – but in the second half you feel you are losing control, making error after error. You have lost all confidence. The fourth official is an experienced Premier League referee – so although you aren't injured, do you a) carry on or b) ask him to take over?

Cesc Fábregas

Full name: Francesc Fábregas i Soler

Born: 4 May 1987, Barcelona, Spain

Major clubs: Arsenal

International: Spain

Position: Midfielder

When Arsenal poached young Cesc from Barcelona's youth ranks in September 2003, it was a long-term move: one for the future. But despite an early struggle to settle in London, his progress was rapid: a first-team debut came the month after his arrival in a League Cup tie against Rotherham aged 16 years and 177 days, and, the following year after an injury to Patrick Vieira, regular first-team football. Though brought up under the tutelage of the tough-tackling Vieira, Fábregas, a sublime passer able to dictate play, proved himself more playmaker than box-to-box midfielder, and quickly became indispensable. He added toughness to his game, too. "I'm not the kind of guy who plays the hard man," he said in 2007, "...I mean, look at me – with this body? But the truth is I've learnt to take care of myself. I'm tougher now, and I need to be." In 2008 he was given the captain's armband at the age of just 21, partly a move by Arsène Wenger to deter interest from top Spanish clubs. Fábregas made his Spain debut in 2006, and started on the bench for the majority of Spain's matches at Euro 2008. But he managed to score his first international goal against Russia, and the winning penalty in the quarter-final shootout against Italy. He started in the final against Germany, which Spain won 1-0, and was subsequently named in Uefa's Team of the Tournament.

2

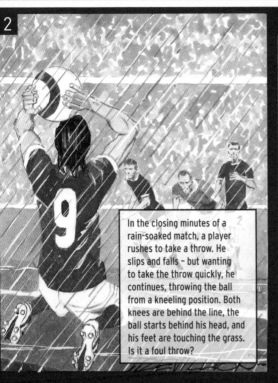

In the closing minutes of a rain-soaked match, a player rushes to take a throw. He slips and falls – but wanting to take the throw quickly, he continues, throwing the ball from a kneeling position. Both knees are behind the line, the ball starts behind his head, and his feet are touching the grass. Is it a foul throw?

3

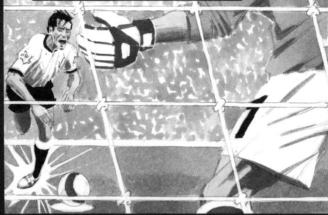

In a fierce derby match, the away team have already had four red cards, and have used all their subs. You award them an 80th minute penalty. But as the kick-taker runs up to take it, he twists his ankle and collapses in pain. He is taken off on a stretcher and can't continue. The home captain rushes over and says you must abandon the game immediately, because the away side are now down to six men. What is your decision?

Keith Hackett

1) a) You must fulfil your appointment and continue to the end. Referees in the Premier League have in excess of 10 years' experience, and they've learned to handle almost every situation, so a crisis of confidence like this is unlikely. We also make use of a sports psychologist who works with officials on concentration and awareness. In the days before football psychologists, some of our referees improvised, and would wear a thick rubber band around their wrist. If they felt their attention slipping, or they were making errors, they'd give the band a violent flick. It always worked.

2) Yes, it's a foul throw. His technique is correct, but kneeling is not allowed – as confirmed by Fifa's Q&A on the Laws booklet, published in 2006.

3) Unfortunately the captain is correct: the match must be abandoned because the player cannot continue and his team has been reduced to six players. The away team, already with four red cards, took the decision to have their injured player treated off the field, so reducing themselves to six players, when he could have remained on the field while a colleague took the kick.

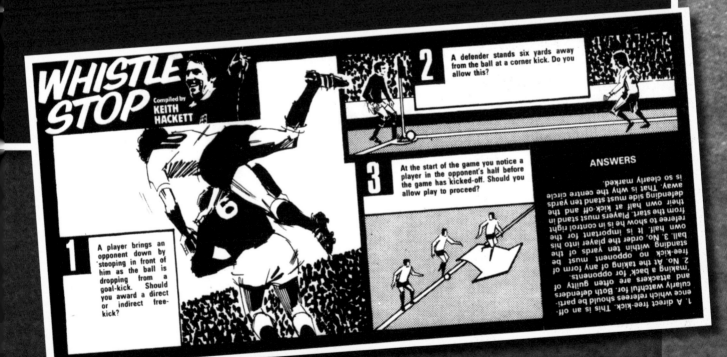

WHISTLE STOP Compiled by **KEITH HACKETT**

1 A player brings an opponent down by stooping in front of him as the ball is dropping from a goal-kick. Should you award a direct or indirect free-kick?

2 A defender stands six yards away from the ball at a corner kick. Do you allow this?

3 At the start of the game you notice a player in the opponent's half before the game has kicked-off. Should you allow play to proceed?

ANSWERS

1. A direct free-kick. This is an offence which referees should be particularly watchful for. Both defenders and attackers are often guilty of 'making a back' for opponents.
2. No. At the taking of any form of free-kick no opponent must be standing within ten yards of the ball. 3. No, order the player into his own half. It is important for the referee to show he is in control right from the start. Players must stand in their own half at kick-off and the defending side must stand ten yards away. That is why the centre circle is so clearly marked.

A "Whistle Stop" strip by Trevillion and Hackett – published in Shoot! magazine in 1982

Jonathan Woodgate

Full name: Jonathan Simon Woodgate

Born:
22 January 1980, Middlesbrough, England

Major clubs:
Leeds, Newcastle, Real Madrid, Middlesbrough, Tottenham

International:
England

Position: Defender

A tall, dominating central defender, known for his injury record and his modern-footballer alice band, Woodgate began his career at Leeds aged 16. His progress there was eye-catching: he made his first-team debut in 1998, and went on to be an integral part of a hugely successful era for the club, peaking with a Champions League semi-final appearance in 2001. But it was also at Leeds that he was embroiled in an infamous trial after an Asian student was assaulted outside a nightclub. Team-mate Lee Bowyer was cleared, while Woodgate was convicted of affray. In January 2003 he signed for Newcastle for £9m, but was hampered by a string of injuries – which made his £13.4m move to Real Madrid in August 2004 even more astonishing. The Spanish press were baffled, particularly as Woodgate

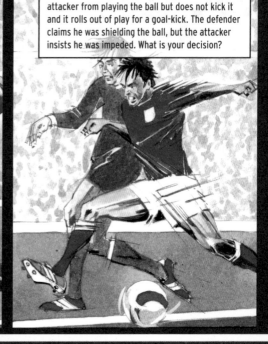

1 In a penalty shootout, the taker in the team losing 5-4 shoots straight at the keeper. The ball hits his knees and spins high into the air. The keeper runs off, thinking he has saved the ball, and is mobbed by his team-mates. But the ball spins into the goal after landing. What is your decision?

2 A defender, using his upper body, prevents an attacker from playing the ball but does not kick it and it rolls out of play for a goal-kick. The defender claims he was shielding the ball, but the attacker insists he was impeded. What is your decision?

Gareth Barry

Full name: Gareth Robert Barry

Born: 23 February 1981, Hastings, England

Major clubs: Aston Villa, Manchester City

International: England

Position: Midfielder

One of the best midfielders in the English game, Barry made his name at Aston Villa having joined them from Brighton as a 16-year-old. He made his Villa debut on 2 May 1998 as a defender but soon established himself as a tough-tackling and creative midfielder, at the heart of the Villa team for 12 years. But his departure from Villa Park did a lot to damage his image. In May 2008 Liverpool made the first of a series of bids for Barry, all of which were rejected by Villa. But Barry, determined to press the move through, spoke out publicly and criticised manager Martin O'Neill for handling the situation badly. "My mind's made up, I want to join Liverpool. There's no going back, it's time for me to move on. I'm desperate to play Champions League football and that's why I have to leave Villa." But the tactic failed: Barry was fined two week's wages, stripped of the captaincy and another bid of £15m was rejected. He sought to make amends and returned to action, making his 400th Villa appearance in a Uefa Cup tie, and even earning back the captaincy. But In June 2009 Manchester City made a £12m bid, offering £100,000-a-week wages, and Barry said yes – earning derision from fans who remembered his "desperation" for

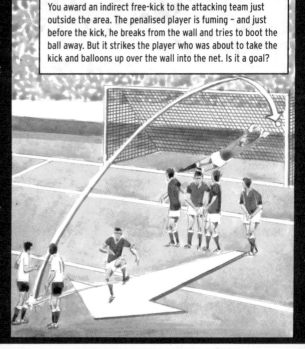

1 You award an indirect free-kick to the attacking team just outside the area. The penalised player is fuming – and just before the kick, he breaks from the wall and tries to boot the ball away. But it strikes the player who was about to take the kick and balloons up over the wall into the net. Is it a goal?

Keith Hackett

1) No goal. The law states the ball isn't in play until "it is kicked and moves" – clearly this means kicked by a member of the non-offending team. In this situation, show the defender the yellow card for delaying the taking of a free-kick, and have the kick retaken.

a) A new penalty. This isn't obstruction: "intentional obstruction" disappeared from the laws in 1995, and was replaced by "impeding". Players are allowed to shield the ball, as long as the ball is in playing distance. You may also show the defender a yellow or red card if you judge the shove to be unsporting behaviour or serious foul play respectively.

3) Delay the kick-off until the obvious new damage is repaired. In my 35 years of active officiating I was always thoroughly impressed by the integrity of the groundstaff, who always take pride in their playing surface.

3

You award a direct free-kick outside the penalty area. A striker waits in the box in an offside position. As the ball is floated in towards him, he darts back into an onside position and a team-mate, who is onside, runs through, collects the ball and scores. Is it a goal?

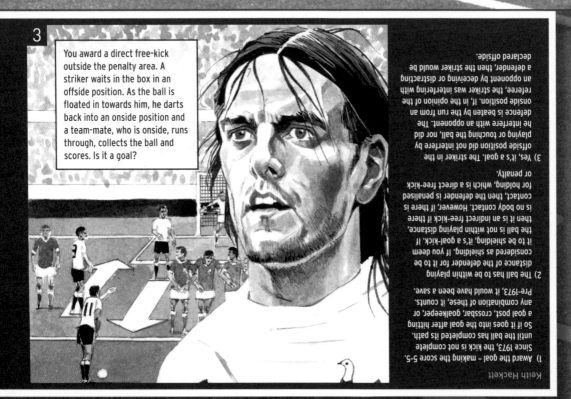

1) Award the goal – making the score 5-5. Since 1973, the kick is not complete until the ball has completed its path. So if it goes into the goal after hitting a goal post, crossbar, goalkeeper, or any combination of these, it counts. Pre-1973, it would have been a save.

2) The ball has to be within playing distance of the defender for it to be considered as shielding. If you deem it to be shielding, it's a goal-kick. If the ball is not within playing distance, then it is an indirect free-kick if there is no body contact. However, if there is contact, then the defender is penalised for holding, which is a direct free-kick or penalty.

3) Yes, it's a goal. The striker in the offside position did not interfere by playing or touching the ball, nor did he interfere with an opponent. The defence is beaten by the run from an onside position. If, in the opinion of the referee, the striker was interfering with an opponent by deceiving or distracting a defender, then the striker would be declared offside.

Keith Hackett

was injured when the transfer went through. He then stayed injured for 14 more months before making his debut in 2005 – during which he scored a spectacular own goal and was sent off. "I can't believe it," he said afterwards. "But I've had worse things in my life. Things can only get better." He did go on to prove his ability at Real, but more injuries limited his chances and ultimately ended his career in Spain. In August 2006 he moved back to his hometown club Middlesbrough on loan, and signed for them permanently in April 2007 for £7m. But he only stayed until January 2008, when he moved to Spurs for the same fee.

2

A penalty hits the post: the ball rebounds straight back to the taker without touching the keeper or any other player. He knows he can't play it again, so he shields it with his body, waiting for a colleague to race in. But a defender gets there first, shoves him out of the way and boots the ball clear. Is it
a) a new penalty? or b) an indirect free-kick to the defending side for obstruction?

3

In the first half the away side are playing slick, one-touch football. At the end of half-time, you're informed that the groundstaff have spent the interval watering and roughing up the surface. The pitch isn't dangerous, and is still playable. Do you intervene?

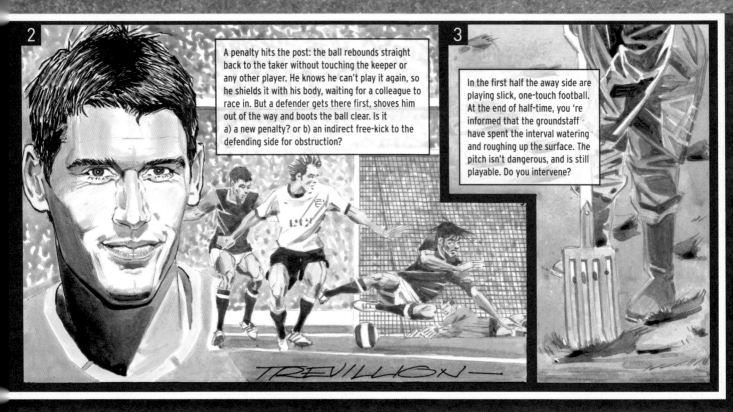

TREVILLION—

Champions League football a year earlier. Barry told them: "I needed a new challenge, I have a massive fear of going stale. A lot of people will question my decision to join City, but I'm excited by this challenge."

Barry made his England debut under Kevin Keegan in 2000 but fell out of favour under Sven-Göran Eriksson. He was recalled to the squad by Steve McClaren in 2007.

Cristiano Ronaldo

Full name:
Cristiano Ronaldo dos Santos Aveiro

Born: 5 February 1985, Madeira, Portugal

Major clubs: Sporting CP, Manchester United, Real Madrid

International: Portugal

Position: Midfielder

Widely rated the best player of his generation, Ronaldo's record £80m move to Real Madrid in 2009 made him the highest paid player in the world: recognition of an extraordinary talent fuelled by unswerving self-belief. The Portuguese youngster's big break came in 2003 when he was spotted at Sporting Lisbon by Manchester United, Sir Alex Ferguson sanctioning a £12.24m deal for the 18-year-old. His early impact was erratic: often over-elaborate trickery and little end product. But the belief was there from the start: "Lots of young players have triumphed at United, so why can't it happen to me? I'm not worried that I'm young." His progress was steady – he attracted headlines and negative attention for petulance and gamesmanship, but also built consistency and tactical awareness, and a highly

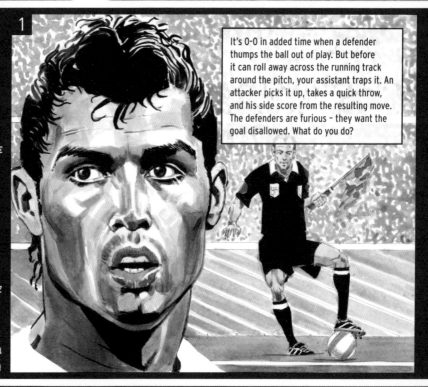

1 It's 0-0 in added time when a defender thumps the ball out of play. But before it can roll away across the running track around the pitch, your assistant traps it. An attacker picks it up, takes a quick throw, and his side score from the resulting move. The defenders are furious – they want the goal disallowed. What do you do?

Keith Hackett

1) The goal stands. Assistants are advised not to act as ball-boys, but if they can stop the ball running away there's no reason not to.

2) Ask another member of the away team to join you for the toss-up. If they all refuse, then you should toss the coin: the home captain can call, and you then inform the away team who is kicking off. Clearly you're in for a difficult afternoon. You should warn both sides – and after the match, report the incident to the competition.

3) The defender is right – take no action. If the defender had deliberately handled the ball before it crossed the line in a failed attempt to stop it going in, you would caution him for unsporting behaviour. But, in this instance, the ball was already over the line and out of play when it was handled, so no offence has been committed.

Nicolas Anelka

Full name:
Nicolas Sebastian Anelka

Born: 14 March 1979, Versailles, France

Major clubs: PSG, Arsenal, Real Madrid, Liverpool, Manchester City, Fenerbahce, Bolton, Chelsea

International: France

Position: Striker

Nicknamed "Le Sulk" for his aloof demeanour and failure to settle at one club, Anelka earned himself a famously bad press over the years – but also stands as one of the game's most consistent top-level strikers. He joined Arsenal in 1997 aged 17, moving to London from Paris St-Germain for a fee of £500,000. He made a huge impact in his second season as Arsenal won the Double, but the following year it all fell apart: a perceived arrogance and indifference to life as a top footballer turned fans against him. After a torrid few months he finally had his way, joining Real Madrid in a record £22.3m move. But he again failed to fit in – at one point suspended for refusing to train – and after 19 games returned to PSG for £20m. That didn't last either, as he set about looking for a way back into the Premier League: first joining Liverpool on loan in January 2002, then making a full-time

1 You've awarded a dropped ball inside the penalty area. One of the players who contests the drop is the defending goalkeeper – who, as soon as it lands, dives on to the ball and smothers it. Is this legal?

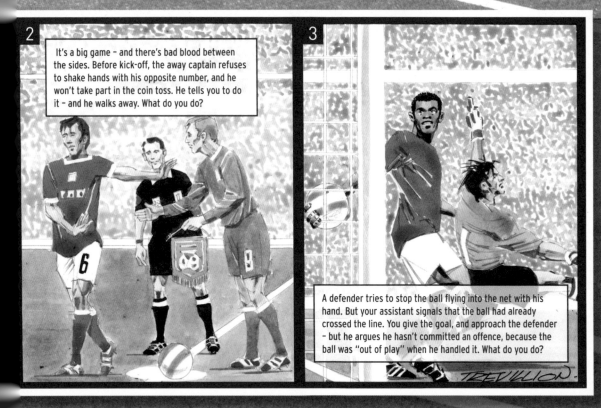

2 It's a big game – and there's bad blood between the sides. Before kick-off, the away captain refuses to shake hands with his opposite number, and he won't take part in the coin toss. He tells you to do it – and he walks away. What do you do?

3 A defender tries to stop the ball flying into the net with his hand. But your assistant signals that the ball had already crossed the line. You give the goal, and approach the defender – but he argues he hasn't committed an offence, because the ball was "out of play" when he handled it. What do you do?

TREVILLION

idual free-kick technique, producing a wicked swerve. In 2008 he the Champions League with United having scored an extraordinary oals in all competitions, and went on to win the Fifa World Player e Year and the Ballon d'Or for the European Footballer of the Year. cored another 26 goals in his final season at Old Trafford. Ferguson

often defended Ronaldo's demeanour: "All the great players have a touch of what you can call 'nice' arrogance. It was the same with George Best." At international level he reached the Euro 2004 final and featured in the 2006 World Cup – famously involved in United team-mate Wayne Rooney's red card in their quarter-final against England.

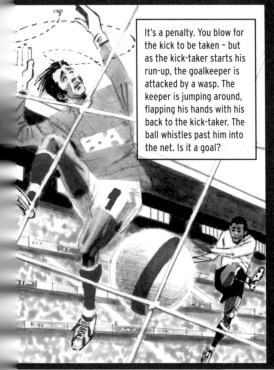

It's a penalty. You blow for the kick to be taken – but as the kick-taker starts his run-up, the goalkeeper is attacked by a wasp. The keeper is jumping around, flapping his hands with his back to the kick-taker. The ball whistles past him into the net. Is it a goal?

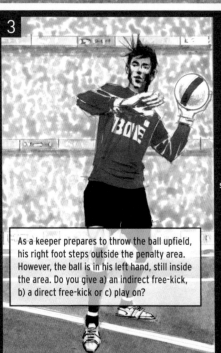

3 As a keeper prepares to throw the ball upfield, his right foot steps outside the penalty area. However, the ball is in his left hand, still inside the area. Do you give a) an indirect free-kick, b) a direct free-kick or c) play on?

TREVILLION

Keith Hackett

1) Yes. The goalkeeper is allowed to do this. However, you must also consider whether it is dangerous play. If you deem that his action in diving at his opponent's feet was either a danger to the opponent, or to himself, then you should award an indirect free-kick against the goalkeeper.

2) No. Award a retaken penalty. The goalkeeper must face the kicker until the ball is kicked. If an "outside agent" is involved in the process, the penalty kick has to be retaken – it's common sense.

3) c) Play on. The fact that the goalkeeper's foot is outside the penalty area is not a consideration – if his hand and the ball did not pass outside the area, you play on. The next time you watch a game look at the position of the assistant referee: it's his job to take up a position opposite the front edge of the penalty area in order to detect any infringement like this. Often the assistant will communicate verbally with the referee, but if an infringement occurs, he will raise the flag and press the buzzer button on it, causing a vibration on the referee's receiver.

move to Manchester City five months later. After three seasons ty he went to Fenerbahçe for one season, before joining Bolton 8m in 2006, and, two years later, Chelsea, for £15m. "I was once ant and hypersensitive," Anelka said in 2006, about his Le Sulk

reputation. "But now I'm mature. I've realised how much I love this sport." For France he made his debut in 1998 and won his first honour at Euro 2000. But he later spent six years out of the squad because of his nomadic club career, before earning a recall in 2008.

Paul Trevillion explains his choice:

"A genius at leading an attack as well as directing the defence. Beckenbauer would run his team's entire operation from sweeper with his elegant playing style and his commanding presence. He never seemed to make an untidy tackle. I remember him talking about how he toyed with attackers: 'I never got too close to a forward when he had his back to me. If he turns you the wrong way with a feint, he's got you off balance with no room to recover. So you either foul him or let him go. I tended to lay off a yard and watch. If he feints to go left I move left – right, I move right. I kept turning him off, like a sheep dog keeps turning the sheep, getting them to turn the way he wants, I am doing the same, forcing the player away from the goal.'"

Franz Beckenbauer, as drawn for Umbro for the USA 94 World Cup

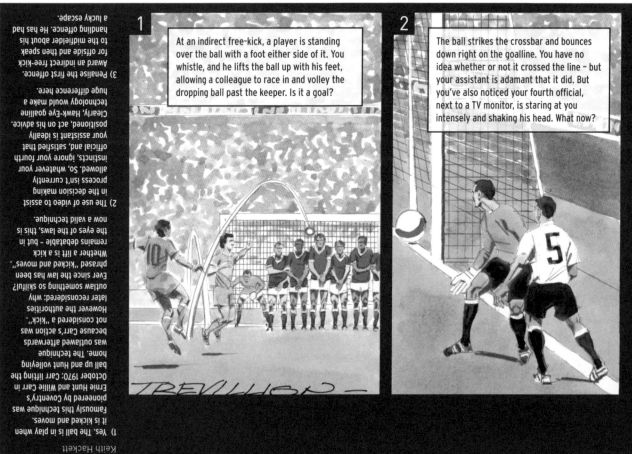

1 At an indirect free-kick, a player is standing over the ball with a foot either side of it. You whistle, and he lifts the ball up with his feet, allowing a colleague to race in and volley the dropping ball past the keeper. Is it a goal?

2 The ball strikes the crossbar and bounces down right on the goalline. You have no idea whether or not it crossed the line – but your assistant is adamant that it did. But you've also noticed your fourth official, next to a TV monitor, is staring at you intensely and shaking his head. What now?

Keith Hackett

1) Yes. The ball is in play when it is kicked and moves. Famously this technique was pioneered by Coventry's Ernie Hunt and Willie Carr in October 1970: Carr lifting the ball up and Hunt volleying home. The technique was outlawed afterwards because Carr's action was not considered a "kick". However the authorities later reconsidered: why outlaw something so skilful? Ever since the law has been phrased "kicked and moves". Whether a lift is a kick remains debatable – but in the eyes of the laws, this is now a valid technique.

2) The use of video to assist in the decision making process isn't currently allowed. So, whatever your instincts, ignore your fourth official and, satisfied that your assistant is ideally positioned, act on his advice. Clearly, Hawk-Eye goalline technology would make a huge difference here.

3) Penalise the first offence. Award an indirect free-kick for offside and then speak to the midfielder about his handling offence. He has had a lucky escape.

FRANZ BECKENBAUER

Full name: Franz Anton Beckenbauer

Born: 11 September 1945, Munich

Clubs: Bayern Munich, New York Cosmos, Hamburg

Country: West Germany

Position: Sweeper/midfielder

Franz Beckenbauer, the Kaiser, has dominated German football, and particularly Bayern Munich, for nearly 40 years. He started as an attacking midfielder, but dropped deeper, becoming a sweeper, and has been credited with defining the role of the libero. He was a roving player, tactically and positionally astute, capable of orchestrating play from deep.

He made his West Germany debut in 1965 and went on to win 103 caps, scoring 14 goals. The team were beaten finalists in the 1966 World Cup, but in 1970 Beckenbauer helped them gain revenge, scoring in a win over England. In the semi-final against Italy, dubbed the Match of the Century, Beckenbauer broke his clavicle but played on with his arm in a sling, though his side lost 4-3 after extra time. Four years later, Beckenbauer finally won the World Cup, leading his side to a 2-1 win over Holland in the final, during which he man-marked Johan Cruyff. Having won the European Championship in 1972 – beating the Soviet Union 3-0 in the final – West Germany became the first side to hold the World Cup and the European Championship concurrently.

He spent 13 years with Bayern Munich, during which time he won four German titles and three consecutive European Cups, before playing for New York Cosmos and Hamburg. After retiring he managed West Germany, Marseille and Bayern, twice. With the national team he won the 1990 World Cup, becoming the only man to win the trophy as both captain and manager and, with the Brazilian Mário Zagallo, only the second man to win it as player and manager. He later became club president of Bayern Munich.

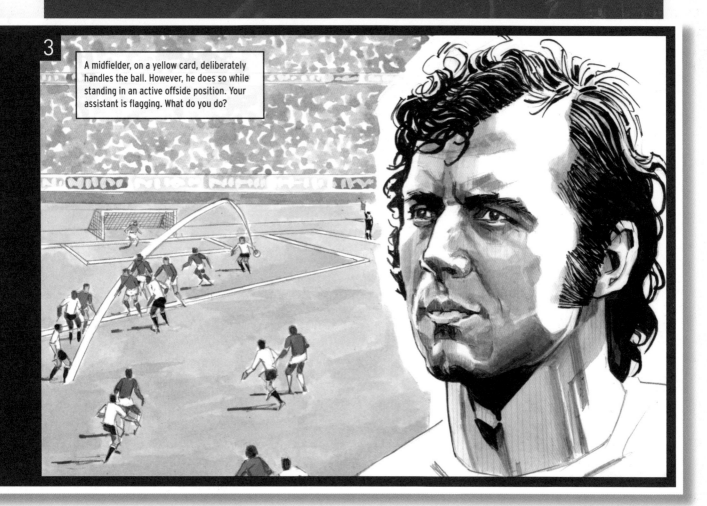

3

A midfielder, on a yellow card, deliberately handles the ball. However, he does so while standing in an active offside position. Your assistant is flagging. What do you do?

TREVILLION

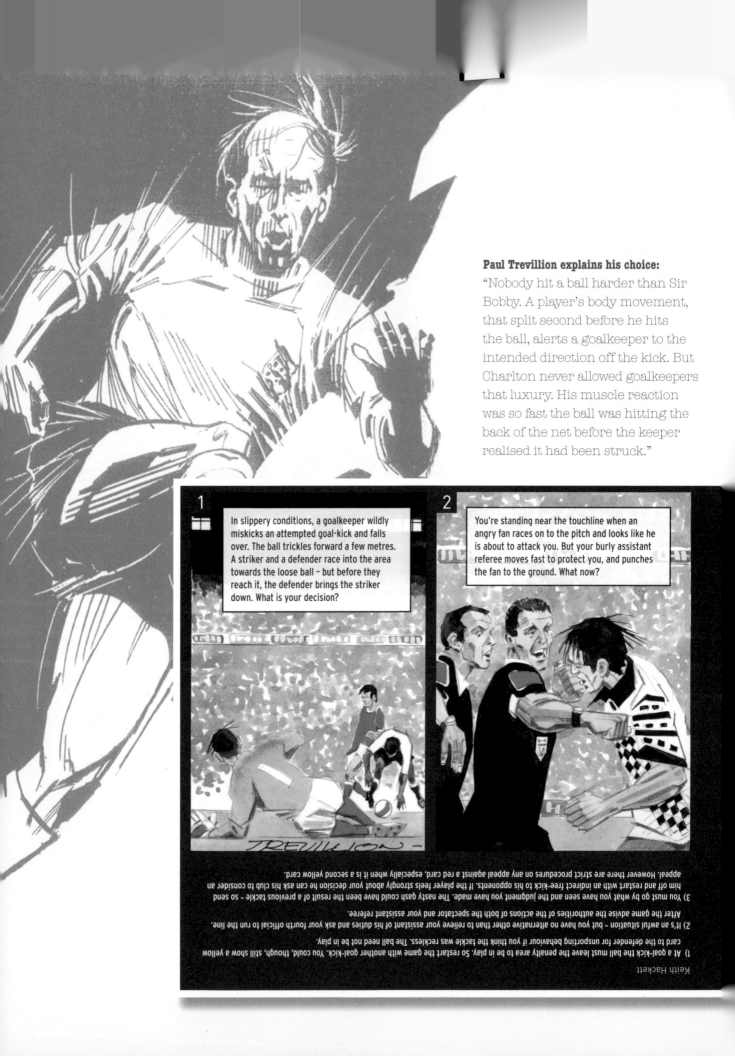

Paul Trevillion explains his choice:

"Nobody hit a ball harder than Sir Bobby. A player's body movement, that split second before he hits the ball, alerts a goalkeeper to the intended direction off the kick. But Charlton never allowed goalkeepers that luxury. His muscle reaction was so fast the ball was hitting the back of the net before the keeper realised it had been struck."

1 In slippery conditions, a goalkeeper wildly miskicks an attempted goal-kick and falls over. The ball trickles forward a few metres. A striker and a defender race into the area towards the loose ball – but before they reach it, the defender brings the striker down. What is your decision?

2 You're standing near the touchline when an angry fan races on to the pitch and looks like he is going to attack you. But your burly assistant referee moves fast to protect you, and punches the fan to the ground. What now?

1) At a goal-kick the ball must leave the penalty area to be in play. So restart the game with another goal-kick. You could, though, still show a yellow card to the defender for unsporting behaviour if you think the tackle was reckless. The ball need not be in play.

2) It's an awful situation – but you have no alternative other than to relieve your assistant of his duties and ask your fourth official to run the line. After the game advise the authorities of the actions of both the spectator and your assistant referee.

3) You must go by what you have seen and the judgment you have made. The nasty gash could have been the result of a previous tackle – so send him off and restart with an indirect free-kick to his opponents. If the player feels strongly about your decision he can ask his club to consider an appeal. However there are strict procedures on any appeal against a red card, especially when it is a second yellow card.

Keith Hackett

BOBBY CHARLTON

Full name: Sir Robert Charlton

Born: 11 October 1937, Northumberland, England

Major Clubs: Manchester United, Preston, Waterford

Country: England

Position: Midfielder

A survivor of the Munich air disaster aged 20, Charlton became a true English football legend: a European Cup-winning Manchester United stalwart for nearly 20 years, and a World Cup winner with England. A hard-working attacking midfielder, with a blistering shot off either foot, he was, said Sir Matt Busby, "as near perfection as man and player as it is possible to be".

In total, Charlton made 106 appearances for the national side, during which he scored 49 goals. His two goals in the 1966 semi-final against Portugal were decisive. Though unable to exert his usual influence on the final – where he went head to head with Franz Beckenbauer – he was subsequently described by manager Sir Alf Ramsey as England's "linchpin".

For United he made 758 appearances (a record overtaken by Ryan Giggs in 2009) and scored a remarkable 249 goals. Part of a wonderful side that included George Best and Denis Law, he helped the club to three English titles, an FA Cup and, most importantly, the 1968 European Cup. Here United met Benfica in the final, with Charlton scoring twice.

After leaving United in 1973, Charlton had brief stints in Ireland, Australia and South Africa, and was player manager of Preston North End in 1973-74, a season which ended in relegation. Subsequently he joined Wigan as a director, before being appointed to United's board.

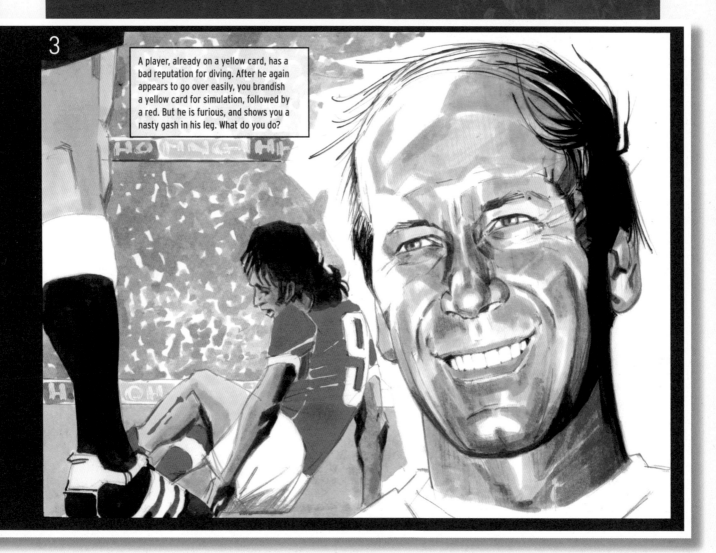

3

A player, already on a yellow card, has a bad reputation for diving. After he again appears to go over easily, you brandish a yellow card for simulation, followed by a red. But he is furious, and shows you a nasty gash in his leg. What do you do?

Roy Hodgson

Full name: Roy Hodgson

Born: 9 August 1947, Croydon, England

Major sides as manager: Halmstads BK, Bristol City, Orebro SK, Malmo FF, Neuchâtel Xamax, Switzerland, Inter, Blackburn, Grasshoppers, FC Copenhagen, Udinese, UAE, Viking FK, Finland, Fulham

When Hodgson was appointed by struggling Fulham in 2007 to replace Lawrie Sanchez, fans were uncertain: despite his enormous experience and track record, Hodgson seemed somehow out of date, a nomadic manager – not the sort of glamour name a progressive, ambitious club should be chasing. But he quickly proved how much experience and knowledge matter at the top level. Hodgson's career to that point had been rich and varied: the highlights guiding the Swiss national team to qualification for the 1994 World Cup and Euro 96, and managing Inter. His coaching career had begun in Sweden in 1976 where he revolutionised the fortunes of Halmstads BK, and quickly earned a deserved reputation as a dynamic, forceful coach. In the mid 80s he led Malmo to five consecutive League titles – an extraordinary achievement. It was his subsequent work at Swiss club Neuchâtel Xamax which put him in the frame for the national job, which in turn raised his profile enough for

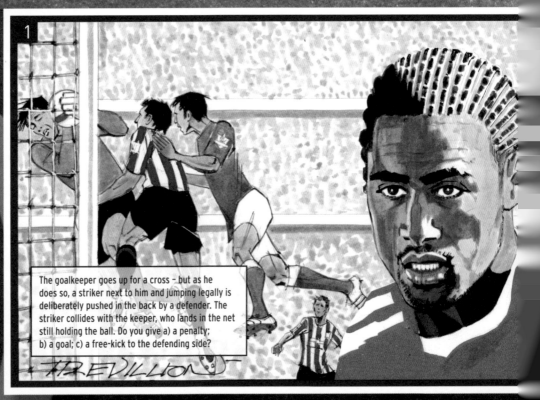

1 In the last seconds of a cup tie, the away team score a dramatic last gasp equaliser from a corner. You give the goal, and play restarts. But then one of your assistants informs you that the away side had 12 players on the pitch when the goal was scored – one of their subs had come on unnoticed seconds earlier. a) What do you do with the spare player? b) Can you rule out the goal retrospectively? c) How do you re-start?

Glen Johnson

Full name: Glen McLeod Cooper Johnson

Born: 23 August 1984, Greenwich, England

Major clubs: West Ham, Chelsea, Portsmouth, Liverpool

International: England

Position: Right-back

After just 15 appearances for West Ham, Johnson became the first player to move to Chelsea following Roman Abramovich's takeover in 2003, signing for £6m. But under Claudio Ranieri and then José Mourinho he failed to secure a first-team place. He was deemed too flighty to fit into Mourinho's no-nonsense structure, stalling his development. He joined Portsmouth on loan for 2006-07, and at Fratton Park he quickly rediscovered his confidence and form as a speedy, attacking wing-back: the move was made permanent the following season. His progress, notably an ability to dominate from right-back, was spotted by Rafa Benítez, who paid £17m to take him to Liverpool in 2009. Johnson had made his England debut in 2003 but, after a poor performance against Denmark in 2005, dropped out of

1 The goalkeeper goes up for a cross – but as he does so, a striker next to him and jumping legally is deliberately pushed in the back by a defender. The striker collides with the keeper, who lands in the net still holding the ball. Do you give a) a penalty; b) a goal; c) a free-kick to the defending side?

2

A goalkeeper takes a goal kick, which loops up very high. An attacker on his team, who was standing in an offside position when the ball was kicked, runs back into his own half unmarked and collects the ball. Do you still give offside?

TREVILLION

3

During a stoppage in a U12's game, a forward complains that an opponent made a racist remark to him. The opponent admits it, and says sorry. What do you do?

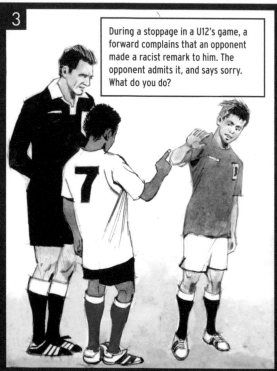

nter to take notice. He took them to the Uefa Cup final in 1997 before returning to England for a spell at Blackburn, which started well but was ended by a poor start to his second season. Before that failure he had been favourite to succeed Glenn Hoddle as England coach. Later jobs included leading the United Arab Emirates and taking Finland close to

Euro 2008, before he arrived at Fulham – saving them from relegation in his first season, and taking them to seventh place finish, and European qualification, in his second. "You have to be a benevolent dictator," he said, asked about his style. "If you have democracy you get nowhere. On the big issues, people expect their leader to lead."

2

In an under-13 game, an attacker traps the ball between his knees and begins bunny-hopping towards goal. A frustrated defender kicks the ball away. The attacking player's furious father demands you red-card the defender for raising his studs. What action, if any, do you take?

3

You are a retired professional player, officiating your first lower-league game. In the first minute the ball is crossed in and your instincts get the better of you – you jump and head the ball into the net. What do you do next?

contention. It wasn't until Fabio Capello's arrival that he won back his place, though he continued to attract criticism for being too attack-minded and failing to hold his position, often leaving the rest of the defence exposed at crucial moments. Capello, though, responded to

the critics by confirming his faith in a player who, at his best, provides teams with a potent creative outlet. "For me Johnson is one of the best right-backs in the world. This is my opinion. I really think that. I'm very happy with Johnson."

Martin O'Neill

Full name: Martin Hugh Michael O'Neill

Born: 1 March 1952, Kilrea, Northern Ireland

**Major clubs as player:
Nottingham Forest, Norwich,
Manchester City, Notts County**

**Major clubs as manager: Wycombe,
Norwich, Leicester, Celtic, Aston Villa**

International: Northern Ireland

Articulate and engaging, and considered one of the game's top managers, O'Neill is most associated with his spell at Celtic between 2000 and 2005, where he won three league titles and reached the Uefa Cup final. A success as both player and manager during his career in football, it all began when he was spotted by Nottingham Forest in 1971. He went on to become an integral part of Brian Clough's midfield in the club's golden era, including their 1979 and 1980 European Cup wins, though he missed the first final. He captained Northern Ireland into the second round of the 1982 World Cup – the highlight of a 62-cap career. He also played for Norwich, Manchester City and Notts County. His life in management began at Grantham, before he joined Wycombe, winning the Conference title in 1992, and promotion to Division Two in 1993. He joined Norwich in 1995, but stayed just months following a row over transfers, and moved on to Leicester. He took City into the top flight, then to a succession of eye-catching top-half finishes and two League Cup wins. He joined Celtic in June 2000, but after that extraordinarily

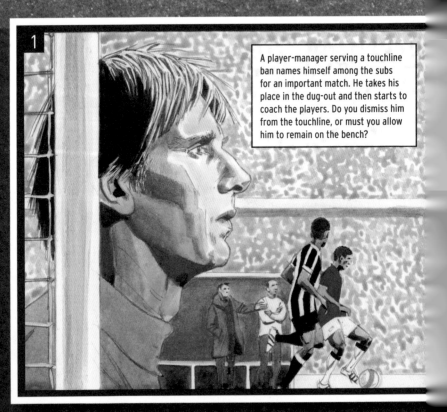

Keith Hackett

In a tempestuous game, a defender goes in hard on the home side's star striker. The defender is already on a yellow card, so you decide to send him off. But as you l[e] in your notebook you realise to your horror that the str[iker] also already has two yellow cards to his name: when yo[u] booked him the second time, you failed to send him off. How do you solve this mess – given that the player the defender fouled should not have been on the pitch?

1) This is any referee's ultimate nightmare. You cannot ignore the defender's offence on the star striker, so show him a second yellow card and send him off. You must then correct your error and send off the star striker too. And then you must then hand yourself in. After the game you must report everything that happened to the appropriate competition – and you can almost certainly expect action to be taken against you.

2) Award the goal. A penalty taker is allowed to hesitate in his run-up, but he is not allowed to stop. The run-up must be one continuous movement.

3) Award a retaken goal-kick. Unfortunately for the striker, the defender is right – the ball is not in play from a goal-kick until it has passed outside the area, so no offence has been committed.

Edwin van der Sar

Full name: Edwin van der Sar

Born: 29 October 1970, Voorhout, Netherlands

Major clubs: Ajax, Juventus, Fulham, Manchester United

International: Holland

Position: Goalkeeper

Van der Sar is Holland's most capped player of all time: a record which says everything about his quality, consistency and ability to dominate at the very highest level. He also has the rare honour of being a Champions League winner with two sides – Manchester United and Ajax – victories which came 14 years apart. He made 226 appearances for the Dutch giants before becoming Juventus's first non-Italian goalkeeper in 1999. He made 66 Serie A appearances before losing his place to Gianluigi Buffon, prompting a £7.1m move to Fulham in 2001. After 127 league games there, where he earned praise for his athletic and resolute performances, he joined United for £2m in 2005. "Edwin is the best goalkeeper I've had since Peter Schmeichel," Sir

A player-manager serving a touchline ban names himself among the subs for an important match. He takes his place in the dug-out and then starts to coach the players. Do you dismiss him from the touchline, or must you allow him to remain on the bench?

Alex Ferguson said. "He is a winner. He has strength of character; he really looks after himself and he trains very well. There are many play[ers] who, having reached his age and achieved what he has done in his car[eer]

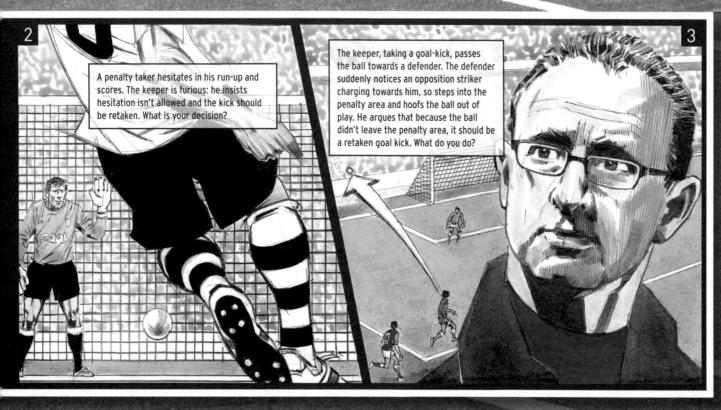

2 A penalty taker hesitates in his run-up and scores. The keeper is furious: he insists hesitation isn't allowed and the kick should be retaken. What is your decision?

3 The keeper, taking a goal-kick, passes the ball towards a defender. The defender suddenly notices an opposition striker charging towards him, so steps into the penalty area and hoofs the ball out of play. He argues that because the ball didn't leave the penalty area, it should be a retaken goal kick. What do you do?

successful five years resigned to care for his ill wife, Geraldine. He returned to football in 2006, joining Aston Villa, and expressed the familiar enthusiasm which has made him such a sought-after leader:

"What a challenge: trying to restore this club to its days of former glory seems a long way away – but why not try? It is nearly 25 years since they won the European Cup – but that is the dream."

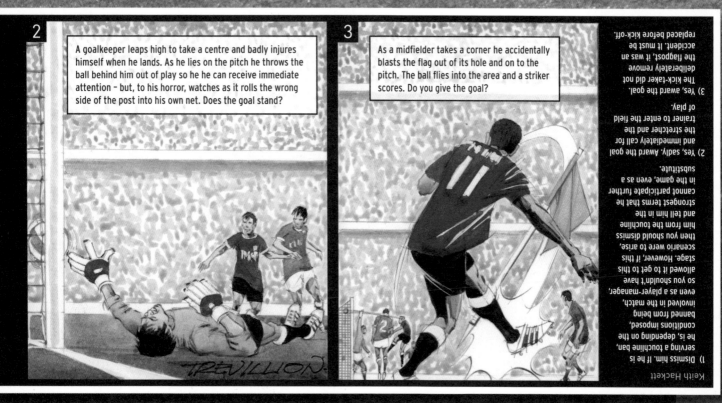

2 A goalkeeper leaps high to take a centre and badly injures himself when he lands. As he lies on the pitch he throws the ball behind him out of play so he he can receive immediate attention – but, to his horror, watches as it rolls the wrong side of the post into his own net. Does the goal stand?

3 As a midfielder takes a corner he accidentally blasts the flag out of its hole and on to the pitch. The ball flies into the area and a striker scores. Do you give the goal?

Keith Hackett

1) Dismiss him, if he is serving a touchline ban, he is, depending on the conditions imposed, banned from being involved in the match, even as a player-manager, so you shouldn't have allowed it to get to this stage. However, if this scenario were to arise, then you should dismiss him from the touchline and tell him in the strongest terms that he cannot participate further in the game, even as a substitute.

2) Yes, sadly. Award the goal and immediately call for the stretcher and the trainer to enter the field of play.

3) Yes, award the goal. The kick-taker did not deliberately remove the flagpost, it was an accident. It must be replaced before kick-off.

want to take it easy. But he has a desire to carry on." In 2009 he went a record 1,311 minutes without conceding a league goal and kept 21 clean sheets in total in 2008-09, winning Uefa's Best

European Goalkeeper award for a second time. For Holland, he made his debut in 1995, and captained them at the 2006 World Cup and Euro 2008.

PAUL GASCOIGNE

Full name: Paul John Gascoigne

Born: 27 May 1967, Dunston, Tyne & Wear

Major clubs: Newcastle, Tottenham, Lazio, Rangers, Middlesbrough, Everton

Country: England

Position: Midfielder

One of the world's most precocious footballers. Barrel-chested, with extraordinary control, Gazza compensated for his lack of pace with captivating artistry and energy. But the livewire personality that fed his talent was ultimately his undoing. For all the flashes of brilliance, the enduring image of Gazza is one of sadly unfulfilled talent.

Gascoigne first appeared as a talented youngster with Newcastle but joined Spurs in 1988. The 1991 FA Cup showed both sides of him: in the semi, a piledriving free-kick against Arsenal, but in the final a reckless tackle ruptured his own cruciate ligament, delaying a pre-agreed move to Lazio. His time in Italy was inconsistent and he moved on to Rangers in 1995, where he won two Scottish titles.

But Gascoigne's greatest moments occurred in an England shirt. His charismatic performances in the 1990 World Cup, where he inspired England to the semi-finals, defined the tournament for his country. His tears in the semi-final – after a yellow card ruled him out of the final – said so much about him. Subsequent performances for England were fitful – though he scored a wonderful goal against Scotland at Euro 96 – and his international career ended after he was left out of the squad for the 1998 World Cup.

He went on to have spells with Middlesbrough and Everton and later with Burnley, in China with Gansu Tianma, and at Boston United, before his playing career finally ground to a halt. After an unsuccessful attempt at management with Kettering Town, Gascoigne's always complicated personal life hit more trouble. But whatever the future holds, for Italia 1990, he will always have a place in the heart of English football.

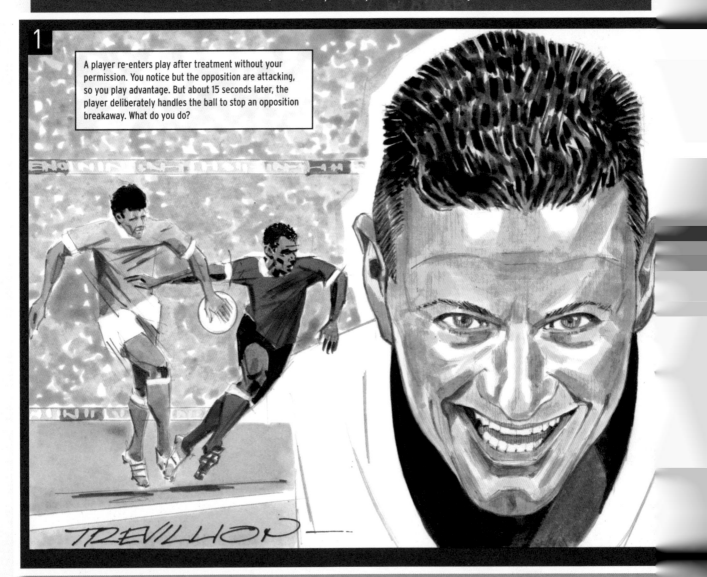

1

A player re-enters play after treatment without your permission. You notice but the opposition are attacking, so you play advantage. But about 15 seconds later, the player deliberately handles the ball to stop an opposition breakaway. What do you do?

Paul Trevillion explains his choice:

"What a winner he could be. When he had the ball, he only wanted to go one way: forward. And you can only go forward if there's room, which your opponents are denying you – so you must be prepared to gamble, to take a chance... to do the impossible. That's where Gascoigne excelled. In a one-on-one Gascoigne never chickened out... and he invariably won."

Paul Gascoigne as drawn for Match magazine in 1990

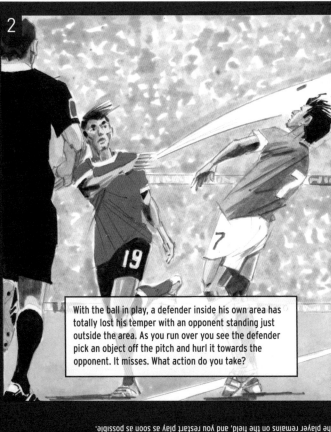

With the ball in play, a defender inside his own area has totally lost his temper with an opponent standing just outside the area. As you run over you see the defender pick an object off the pitch and hurl it towards the opponent. It misses. What action do you take?

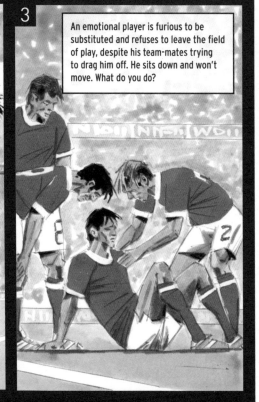

An emotional player is furious to be substituted and refuses to leave the field of play, despite his team-mates trying to drag him off. He sits down and won't move. What do you do?

1) Stop play. Issue the player with a yellow card for entering the field of play without your permission. Then issue him with a second yellow, followed by a red, for committing an act of unsporting behavior. Restart play with a direct free-kick to the opposing team.

2) Stop play and show the defender the red card. Award a direct free-kick from the point where the opponent was. It doesn't matter that the throw was off target; a player must be sent off if he strikes or attempts to strike an opponent.

3) You can't wait for ever. The substitution is a club decision: you can't get involved. So the player remains on the field, and you restart play as soon as possible.

Keith Hackett

Mike Riley

Full name:
Michael Anthony Riley

Born: 17 December 1964, Leeds, England

Referee

For 13 years one of the Premier League's most talked-about referees, Riley's track record includes several of refereeing's biggest honours: running the 2002 FA Cup final between Arsenal and Chelsea, the 2004 Carling Cup final between Bolton and Middlesbrough, and two games at Euro 2004. He started

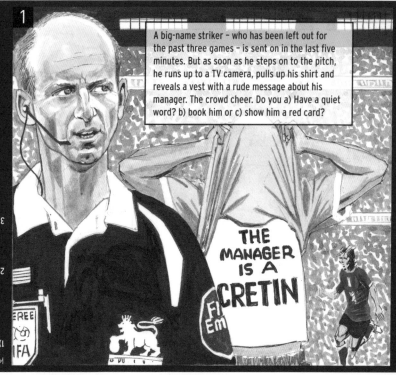

A big-name striker – who has been left out for the past three games – is sent on in the last five minutes. But as soon as he steps on to the pitch, he runs up to a TV camera, pulls up his shirt and reveals a vest with a rude message about his manager. The crowd cheer. Do you a) Have a quiet word? b) book him or c) show him a red card?

Keith Hackett

1) b) Book the striker and restart play in the appropriate manner. Players must always remember that raising the shirt above the head is a cautionable offence. In this case, the authorities would deal with the content of the slogan later.

2) Award a dropped ball. The gloves count as "outside interference", like any other obstacle. You must drop the ball on the six-yard line.

3) Award a goal. The attackers are correct and no offence has been committed. This is an extremely challenging question, though. There is currently nothing in the laws of the game to cover this situation – I have raised it with Fifa. But as things stand, each individual referee would have to make a judgment and I based mine on this: a) If you had seen in time that the goalkeeper was unconscious, you would have blown up before the goal was scored. You would then award a dropped ball where the keeper was hit (or on the six-yard line). You would not award a retaken penalty, because no offence has been committed. b) However, as you didn't see that the keeper was unconscious in time, you cannot intervene: it's a goal.

his journey to the top aged 14 – volunteering to run the line for his school team while he was injured and unable to play. He worked his way up the ranks of youth and non-league refereeing before reaching the top – and said he owes a lot to his biggest inspiration, referee George Courtney, who retired in 1991 having run matches at the 1986 and 1990 World Cups. "I learnt enormously from watching him. A great referee and a

Steven Gerrard

Full name:
Steven George Gerrard

Born: 30 May 1980, Liverpool, England

Major clubs: Liverpool

International: England

Position: Midfielder

Facing a crucial late penalty, the goalkeeper starts to do a daft Bruce Grobbelaar wobbly-leg dance. The taker is furious, and starts a mocking dance of his own. You tell them to get on with it – but the penalty taker says he won't take the kick "until the keeper stops being an idiot". Both carry on dancing. What do you do?

Keith Hackett

1) Don't join in the dancing – you must end this idiocy quickly. I would walk towards the two players, then stop halfway and request that they join me, which would put an immediate stop to the dancing. When I had their attention, I'd warn them in no uncertain manner that they were a disgrace and damaging the image of the game – and that if they did it again, they'd been booked for unsporting behaviour.

2) b) Caution him for unsporting behaviour. Goalkeepers attempting to extend their vision of their goal in this way is a problem. Many years ago I was at one of my local grounds Stockbridge Works whose groundsman Big Jack took great pride in the state of the field of play. The first thing he'd do on a match day was go to the dressing rooms and make it very clear that any goalkeeper marking his pitch in this way would do so at his peril. At one particular game, he was so annoyed to see a goalkeeper ignoring his rule, taking huge divots out of the pitch, that Big Jack intervened in the half-time team talk to give the keeper a firm final warning. When the keeper then did it again in the second half, Big Jack strode onto the pitch and, with a straight right-hand punch, knocked the keeper spark out. He always regretted getting into trouble – but he'd always remind me of the story whenever I visited Stockbridge.

3) Yes, give the goal. You would already have inspected the headgear at half time and approved it as safe and legal.

Perhaps the closest to a complete midfield operator in the modern English game, Gerrard's ability to run a match is world-class. Capable of strong defensive play as well as creativity and prolific goal-scoring, he made his debut at Liverpool, where he had been since the age of nine, in 1998, and replaced Sami Hyypia as club captain in 2003.

His string of domestic and European cup successes, alongside his ability and workrate, has won back those fans left disappointed when he twice declared, then reversed, his intention to leave for Chelsea in 2004 and 2005, the second time weeks after lifting the Champions League in Istanbul. His two goals in the 2006 FA Cup final

2

In the dying seconds of a cup tie a goalkeeper goes up for a corner, and discards his gloves on his goalline. But the corner is cleared and, with the keeper stranded upfield, the ball is booted back towards his empty net. But as it rolls towards the goalline, it hits the gloves and is deflected wide. What do you give?

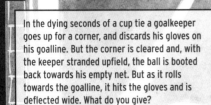

3

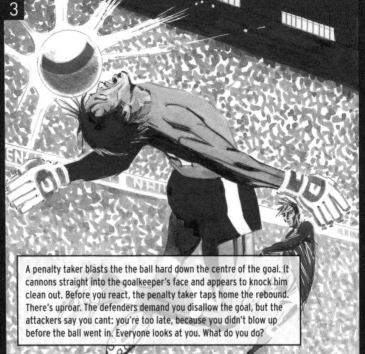

A penalty taker blasts the the ball hard down the centre of the goal. It cannons straight into the goalkeeper's face and appears to knock him clean out. Before you react, the penalty taker taps home the rebound. There's uproar. The defenders demand you disallow the goal, but the attackers say you cant: you're too late, because you didn't blow up before the ball went in. Everyone looks at you. What do you do?

great ambassador for English football." For all his consistency and calm authority, Riley was also involved in plenty of controversial moments, but deserved his reputation as one of the game's elite officials. When

Keith Hackett announced his retirement as head of PGMOL in 2009, Mike Riley was appointed as his successor: a mark of his standing in the game among fellow professionals.

2

At the start of the second half, the home-team goalkeeper comes to you with a complaint. He points out that in the first half his opposite number has scuffed up his six-yard line. There are three clear marks, one in line with each goalpost, and one dead centre. You then notice the away-team keeper doing it again at the other end. The home keeper is furious and says his rival gained an unfair advantage in the first half – denying goal-scoring chances. Do you a) Take no action? b) Caution the away goalkeeper? or c) Send him off?

3

A goalkeeper took a bad knock to the head in the first half and comes out for the second wearing a Petr Cech-style headguard. In injury time, with his team one goal down, he comes up for a late corner – and powers a stunning header into the net. The opposition go wild, claiming his rubberised head gear gave him an advantage. Do you give the goal?

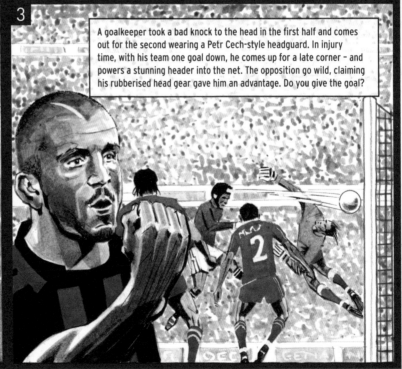

against West Ham meant he had scored in the finals of all the major club trophies, having done so already in the League Cup, the Uefa Cup and the Champions League. He made his England debut in 2000 and played in Euro 2000 and 2004, and the 2006 World Cup. In 2009 Zinedine Zidane paid the ultimate tribute: "Is Gerrard the best in the world? He might

not get the attention of Messi and Ronaldo but yes, I think he might be." Gerrard's association with Liverpool runs deeper than his playing career: his 10-year-old cousin, Jon-Paul Gilhooley, was among the victims of the 1989 Hillsborough disaster, when Gerrard was nine. "Seeing his family's reaction," Gerrard said, "drove me on to become the player I am today."

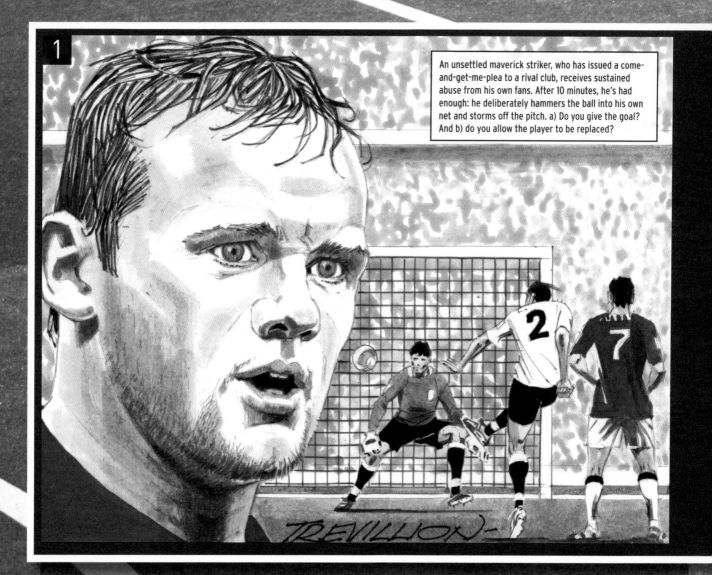

1

An unsettled maverick striker, who has issued a come-and-get-me-plea to a rival club, receives sustained abuse from his own fans. After 10 minutes, he's had enough: he deliberately hammers the ball into his own net and storms off the pitch. a) Do you give the goal? And b) do you allow the player to be replaced?

TREVILLION

Wayne Rooney

Full name: Wayne Mark Rooney

Born: 24 October 1985, Liverpool, England

Major clubs: Everton, Manchester United

International: England

Position: Striker

Long tipped as a prodigy, Rooney started in Everton's youth teams at the age of 10, quickly impressing coaches with his pace and instinct. His progress was rapid, and five days before his 17th birthday he scored his first goal for the first team. As anticipated, he shone at Everton, with fans reassured that, despite mounting interest from bigger clubs, Rooney would stay – having once celebrated a goal by revealing a T-shirt inscribed: "Once a Blue, always a Blue." It wasn't to be. Chasing European football he requested a transfer in 2004 and, after a long, messy period of negotiation and accusations, joined Manchester United for £25.6m – an enormous fee for a teenager. His debut, in which he scored a hat-trick against Fenerbahçe in the Champions League, set the tone for things to come. He would go on to win a string of league titles and cups, including the Champions League itself in 2008. He made his England debut in 2003, aged 17, and featured in Euro 2004 and the 2006 World Cup, then was top scorer in the campaign to reach the 2010 World Cup. Rooney is well known for his combative nature, and was sent off in the 2006 quarter-final for a challenge on Portugal's Ricardo Carvalho, with United team-mate Ronaldo apparently encouraging the red card, then winking at the Portugal bench. In 2009, the 100m world record holder Usain Bolt gave Ronaldo some blunt advice: "He should stop acting like a wuss, stop being so soft and be more like Rooney, be aggressive. No one in football will try it on with Rooney."

2 After a stoppage for injury, a player sportingly returns the ball to the opposition goalkeeper. But as the keeper stoops to pick the ball up, he slips, fumbles and it rolls behind him into the net. The crowd roar – but both captains rush to you and tell you not to award a goal. What do you do?

3 A winger is wearing white strapping around his ankles, over the top of his black socks. A defender complains that it is giving the winger an unfair advantage: his quick foot movements making the ball hard to follow. Do you intervene?

1) a) Yes. Award the goal, as you would any other own goal. The fact that it was deliberate makes no difference. b) Yes, if the team haven't already used their full complement of substitutes then they can bring a new player on to replace the striker. But you must still take action over this incident. After the game you should report the player to the authorities for his behaviour, and for leaving the field without permission.

2) Award the goal. The laws of the game don't allow you to disallow a goal and award a retaken dropped ball. However, I'd be very confident that, in this situation, the players would provide the solution – allowing the opponents to score unchallenged from the restart. Failing that, there is the Arsenal/Sheffield United precedent. In 1999, Arsenal beat United 2-1 in the FA Cup fifth round. The winning goal came after United kicked the ball out so their injured player could be treated. Arsenal's Ray Parlour took the throw, intending to return it to United – but his colleague Kanu misread the situation, intercepted and crossed for Marc Overmars to score. It provoked uproar, but the laws of the game did not allow the referee to intervene. After the game, though, Arsène Wenger offered Steve Bruce a replay, and with the FA's consent, it took place 10 days later.

3) No. There is nothing in the laws to stipulate that strapping around the ankles has to be the same colour as his socks.

Keith Hackett

WHISTLE STOP
Compiled by **KEITH HACKETT**

1 The ball has crossed the touchline when a player deliberately hits an opponent. Should you (a) send the offender off, or (b) award a direct free-kick?

2 A player taking a corner, kicks the ball against the corner flag and proceeds to run at goal with the ball. Do you (a) allow play to continue, (b) award a drop ball, or (c) award an indirect free-kick?

3 A defender, seeing a linesman's flag raised, catches the ball. You are satisfied the linesman was incorrect to flag. Do you (a) award a free-kick against the defender, (b) award a drop ball, or (c) play on?

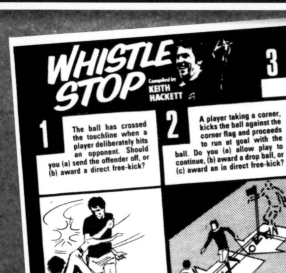

MATCH POINT
I recently had the difficult decision of postponing Oldham's home game with Burnley. Luckily enough, secretary Tom Finn gave me ample warning that the pitch was very heavy. I went to Boundary Park at about 2 o'clock and after checking the weather forecast decided that I could save the Burnley supporters from travelling by calling the game off.

ANSWERS
1. Send the offender off (a). The game should restart with a throw-in. 2. Award an indirect free-kick (c). 3. Award a free-kick against the defender (a).

A "Whistle Stop" strip by Trevillion and Hackett – published in Shoot! magazine in 1983

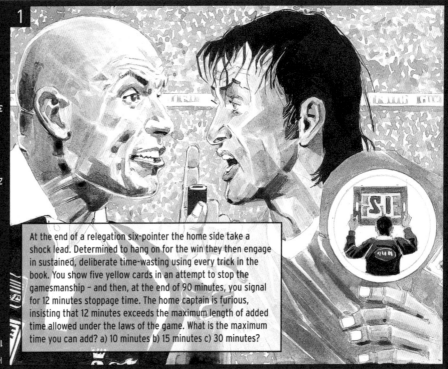

At the end of a relegation six-pointer the home side take a shock lead. Determined to hang on for the win they then engage in sustained, deliberate time-wasting using every trick in the book. You show five yellow cards in an attempt to stop the gamesmanship – and then, at the end of 90 minutes, you signal for 12 minutes stoppage time. The home captain is furious, insisting that 12 minutes exceeds the maximum length of added time allowed under the laws of the game. What is the maximum time you can add? a) 10 minutes b) 15 minutes c) 30 minutes?

Keith Hackett

1) There's no limit to the amount of time you can add on. I'd pull the captain over and make him and everyone else aware that I would be staying until midnight to make sure the right amount of added time was played. If players continued to waste time, I would continue showing yellow cards and dismissing any repeat offenders. I'd also make it very clear to the captain that if this behaviour continued and his team went down to seven men as a result of my red cards, the game would be abandoned and he and his team would be reported to the authorities.

2) Allow play to continue – do not award an offside. Wait until the ball eventually goes out of play – for a goal, a throw, a corner, etc – and then book the goalkeeper for leaving the field of play without permission.

3) Order a retake because the sub hasn't entered the field of play before taking the kick. A substitution isn't complete unless the player has entered the field at the halfway line. The fourth official manages this process to ensure the law has been complied with. An alert referee would have intervened sooner to stop the player taking the corner.

One of the Premier League's most respected and recognisable officials, Webb started refereeing at local level in 1989, and progressed through the leagues relatively quickly, appointed a Football League assistant referee in 1996. Two years later he stepped up as a Premier League assistant, and made the national list in 2000 (see page 120 for details of refereeing career progression). He was named on the Select Group of Premier League referees in 2003, making his "debut" in October for Fulham's 0-0 draw with Wolves, and was appointed a Fifa official in

Petr Cech

Full name:
Petr Cech

Born: 20 May 1982, Plzen, Czech Republic

Major clubs: Blsany, Sparta Prague, Rennes, Chelsea

International: Czech Republic

Position: Goalkeeper

One of the world's finest goalkeepers, Cech joined Chelsea in July 2004, seemingly as back-up for Carlo

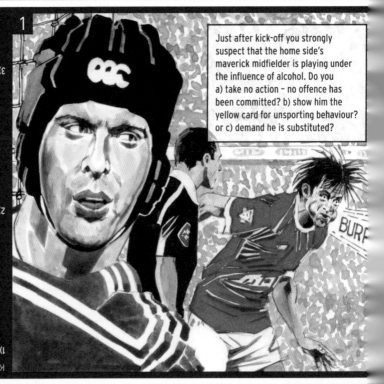

Just after kick-off you strongly suspect that the home side's maverick midfielder is playing under the influence of alcohol. Do you a) take no action – no offence has been committed? b) show him the yellow card for unsporting behaviour? or c) demand he is substituted?

Keith Hackett

1) a) Take no action, but continue to monitor his behaviour closely. There's nothing in the laws on this, so you need to use common sense: if at any time he acts in a way which endangers himself or an opponent, you should consult with the club's officials – it remains their decision to replace him. You are not powerless, though. If, for instance, several players had been on the same bender and were playing dangerously, you could abandon the game and report the matter to the authorities.

2) c) Penalise both. It is an offence to impede the keeper when he attempts to release the ball: he must be allowed the opportunity to run wide of his opponent within the six seconds allowed. Show the striker the yellow card. But, equally, the goalkeeper has committed an act of violent conduct after you blew the whistle for the first offence, so show him the red card. Because you had blown for the first offence, restart play with an indirect free-kick to the defending side.

3) Your assistant is correct: the striker is offside. You should remind the player disputing the decision that there's only no offside if the ball is received direct from a goal-kick, a corner or a throw.

Cudicini despite costing £7m. But an injury to the Italian in pre-season meant an immediate first-team spot, a chance which Cech, an articulate, deep-thinker about the game, grasped. Agile, tall and dominant, he went 1,025 minutes without conceding during his debut season as Chelsea won their first title in 50 years, then kept 25 clean sheets as José Mourinho's side retained the title. He remained at the heart of Chelsea success in the seasons that followed, overcoming a spell out of the game following a horrific injury suffered in a game against Reading in

2

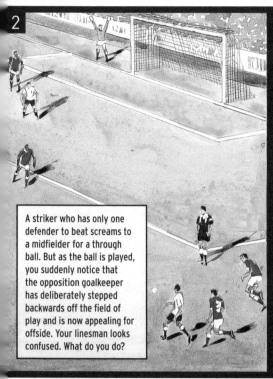

A striker who has only one defender to beat screams to a midfielder for a through ball. But as the ball is played, you suddenly notice that the opposition goalkeeper has deliberately stepped backwards off the field of play and is now appealing for offside. Your linesman looks confused. What do you do?

3

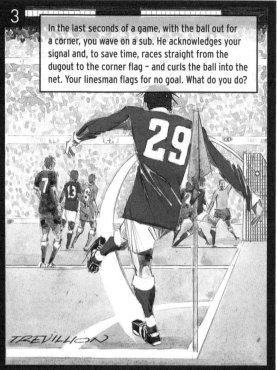

In the last seconds of a game, with the ball out for a corner, you wave on a sub. He acknowledges your signal and, to save time, races straight from the dugout to the corner flag – and curls the ball into the net. Your linesman flags for no goal. What do you do?

TREVILLION

Howard Webb

Full name: Howard Melton Webb

Born: 14 July 1971, Rotherham, England

Referee

2005, running games at the 2006 European Under-21 Championship, at Euro 2008 and the 2009 Confederations Cup. A police sergeant, he agreed a five-year career break in 2008 to focus full-time on refereeing, and said he used his experiences with the police to help him make swift, decisive calls under pressure. "To be a referee at any level, but particularly this level, you need to be confident," he said. "Not egotistical or desiring to be the centre of attention, but be prepared to stand up and be counted – to make unpopular decisions if you have to."

2

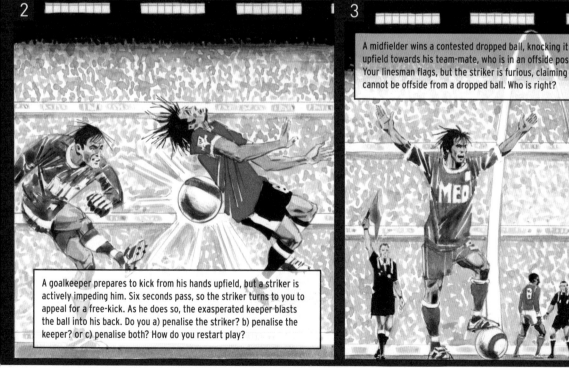

A goalkeeper prepares to kick from his hands upfield, but a striker is actively impeding him. Six seconds pass, so the striker turns to you to appeal for a free-kick. As he does so, the exasperated keeper blasts the ball into his back. Do you a) penalise the striker? b) penalise the keeper? or c) penalise both? How do you restart play?

3

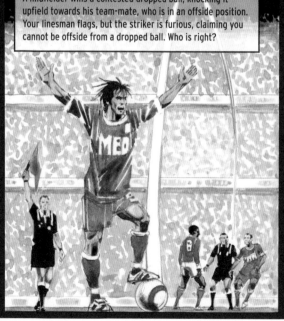

A midfielder wins a contested dropped ball, knocking it upfield towards his team-mate, who is in an offside position. Your linesman flags, but the striker is furious, claiming you cannot be offside from a dropped ball. Who is right?

October 2006. As he challenged Stephen Hunt for a loose ball, his head was hit by Hunt's knee, resulting in a depressed skull fracture, an injury which could have killed him. He didn't return to the first team until 20 January 2007, and did so wearing a tailor-made rubber head guard to give him extra protection. He made his debut for the Czech Republic in February 2002, and was named the best goalkeeper in Euro 2004 after helping his side reach the semi-finals. He also featured in the 2006 World Cup and Euro 2008.

Paul Scholes

Full name: Paul
Aaron Scholes

Born: 16 November
1974, Salford,
England

Major clubs:
Manchester United

International:
England

Position: Midfielder

A proper one-club icon,
and one of the Premier
League's most consistent
midfielders for well over
a decade, Scholes is a
reverse of the modern
footballer caricature:
shy, unflamboyant and
never one to trouble the
paparazzi. An Oldham fan
as a boy, he began training with Manchester United aged 14, and joined as a
full-time trainee after leaving school in 1991. He signed as a professional two
years later, and made his debut in September 1994, scoring twice as a striker
against Port Vale in the League Cup. The following season he scored 14 times

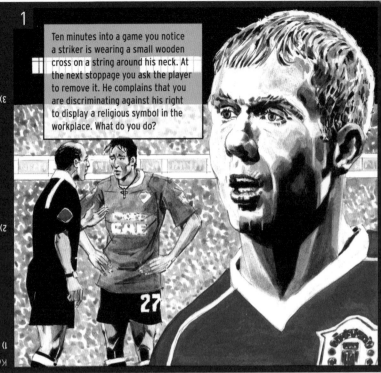

1

Ten minutes into a game you notice
a striker is wearing a small wooden
cross on a string around his neck. At
the next stoppage you ask the player
to remove it. He complains that you
are discriminating against his right
to display a religious symbol in the
workplace. What do you do?

Keith Hackett

1) Explain clearly that a player must not use
any equipment or wear anything that is
dangerous to himself or any other player,
including jewellery, and ask him to leave
the field until it is removed. If the player is
convinced you are discriminating against
him, he can write to the FA. You should also
report the matter so that the club can be
reminded of their responsibility to ensure
their players conform to law.

2) d) Do nothing – apart from make sure the
home club know what has happened to their
ball. Before kick-off the ball is handed to
you and it is your responsibility to return
it at the end of the game. Protocol would
be for the referee to take the ball off the
pitch and allow the home club to make the
decision to award it to the player, but I
wouldn't make a fuss. In the professional
game, I'm sure no one would really
begrudge the striker keeping it.

3) Stop play until the player leaves the field.
A player cannot take part in a game with
blood anywhere on him or his clothing – but
neither can a referee demand a substitution.
You do, though, have the power to insist
the player leaves the field of play. Do not
allow him back on until all the kit has been
replaced and the bleeding has stopped.

as United won another double, but it wasn't until 1997-98 following Roy
Keane's knee injury that he moved into midfield, rapidly settling into the
new role. He developed a fine range of passing as well as a combative
attitude, and retained his goalscoring instinct. His performances at

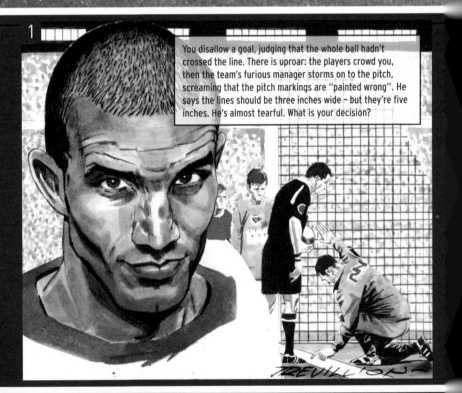

1

You disallow a goal, judging that the whole ball hadn't
crossed the line. There is uproar: the players crowd you,
then the team's furious manager storms on to the pitch,
screaming that the pitch markings are "painted wrong". He
says the lines should be three inches wide – but they're five
inches. He's almost tearful. What is your decision?

Keith Hackett

1) Don't enter into any discussion with the
manager: remove him from the pitch, dismiss
him from the technical area and report him
to the authorities. He has no right to enter
the field of play to question your decision. 30
minutes after the game, I would then allow the
manager to enter my dressing room, where I
would remind him that the laws of the game
do allow lines that are up to five inches wide.
The width of the lines at any ground isn't
determined by the groundsman, the manager,
or the referee – it's determined by the width of
the goalposts. If the goalposts are three inches
wide, so are the lines – if the posts are five
inches wide, the lines are, too. You were right –
the manager was very wrong.

2) c) Delay the kick-off. You cannot play with
unmarked shirts, and borrowing the home
side's kit would mean problems with both
club's shirt sponsors – and you would have to
find a different-coloured goalkeeper's jersey.
Referees need to be aware of this issue. Your
priority is to get the match played, so, taking
police advice and using their help to retrieve
the kit, I would delay kick-off.

3) a) A penalty. The strapping does not mean he
can use the excuse that this was unavoidably
ball to hand: he has simply used his hand to
prevent a goal. Send him off.

Joining Liverpool from Watford in 1992, James gradually won a first-
team spot from Bruce Grobbelaar, and an image from the media as
one of the "Spice Boys" - a group of young, flash players including
Jamie Redknapp, Robbie Fowler and Steve McManaman. When Liverpool
reached the FA Cup final in 1996, James famously convinced the

squad to wear cream Armani suits, cementing that reputation. But his
Liverpool career ended when a bad run of form cost him his place to
American Brad Friedel. He moved on to Aston Villa in 1999, and from
there to West Ham and Manchester City. James made his international
debut in 1997, but didn't become first-choice until 2002. He started all

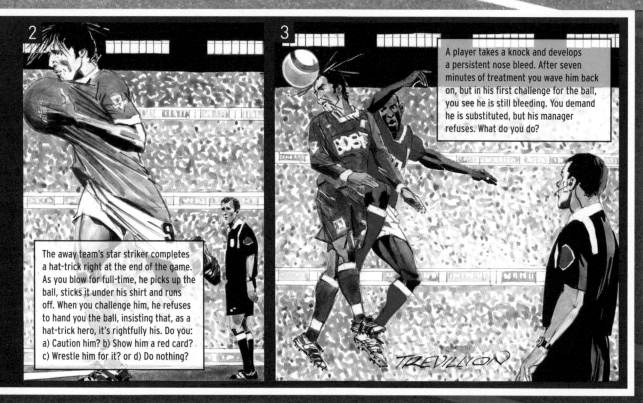

2

The away team's star striker completes a hat-trick right at the end of the game. As you blow for full-time, he picks up the ball, sticks it under his shirt and runs off. When you challenge him, he refuses to hand you the ball, insisting that, as a hat-trick hero, it's rightfully his. Do you: a) Caution him? b) Show him a red card? c) Wrestle him for it? or d) Do nothing?

3

A player takes a knock and develops a persistent nose bleed. After seven minutes of treatment you wave him back on, but in his first challenge for the ball, you see he is still bleeding. You demand he is substituted, but his manager refuses. What do you do?

TREVILLION

the centre of United's Premier League, FA Cup and Champions League winning side in 1998-99 secured his position at the heart of their successful sides in the years that followed, though his tackling has brought frequent attention from referees and he missed the 1999

Champions League final through suspension. He made his England debut in 1997 against South Africa, and featured in the 1998 and 2002 World Cups. Keane summed up what makes Scholes so special: "No celebrity bull, no self-promotion – just an amazingly gifted player."

2

Before a Championship game you are informed that the away side's coach has broken down. The squad arrange taxis to get them and their equipment to the ground and arrive just in time – but in their haste they have left their shirts behind. Do you a) Let them borrow the home side's away kit? b) Let them play in unmarked white T-shirts? or c) Delay the kick-off for an hour while the kit is retrieved?

3

In the last five minutes of a crucial cup tie a defender injures his arm. But with all subs already used, he's determined to play on, so his physio straps his arm to his side with a makeshift sling. Then, moments later, with the keeper beaten, you watch as the defender deliberately deflects a goalbound shot to safety with his strapped-down arm. Is it a) A penalty? b) A dropped ball? or c) A corner?

David James

Full name: David Benjamin James

Born: 1 August 1970, Welwyn Garden City, England

Major clubs: Watford, Liverpool, Aston Villa, West Ham, Man City, Portsmouth

International: England

Position: Goalkeeper

England's games at Euro 2004, but after a high-profile mistake in a World Cup qualifier against Austria, he lost the shirt to Paul Robinson. But after a few years out of favour he found the consistency that had so long eluded him, putting in a series of superb, dominant, eye-catching performances for Portsmouth, which

were rewarded in 2008 with an FA Cup winner's medal, and his place back as first-choice for England. Away from football, James has a broad range of interests, from art and writing to environmentalism and charity work – all a long way from that 90s Spice Boy image.

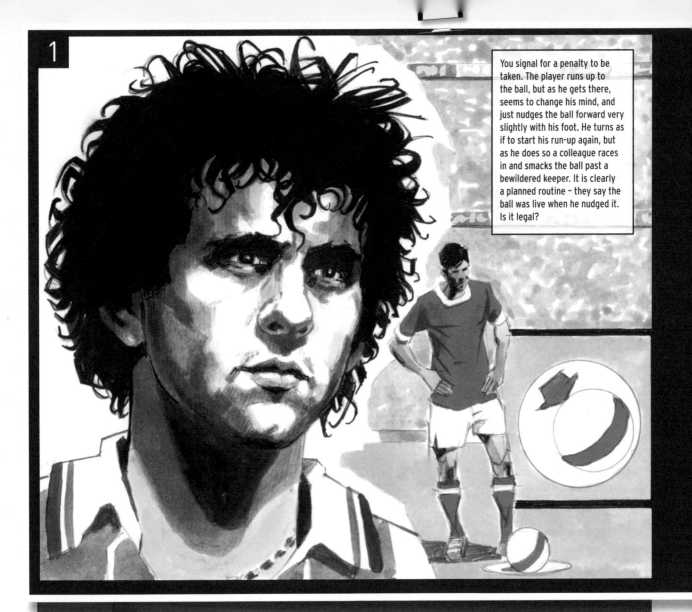

You signal for a penalty to be taken. The player runs up to the ball, but as he gets there, seems to change his mind, and just nudges the ball forward very slightly with his foot. He turns as if to start his run-up again, but as he does so a colleague races in and smacks the ball past a bewildered keeper. It is clearly a planned routine – they say the ball was live when he nudged it. Is it legal?

MICHEL PLATINI

Full name: Michel François Platini

Born: 21 June 1955, Joeuf, France

Major clubs: Nancy, Saint-Etienne, Juventus

Major sides as manager: France

Country: France

Position: Attacking midfielder

An impish, enterprising playmaker and a deadly finisher, Platini was one of the finest passers of his generation and a renowned dead-ball specialist.

After spells with AS Nancy and St-Etienne – with whom he won the French championship in 1981 – he joined Juventus. His start in Italy was slow but, after a change in tactics, Platini's form recovered, and they reached the final of the European Cup. He subsequently won two Italian titles, and his individual brilliance was recognised with three consecutive European Footballer of the Year awards (1983-85). However, the highlight of his career, scoring the winner in the 1985 European Cup final against Liverpool, was marred by the Heysel disaster. He was much criticised for his exuberant goal celebration, and said later: "Something inside me died that night."

With the national side he formed part of the "carré magique" ("magic square") with Alain Giresse, Luis Fernandez and Jean Tigana, in what was perhaps the first great France side. He played in three World Cups (reaching the semi-finals in 1982 and 1986), but it was the 1984 European Championship that cemented his reputation, as his nine goals fired France to their first major trophy. Though nominally a midfielder, he retired as his country's leading goalscorer, with 41 from 72 games. Nevertheless, it is his vision which lingers most in the memory; as Bobby Charlton said: "What a playmaker. He could thread the ball through the eye of a needle as well as finish."

He was France coach between 1988 and 1992, and was appointed president of Uefa in 2007.

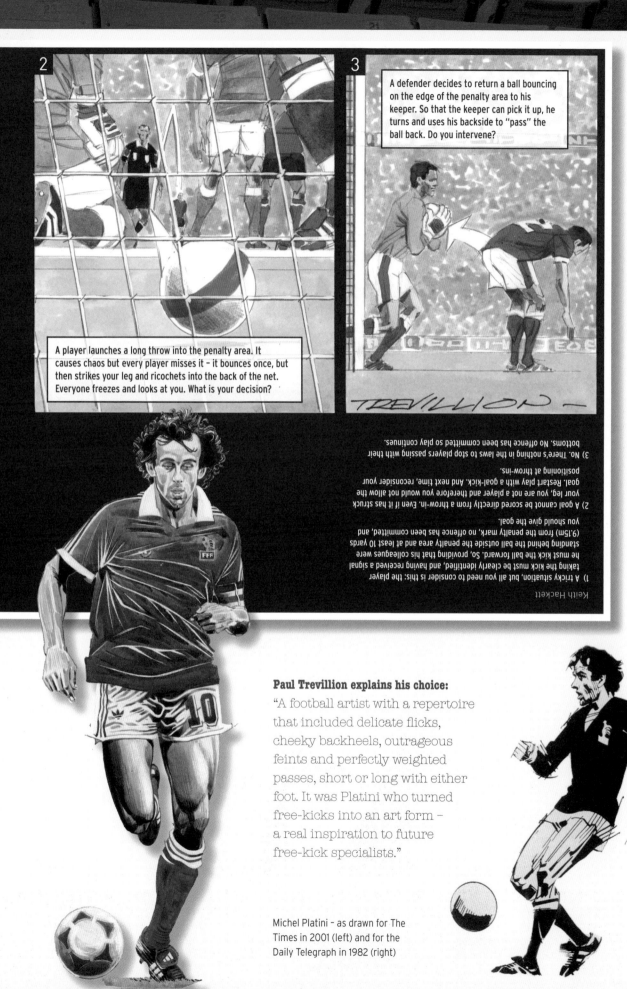

2 A player launches a long throw into the penalty area. It causes chaos but every player misses it – it bounces once, but then strikes your leg and ricochets into the back of the net. Everyone freezes and looks at you. What is your decision?

3 A defender decides to return a ball bouncing on the edge of the penalty area to his keeper. So that the keeper can pick it up, he turns and uses his backside to "pass" the ball back. Do you intervene?

TREVILLION –

Keith Hackett

1) A tricky situation, but all you need to consider is this: the player taking the kick must be clearly identified, and having received a signal he must kick the ball forward. So, providing that his colleagues were standing behind the ball outside the penalty area and at least 10 yards (9.15m) from the penalty mark, no offence has been committed, and you should give the goal.

2) A goal cannot be scored directly from a throw-in. Even if it has struck your leg, you are not a player and therefore you would not allow the goal. Restart play with a goal-kick. And next time, reconsider your positioning at throw-ins.

3) No. There's nothing in the laws to stop players passing with their bottoms. No offence has been committed so play continues.

Paul Trevillion explains his choice:

"A football artist with a repertoire that included delicate flicks, cheeky backheels, outrageous feints and perfectly weighted passes, short or long with either foot. It was Platini who turned free-kicks into an art form – a real inspiration to future free-kick specialists."

Michel Platini – as drawn for The Times in 2001 (left) and for the Daily Telegraph in 1982 (right)

Zlatan Ibrahimovic

Full name: Zlatan Ibrahimovic

Born: 3 October 1981, Malmo, Sweden

Major clubs: Malmo FF, Ajax, Juventus, Inter, Barcelona

International: Sweden

Position: Striker

Ibrahimovic has often been seen as an enigma – inconsistent and moody, a talented player who fails to shine in the biggest games. But such doubts have never troubled him. When asked, aged 20, what could stop him from becoming the greatest player in the world, he replied simply: "injury". But the self-belief is backed up by talent: simultaneously a target man and a playmaker, he is capable of dribbling through entire teams, of defence-splitting passes and remarkable goals. A Swede of Bosnian and Croatian descent, he started with Malmo before moving, aged 19, to Ajax. In 2004 he earned a move to Juventus, and when they were relegated in the calciopoli scandal he moved to Inter, where he added more steel and some consistency to his

1 A player you've already booked commits another bookable offence – but the opposition have a clear goalscoring chance, so you play on: you decide to send him off when the ball next goes dead. But as play continues, the move peters out and the ball is booted up to the other end. You watch in horror as the player you planned to dismiss now scores with a long-range volley. What do you do?

2 You award a free-kick. In an attempt to stop it being taken quickly, an opponent deliberately stands in front of the ball. You warn him and tell him not to do it again – but at the next free-kick, he does. Exasperated, the kick-taker kicks the ball at the player, who screams out in apparent agony. What do you do?

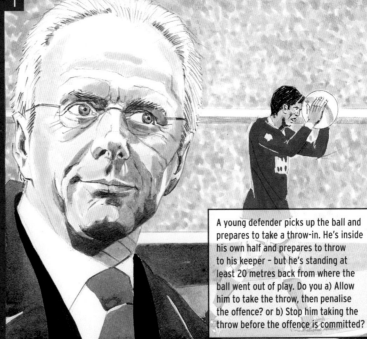

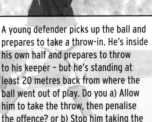

1 A young defender picks up the ball and prepares to take a throw-in. He's inside his own half and prepares to throw to his keeper – but he's standing at least 20 metres back from where the ball went out of play. Do you a) Allow him to take the throw, then penalise the offence? or b) Stop him taking the throw before the offence is committed?

Keith Hackett

1) b) In many games referees need to be educators and I encourage proactive rather than reactive refereeing. Prevention of offences will often improve the game and your standing as a referee. So in this situation, act quickly and try to stop the throw before he has taken it. Advise the player that he must take throws from within a reasonable distance of where the ball went out. Only if the player then takes no notice or repeats the offence later should you award a foul throw.

2) Yes, allow the change – there is nothing to stop a change of taker. Remember, however, that the law does allow the goalkeeper to move from side to side on the line – only penalise him if he moves forward.

3) This is your decision, not his. Your options for dealing with this serious issue are clearly set out. In the first instance, stop play and approach the technical area, requesting that the ground security officer, the police commander and the club's chief executive meet you. Explain the problem and request police action and an announcement over the PA. At the same time, encourage the players to continue playing, to show that the racists will not succeed in disrupting the game. Only if, on returning to the pitch, the abuse continues, should you then move to take police advice over an abandonment. Either way, the matter would be reported to the governing body who would take very firm action. Fortunately, I find it hard to imagine this scenario in Britain.

Known for his attraction to big-salaried jobs and beautiful women, Sven is an unlikely playboy. Cool, calm and considered, he moved into management in 1978 having retired as a defender in Sweden's lower divisions aged 27 through injury. But his intelligent tactical authority would take him to some of the game's top club jobs, to a series of honours, and to league and cup doubles in Sweden, Portugal and Italy.

It was at Lazio, from 1997, that he really shone, winning Serie A, the Coppa Italia and the Italian Supercup, and the Cup Winners' Cup – an extraordinary haul which cemented his reputation as one of the world's top managers. It was in 2000 that he was approached by England to replace Kevin Keegan – a hugely controversial move, making him the nation's first foreign manager. He failed to lead England to major

3 In the penalty area, a defender pulls an opposition striker's long dreadlocks. But they come away in his hand – they are loose hair extensions. The striker plays on, but the move comes to nothing. Do you give a penalty?

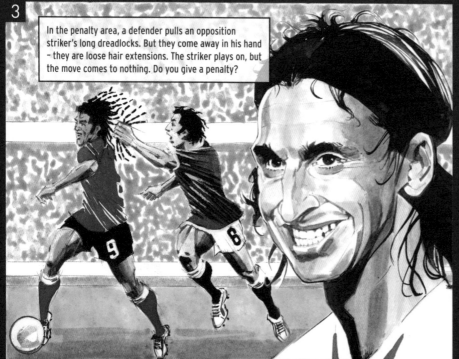

1) You should have stopped play long before the player had a chance to score. But as you didn't, you should now disallow the goal. Show the player the red card and restart with a free-kick close to the original offence. This is a mess and it should never have happened. The situation is clear: any player committing a second cautionable offence should be sent off immediately. The only exception is when you believe the opponents have an obvious goalscoring chance. So in this situation, you were right to play on, but you should have stopped play the moment that chance was no longer "obvious". When the ball was cleared, you should have blown up, dismissed the player and restarted with an indirect free-kick from where the ball was when play was stopped.

2) Show the defending player a yellow card for delaying the restart. I would also acknowledge the frustration felt by the kick-taker, but warn him not to take "direct action" again.

3) Yes. The defender has committed an offence. But because his action has not denied an obvious goalscoring opportunity, show him a yellow card for an act of unsporting behaviour, not a red.

play: in 2008-09 he was Serie A's top scorer with 25 goals. Between 2004 and 2009 Ibrahimovic won six successive championships – two with Ajax and four in Italy, though the 2006 Serie A title was revoked due to the match-fixing scandal. His reputation was such that he was signed by treble-winning Barcelona in 2009 in an astonishing part-exchange deal with Samuel Eto'o: the deal valued Ibrahimovic at £62m. He duly scored on his league debut.

2 You award a penalty, which is saved by the keeper. But the keeper moved forward before the ball was struck, so you award a retake. The original penalty taker has now lost his bottle – so a different striker steps up to take it. Do you allow the change?

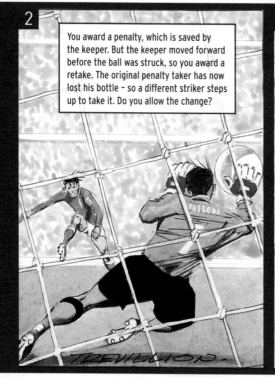

3 After constant racial abuse from home fans towards opposition players, the home captain wants to take his team off the field in protest. But he doesn't want to risk his side being penalised, so demands that you abandon the match instead. What action do you take?

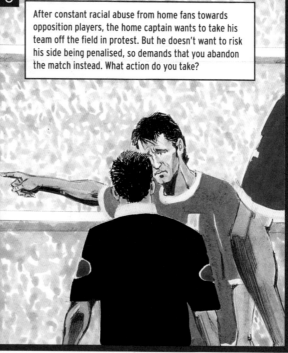

Sven-Göran Eriksson

Full name: Sven-Göran Eriksson

Born: 5 February 1948, Sunne, Sweden

Major sides as manager: Goteborg, Benfica, Roma, Fiorentina, Sampdoria, Lazio, Manchester City, England, Mexico

success, but his time in charge, 67 games from 2001 to 2006, was statistically impressive. He left the job after the 2006 World Cup, at which the side reached his third consecutive quarter-final, and took over at Manchester City a year later on a £2m-a-year contract, funded by the new owner, Thaksin Shinawatra. He lasted just one season, moving next to take over the Mexico national side for another year, before, in July 2009, making his most surprising move of all: joining Notts County on another £2m-a-year contract. He defended the move, saying his decision was motivated by football, not money. "What a wonderful challenge," Sven said. "I started my career at a small Swedish club and we managed to get them into the top flight. Now I will try and do it again."

JOHAN CRUYFF

Full name: Hendrik Johannes Cruyff

Born: 25 April 1947, Amsterdam, Holland

Major clubs as player: Ajax, Barcelona, Los Angeles Aztecs, Washington Diplomats, Feyenoord

Major clubs as manager: Ajax, Barcelona, Catalonia

Country: Holland

Position: Attacking midfielder/forward

Cruyff is arguably the greatest European player of all time. At his peak, he was the complete attacking footballer: a prolific goalscorer – and a scorer of brilliant goals. He would drop deep, or drift out wide, where his pace and technical brilliance could be devastating. His "Cruyff Turn" is iconic – using the inside of one foot to drag the ball behind his standing leg and swivel 180 degrees. He was, as one commentator noted, "the first player who understood that he was an artist".

A product of the Ajax youth system, Cruyff spent nine years in the first team, where he helped pioneer "Total Football", initially under their famous coach, Rinus Michels. He proved himself a natural and charismatic leader who believed that: "It is better to lose with your own vision than with someone else's". He won eight league titles and three European Cups with Ajax, before rejoining Michels at Barcelona, where he won one Spanish title.

With Holland he scored 33 goals in 48 appearances and led the side to the 1974 World Cup final, and was named player of the tournament.

After ending his playing career, following stints in America and a return to Holland, he coached a young and adventurous Ajax to glory in the 1987 European Cup Winners' Cup. There followed eight years as manager of Barça, where he assembled a group of players dubbed "The Dream Team", and guided them to a string of trophies, including the 1992 European Cup and four league titles. His legacy can still be seen at Ajax and Barcelona, with both clubs sticking to his 4-3-3 system and devoted to attacking, fluid football.

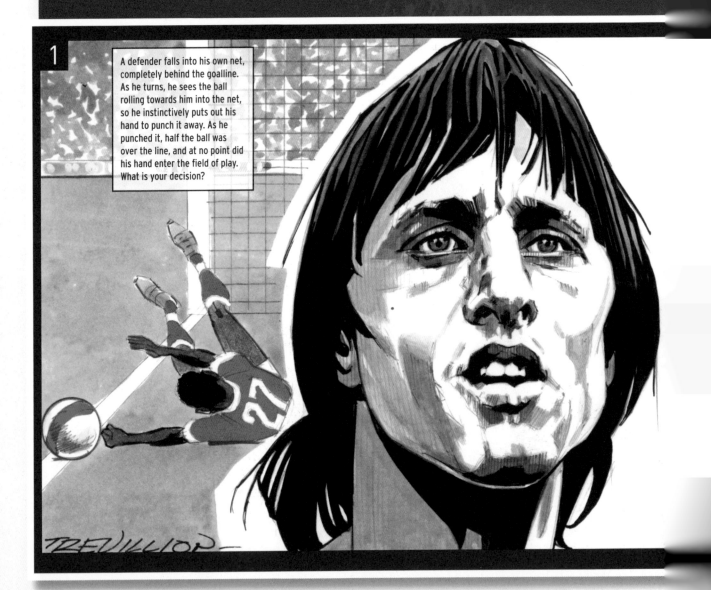

1

A defender falls into his own net, completely behind the goalline. As he turns, he sees the ball rolling towards him into the net, so he instinctively puts out his hand to punch it away. As he punched it, half the ball was over the line, and at no point did his hand enter the field of play. What is your decision?

Paul Trevillion explains his choice:

"Cruyff had skills that could make your eyes pop. He was accuracy itself. If your name was on the ball when he passed it, you got it. From 20 yards, Cruyff could knock the top off an egg and not spill the yolk. With his lightning pace, Cruyff Turn and ability in the air, he was a goal menace from the first kick to the last. A player capable of winning a game on his own."

Johan Cruyff in action for Holland – USA 94 World Cup poster art for Umbro

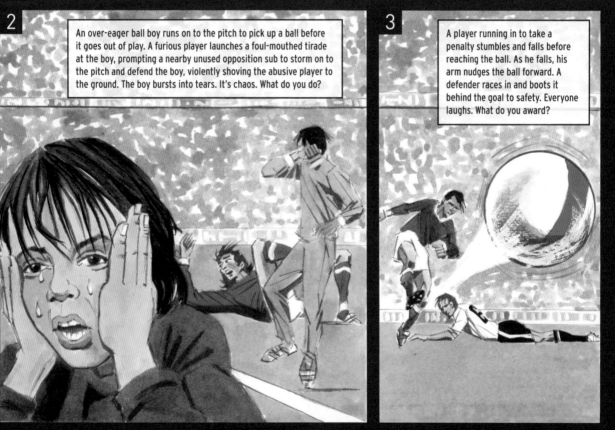

2 An over-eager ball boy runs on to the pitch to pick up a ball before it goes out of play. A furious player launches a foul-mouthed tirade at the boy, prompting a nearby unused opposition sub to storm on to the pitch and defend the boy, violently shoving the abusive player to the ground. The boy bursts into tears. It's chaos. What do you do?

3 A player running in to take a penalty stumbles and falls before reaching the ball. As he falls, his arm nudges the ball forward. A defender races in and boots it behind the goal to safety. Everyone laughs. What do you award?

3) Award a retake. The Law states that the ball must be kicked forward in order to be in play.

2) Think calmly and deal with every aspect of what has happened. The actions of the abusive player are totally unacceptable: show him a red card for offensive language. Show the substitute a red card for violent conduct. Make sure the boy is OK, then restart play with a dropped ball at the point where it was picked up. After the game, send in reports to the appropriate authorities.

1) Award a penalty and dismiss the player for denying a goal. His hand was not in the field of play, but the ball was.

Keith Hackett

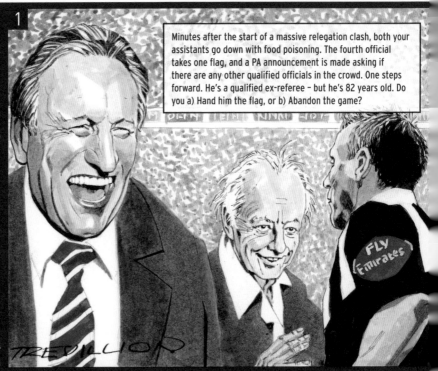

Minutes after the start of a massive relegation clash, both your assistants go down with food poisoning. The fourth official takes one flag, and a PA announcement is made asking if there are any other qualified officials in the crowd. One steps forward. He's a qualified ex-referee – but he's 82 years old. Do you a) Hand him the flag, or b) Abandon the game?

Keith Hackett

1) a) Hand him the flag, wish him all the best, and tell him and the two teams that you will be overseeing all offside decisions in his half. Premier League players can run up to 9.9 metres per second, so don't expect too much. This sort of thing does happen. Older readers will remember Jimmy Hill running the line at Arsenal in 1972 after a PA announcement asking for a replacement linesman. I also have direct experience, having had to ask the crowd for a replacement official before an FA Cup tie at QPR. Two volunteers were brought to my dressing room: one informed me he had just retired from the Southern League officials' list, and was experienced. The other was in his mid-20s and told me he'd qualified as a referee a few days earlier. I decided to go with the older guy, which was just as well – when I broke the news the younger one rolled up his sleeve to reveal the tattoo: 'QPR FOREVER'.

2) You can't take action based on this allegation – but tell your assistants to monitor the situation. If you or your colleagues witness this happening, then you can intervene and stop it. But your first priority must always be to act quickly to get treatment to a player with an apparent head injury, so you rely on the honesty and integrity of players.

3) b) Award a free-kick against him for handball. But this is poor refereeing. The moment the player stopped running you should have blown and penalised the original incident. As it is, you've waited too long.

One of the English game's most recognisable managers – not for the number of honours he has won or the style of his teams, but for his personality. As a player, Warnock didn't reach great heights: a reliable, solid but unspectacular operator for a string of clubs. But as a manager he achieved rapid notoriety. From his first job as boss of Gainsborough Trinity in 1981 through to his high-profile positions at Sheffield United and Crystal Palace, he attracted headlines for his outbursts, particularly his outspoken post-match views on refereeing decisions which go

Franck Ribéry

Full name: Franck Bilal Ribéry

Born: 7 April 1983, Boulogne-sur-Mer, France

Major clubs: Galatasaray, Marseille, Bayern Munich

International: France

Position: Winger

As a French creative midfielder of Algerian descent, Franck Ribéry was always going to be set up by the press as the natural heir to Zinedine Zidane. Ribéry himself has never been shy of the comparison: "Yes, it is true I am his successor, due to my game, my positioning and my qualities." The distinctive-looking winger, who was severely scarred aged two in a traffic accident, initially frustrated those who tipped him as a world-beater, failing to settle and playing for six teams in seven seasons. But after a £23m move to Bayern Munich in 2007 he did find consistent form and secured his status as a player capable of dominating world-class defences, inspiring Bayern to the 2008

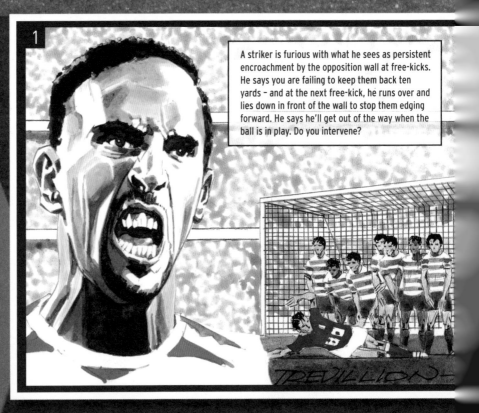

A striker is furious with what he sees as persistent encroachment by the opposition wall at free-kicks. He says you are failing to keep them back ten yards – and at the next free-kick, he runs over and lies down in front of the wall to stop them edging forward. He says he'll get out of the way when the ball is in play. Do you intervene?

Bundesliga title and attracting interest from Real Madrid and England's richest Premier League clubs. Reported approaches from Chelsea and Manchester United prompted general manager Uli Hoeness to set

2

A sub warms up on the touchline. Moments later one of his colleagues goes down holding his head, so you wave the physio on. Later in the game, the same thing happens twice more. The opposition captain is furious – he says it's a ruse: the sub is telling the player to feign injury so the physio can come on and pass tactical information. "They're taking you for a mug," says the captain. What do you do?

3

A player is fouled on the edge of the box, but you play advantage. However, the player who runs on to the loose ball is the side's dead-ball specialist, and he doesn't want the advantage. So he bends over, picks the ball up and says: "Thanks but no thanks – I'll take the free-kick." Do you a) Award the free-kick, b) Award handball against him, or c) Give a drop-ball?

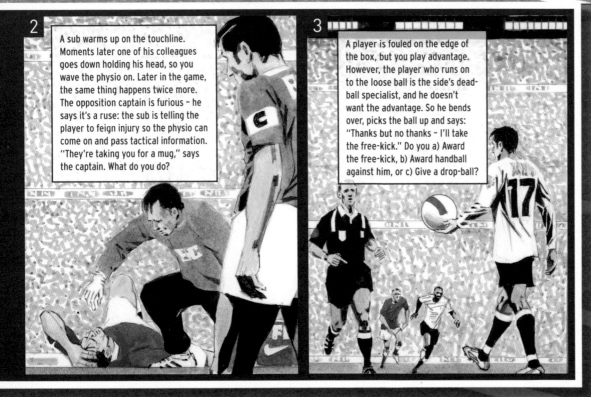

Neil Warnock

Full name: Neil Warnock

Born: 1 December 1948, Sheffield, England

Major clubs as player: Chesterfield, Rotherham, Hartlepool, Scunthorpe, Aldershot, Barnsley, Crewe

Major clubs as manager: Notts County, Huddersfield, Plymouth, Oldham, Bury, Sheffield Utd, Crystal Palace

against his teams. Warnock's mix of wit and fury has made him one of the game's most well-known bosses – loved by some, loathed by others. What is less well known, though, is that he is also a qualified referee – and a man considered by Keith Hackett to be one of the most reliable providers of constructive feedback on officials – even if Graham Poll called him "the worst of all managers". "People are surprised that I have so much time for Neil," Hackett says. "Yes, his rants are famous – but we've spent hours together discussing refereeing. I've always had a high regard for him."

2

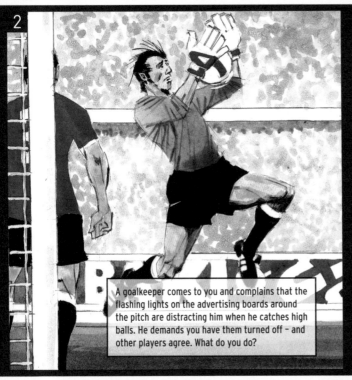

A goalkeeper comes to you and complains that the flashing lights on the advertising boards around the pitch are distracting him when he catches high balls. He demands you have them turned off – and other players agree. What do you do?

3

A shoot-out is under way and all the players have taken one kick. The home captain then approaches you to say that one of his team has lost his bottle and doesn't want to take another. He asks if he can change the order of kick-takers?

1) Book him. As the title of this book suggests, you are the ref, not him. Caution the player for an act of unsporting behaviour and make sure that the wall remains 9.15m from the kick-taker. The instructions to referees for managing free-kicks are clear: a) Ensure that the ball is correctly placed and that the taker knows not to proceed until you give a signal (underpin this message by showing the kick-taker your whistle), b) Pace out 9.15m, and ensure no player encroaches, c) Take up a position and signal for the kick to be taken.

2) Tell them to play on, but report the matter to the authorities at the end of the game. This should be rare: electronic perimeter advertising boards are designed and positioned so that they do not distract the players.

3) Yes, he can change the order of the kick-takers, where all the players in a shoot-out have taken one kick and the score is still equal, the captains are allowed to select in which order his players take their second kicks. So in this case, the player concerned could be put at the bottom of the list.

Keith Hackett

Ribéry's price tag at over £100m: "We have said throughout we will only negotiate under certain conditions. Namely, when another club offers us something crazy." Ribéry made his debut for France in 2006, soon becoming an integral part of one of the world's most potent international sides, and started in the 2006 World Cup final.

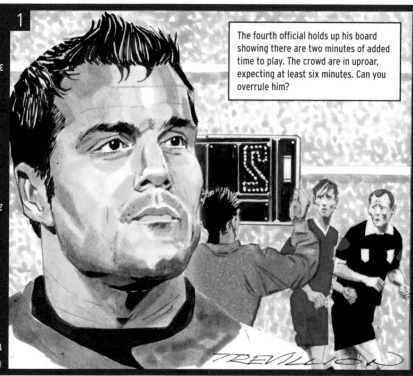

1

The fourth official holds up his board showing there are two minutes of added time to play. The crowd are in uproar, expecting at least six minutes. Can you overrule him?

Keith Hackett

1. Yes. You, as referee, are the sole timekeeper. It's your responsibility to make sure that a mistake like this does not happen. In the top flight, you talk directly to your fourth official via the communication system. And outside the top flight, you show the fourth official how many minutes to display on the board with the following hand signal: hold your arm out horizontally and bring it down to your shorts once for each minute to be added. So in this situation, six downward 'flaps' of the arm would indicate six minutes. But whatever the method of communication and whatever number appears on the board, it is up to you to decide how much time you play.

2 c) Award a dropped ball. When you stop play for an offence committed outside the field of play (when the ball is in play) you must award a dropped ball from where it was when play was stopped. That's how things stand at present, but there is a logical argument against it which might see the Law changed in the next couple of years. Namely, by giving a dropped ball restart you are giving the defence an advantage in being able to contest the ball immediately after being guilty of an offence. If they have committed an offence, then they should not be allowed a 50-50 chance of gaining possession of the ball when play is restarted. It's an issue sure to be debated in the near future.

3) Ask the player to remove the cap or leave the pitch: it does not conform to the laws of the game. Goalkeepers have been allowed to wear caps of various designs for many years: remember Bert Trautmann?

Rated among the world's greatest contemporary goalkeepers – with Petr Cech and Gianluigi Buffon among the rivals – César is a famously superb athlete. Signing for Inter in 2005 as back-up to Francesco Toldo, having won four Rio de Janeiro state league titles in his time at Flamengo, his progress was rapid, developing from understudy to obvious No1 as his confidence grew. Instrumental in Inter's league successes, the 6ft 1in César proved he could make up for his relative lack of height (for an elite goalkeeper) with extraordinary agility,

Robbie Savage

Full name:
Robert William Savage

Born:
18 October 1974,
Wrexham, Wales

Major clubs: Crewe,
Leicester, Birmingham,
Blackburn, Derby

International: Wales

Position: Midfielder

Not world football's greatest player – but certainly one who has provided England's referees with plenty of testing moments during his career. Savage began as a trainee striker at Manchester United, but was released to Crewe in 1994. His battling performances earned him a move to Premier League Leicester for £400,000 in 1997, and in five years there he secured his reputation – the good parts, and the bad. In the 1999 League Cup final Savage famously threw himself to the ground when Tottenham's Justin

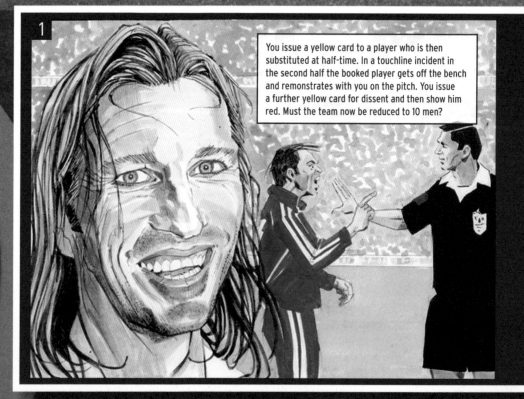

1

You issue a yellow card to a player who is then substituted at half-time. In a touchline incident in the second half the booked player gets off the bench and remonstrates with you on the pitch. You issue a further yellow card for dissent and then show him red. Must the team now be reduced to 10 men?

Edinburgh swung his arm at him, barely making contact. Edinburgh was sent off. Though famous for antagonising opponents and fans, Savage is rarely sent off. His only Premier League red card came as a Blackburn

A winger bursts into the penalty area, dribbling along the goalline. He nutmegs a defender and then tries to run past him, but in doing so, runs off the field of play. The defender's challenge is rash and he fouls the winger – but the foul takes place while the winger is off the field, even though the ball is still in play. Do you a) award a penalty, b) award an indirect free-kick, c) a dropped ball, or d) allow play to go on?

3

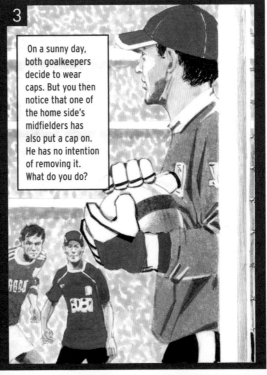

On a sunny day, both goalkeepers decide to wear caps. But you then notice that one of the home side's midfielders has also put a cap on. He has no intention of removing it. What do you do?

Júlio César

Full name:
Júlio César Soares de Espíndola

Born:
3 September 1979, Duque de Caxias, Brazil

Major clubs:
Flamengo, Chievo, Internazionale

International:
Brazil

Position:
Goalkeeper

bravery and speed, and with his command of the penalty area: an ability to pluck or punch any loose cross and smother the fastest of shots. His international career began in 2003 as back-up for Dida, and the following year he made his first starts as Brazil won the Copa América on penalties against Argentina – César saving Argentina's first kick. Despite his starring role he remained understudy until 2007 when he replaced Doni as first-choice. In 2009 Brazil's coach Dunga said: "He is the best in the world. Buffon is also great, but César is fantastic."

2

The ball has stopped on the 18-yard line with half of it outside the penalty area. The keeper reaches out over the 18-yard line, knocks the ball back into the penalty box and picks it up. The opposition are enraged and claim handball. What is your decision?

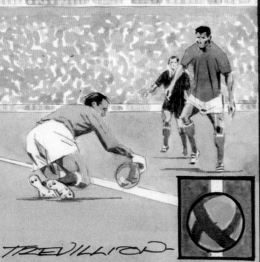

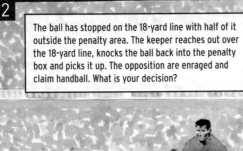

TREVILLION

3

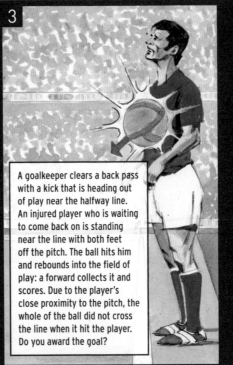

A goalkeeper clears a back pass with a kick that is heading out of play near the halfway line. An injured player who is waiting to come back on is standing near the line with both feet off the pitch. The ball hits him and rebounds into the field of play: a forward collects it and scores. Due to the player's close proximity to the pitch, the whole of the ball did not cross the line when it hit the player. Do you award the goal?

1) You would not reduce the team to 10 men. The referee would request the substituted player leave the technical area and report him to the authorities.

2) The goalkeeper has made contact with the ball outside the penalty area, so you would award a direct free-kick. This is similar to a defender inside the penalty area tripping an opponent outside the area. The point of contact, and hence the free-kick, is outside the penalty area.

3) No, do not give the goal. If you judged that this was an accident and not a deliberate act, restart play with a dropped ball from where the contact occurred on the touchline. If however the player had leant forward and deliberately chested the ball, you would show him a yellow card and restart with an indirect free-kick.

If the referee deemed it an act of unsporting behaviour, a yellow card would be shown.

that in committing this offence the goalkeeper has not denied an obvious goalscoring opportunity. If he has, then a red card would also be given.

The referee also has to ensure

Keith Hackett

player in 2006, for two debatable yellow card offences. He was also famously censured after using the referee's toilet before a Leicester game in 2002, blaming a stomach upset. Graham Poll reported him for entering the referee's room without permission, and he was fined £10,000 by the FA. A friend told the press: "Robbie thinks the whole thing stinks." He retired from international football in 2005.

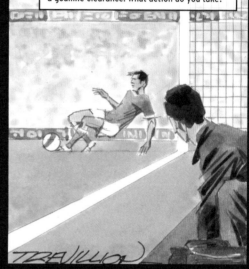

2

A defender who has been receiving treatment off the pitch is desperate to come back on. Suddenly he sees an opposition striker burst through on goal, and, without permission, dashes back on the field, and slides in to make a goalline clearance. What action do you take?

1

The score is 6-5 in a penalty shoot-out when a midfielder walks up to take his crucial kick. However, as he stands over the ball, the opposition fans aim a torrent of foul racist abuse at him. He walks off the pitch down the tunnel and refuses to come back. What do you do?

Keith Hackett

1) Inform the captain that the player is cautioned (yellow card) for leaving the field of play without your permission. Ask the next player of the same team to come forward to take the kick, and ensure that each team take an equal number of kicks until a winner is determined. An equal number of players from each team is required at the *start* of the shoot-out, so an equalisation cannot be made after the midfielder has run off the field. After the match you would make the authorities fully aware of what took place. Racism has no place in football, and the punishment for the club involved would be severe.

2) Show the defender a yellow card for entering the field without your permission. Restart with an indirect free-kick to the attacking team. The player can only be sent off for denying a goal in these circumstances if he came on to the field and deliberately handling the ball. However, he is, in normal play, allowed to kick the ball – so his only transgression is coming on to the field without permission.

3) An outside agent has caused the kicker to miskick. So order the retake of the penalty kick.

Diego Maradona in action – first published in Match magazine in 1990

Paul Trevillion explains his decision:

"The definition of 'little big man'. At full speed, Maradona's close control was breathtaking. There was no daylight between his foot and the ball and when he ran into trouble, if he couldn't dribble his way out, the defenders just bounced off him. On a run, he could take apart any defence in the world and, more important, finish it by putting the ball in the net."

3

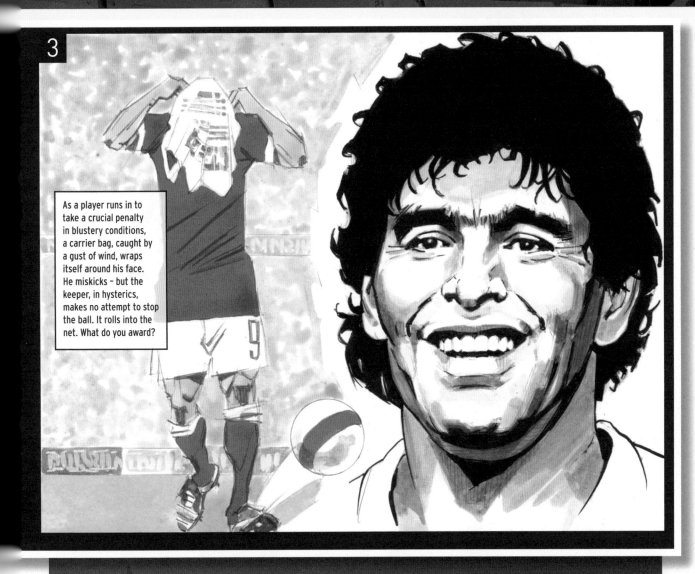

As a player runs in to take a crucial penalty in blustery conditions, a carrier bag, caught by a gust of wind, wraps itself around his face. He miskicks – but the keeper, in hysterics, makes no attempt to stop the ball. It rolls into the net. What do you award?

DIEGO MARADONA

Full name: Diego Armando Maradona

Born: 30 October 1960, Lanús, Argentina

Major clubs: Argentinos Juniors, Boca Juniors, Barcelona, Napoli, Sevilla

Country: Argentina

Position: Attacking midfielder

Diego Maradona gave lie to the old maxim that no one player can win a tournament single-handedly. He guided an otherwise starless Argentina to World Cup victory in 1986 and helped unfancied Napoli to the only two league titles in their history. Charismatic, free-scoring and bullish, Maradona was an individual genius with a gift for inspiring those around him.

After making his name in Argentina, he moved to Barcelona for a world record £5m in 1982, but his stay was blighted by illness, injury and rows with the management. He moved to Napoli – for £6.9m, again a record – where he led them to the top of Serie A in 1987 and 1990, and won the Coppa Italia and the Uefa Cup.

In total he scored 34 goals in 91 matches for Argentina, but it is the 1986 World Cup for which he'll always be most rememebered. He scored five goals and captained the team to victory – but it was the quarter-final, against England, where he really stood out. First for his unashamed handballed "hand of God" goal past Peter Shilton, and second for his simply mesmeric second: receiving the ball in his own half, he swivelled past Steve Hodge, dribbled through three other England defenders, then dragged the ball beyond a sprawled Shilton. It was voted the Goal of the Century.

For one so defined worldwide by his footballing brilliance, it was maybe no surprise that he struggled after his playing career was over. He fell deep into cocaine abuse and developed life-threatening weight problems. But, after demonstrating his personal recovery, he was appointed manager of Argentina in 2008.

Michael Carrick

Full name: Michael Carrick

**Born: 28 July 1981,
Tyne & Wear, England**

**Major clubs: West Ham,
Tottenham, Manchester United**

International: England

Position: Midfielder

A tidy midfielder known for fine passing and consistency, Carrick isn't the English game's most spectacular or talked-about player, but he is among the most effective. He started as a striker for Wallsend Boys, but in 1997 moved to London with West Ham, where he began to play more in midfield. Part of the side which won the 1999 FA Youth Cup final 9-0 against Coventry, his progress was swift. A first-team debut followed against Bradford in August, and after loan spells at Swindon and Birmingham Carrick began to cement himself in West Ham's side. In 2000-01 he was nominated for the PFA Young Player of the Year award, won by Steven Gerrard, and he made his

England debut as a substitute in a friendly against Mexico. When West Ham were relegated the following season, Carrick moved to Spurs for £2.75m – and, in 2006, to Manchester United for a fee

1

A striker takes advantage of a lull in play to adjust a boot that has come loose. But as he removes it, he sees the ball suddenly break upfield to him. He drops the boot, beats his man for pace and smacks the ball into the net with his stockinged foot. He celebrates – but the defenders howl in protest, claiming the goal should be disallowed because he wasn't wearing the correct equipment. What is your decision?

TREVILLION.

James Milner

**Full name:
James Philip
Milner**

**Born: 4 January
1986, Leeds,
England**

**Major clubs:
Leeds,
Newcastle,
Aston Villa**

**International:
England**

Position: Winger

A record 46 England Under-21 caps proves two things: one, that James Milner's potential as a top winger

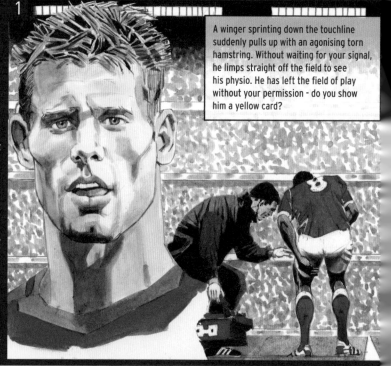

1

A winger sprinting down the touchline suddenly pulls up with an agonising torn hamstring. Without waiting for your signal, he limps straight off the field to see his physio. He has left the field of play without your permission – do you show him a yellow card?

Keith Hackett

1) No – referees aren't dictators: use some common sense and show some compassion – this is a serious injury. At the first stoppage, run over and have a quiet word. Remind the physio to indicate as soon as possible whether the player will be coming back on, or whether a substitution will be made.

2) The home captain is correct. The law was changed in 1997. Before the change, winning the toss meant the captain could choose between either taking the kick-off or choosing ends. Now there is no choice. The team winning the toss has now only the choice of ends, with the kick-off taken by the team that loses the toss.

3) Ask the goalkeeper to remove the bear. The penalty taker's complaint about distraction is valid – I'd ask the keeper to remove the bear, and if he still refused or argued, I'd insist. It is your, and your assistants', responsibility to inspect the goal nets on arrival at the ground and before kick-off, to make sure they are secure and unobstructed. In recent times officials have had to ask broadcasters to remove microphones and sometimes mini-cameras from in and around the nets, where they are not permitted.

had long been recognised; and two, that it took him a very long time to fulfil it. He made his debut for Leeds in 2002 aged only 16 and 309 days, becoming the youngest player to appear in the Premier League, and in December 2002 became the then-youngest player to score a Premier

League goal. But his versatility as a hard-working and intelligent player capable of playing on either wing or at full-back seemed to hold him back, as did the instability of his clubs. He left Leeds, the club he supported as a boy, to join Newcastle in 2004, and was used regularly by Bobby

2

A player takes a quick throw and the ball is passed straight back to him. He's still standing off the pitch, but kicks the ball back to a team-mate before it crosses the line. The team-mate centres the ball and a striker scores. Do you give a) a goal b) a free-kick c) a foul throw or d) a dropped ball?

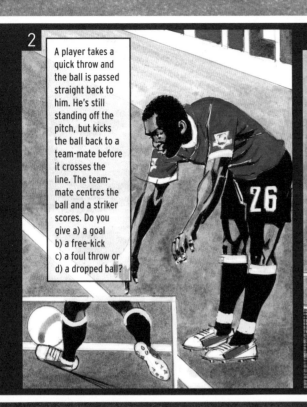

3

You award a free-kick for a striker being offside. But as the goalkeeper goes to take the kick he slices the ball wildly: it hits the back of the striker – who was still standing in an offside position talking to your assistant – and rebounds into the net. The striker now screams for a goal, but the keeper demands the right to retake the kick. What do you give and why?

Keith Hackett

1) **No goal.** You have to consider the danger of injury – and this player is clearly at risk. Restart with a dropped ball. This sort of situation highlights why referees have to be alert to everything going on around them. If you see a player remove a boot, blow up immediately or quickly ask him to leave the field as play continues. The player must then wait for the next stoppage before you allow him back on – and you must also check his kit before letting him continue.

2) a) **A goal.** The ball stayed in play. The whole of it has to cross the touchline before it is dead and in this case the throw-taker can legitimately strike the ball while he's standing off the pitch. It's a complicated one though – if this wasn't a throw-in and a player standing off the field of play without your permission struck the ball, he would earn himself a yellow card.

3) **Award a goal.** The striker's offside position is irrelevant because the ball has been played by an opponent – the only consideration here is whether the ball travels outside the penalty area from the free-kick.

rising to £18.6m, where he became an integral part of Alex Ferguson's title and trophy-winning side. He was cool and calm enough to score one of the penalties against Chelsea in 2008 which won United the Champions League final – and, having returned to England duty in 2005 after a four-year absence, became a regular squad member.

2

The away captain – new to the role – wins the toss and chooses to kick off. But the home captain scoffs at him, claiming winning the toss only lets you choose which end to attack. The away captain angrily disagrees. Who is right?

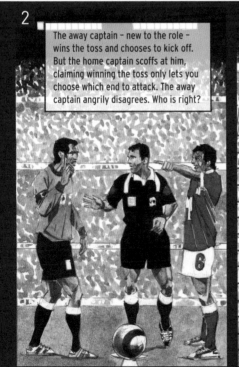

3

Before a cup final, a goalkeeper places his lucky teddybear mascot in the back of his net. It proves a good omen – he pulls off dramatic save after save. But then you give a penalty. The penalty taker is unhappy, saying the bear is putting him off, and refuses to take the kick until it is removed. The keeper argues the bear is off the field of play, so he won't move it. What do you do?

TREVILLION

Robson. But when Robson was sacked he fell out of favour under the new manager, Graeme Souness. Newcastle, Souness remarked, would win nothing "with a team of James Milners". He joined Villa on loan for the 2004-05 season and returned permanently in 2008. By the age of 23 he had played under 16 different managers, but at Villa under Martin O'Neill he finally found some stability, and with it, senior England caps. "He is a very interesting player," Fabio Capello said in 2008. "He represents England's future."

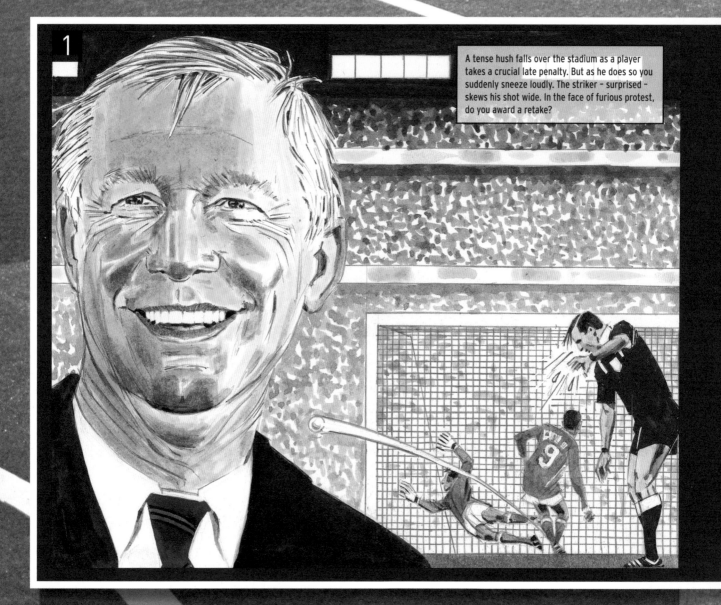

1

A tense hush falls over the stadium as a player takes a crucial late penalty. But as he does so you suddenly sneeze loudly. The striker – surprised – skews his shot wide. In the face of furious protest, do you award a retake?

Sir Alex Ferguson

Full name:
Alexander Chapman Ferguson

**Born: 31 December 1941,
Glasgow, Scotland**

**Major clubs as player: Queen's Park,
St Johnstone, Dunfermline, Rangers,
Falkirk, Ayr Utd**

**Major sides as manager: St Mirren,
Aberdeen, Manchester United, Scotland**

A solid striker who joined Rangers from Dunfermline for a then-record £65,000 in 1967, Ferguson later played for Falkirk and Ayr United – but it's as a manager that he'll always be remembered. He is, quite simply, the most successful club manager of his generation, winning more titles and trophies than any other, setting countless records.

He joined Manchester United in November 1986, having previously managed East Stirlingshire, St Mirren and Aberdeen, and having run the Scotland side following the sudden death of Jock Stein.

Before agreeing a deal with United to replace Ron Atkinson, Ferguson rejected approaches from both Spurs and Arsenal. Famously, he didn't make an instant impact at Old Trafford. Despite high-profile signings, nothing clicked, and in 1989-90, after a 5-1 loss to Man City, fans and journalists turned on him. But as they struggled in the league, they did set off on an FA Cup run – and, after a replay, narrowly beat Crystal Palace in the final. The trophy saved Ferguson's job, and the rest is history. Abrasive, controversial and passionate, he went on to build United into the most powerful force in English football, and one of the world's top sides. In 1999, after United's two late goals won the European Cup against Bayern Munich, Ferguson's reaction produced a quote which will live on long after he has gone. "I can't believe it. I can't believe it. Football. Bloody hell."

2

A player taking a kick-off scuffs the ball and nudges it a second time with his foot before any other player has touched it. Do you stop play, and if so how do you restart?

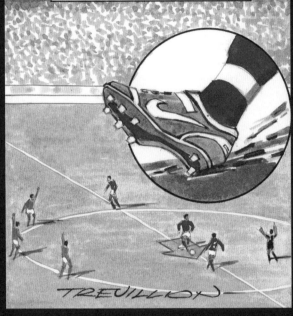

TREVILLION

3

A striker is lying injured in the opposition penalty area, but you allow play to go on. As the opposition keeper bends down to check on the striker, he fails to notice that the ball has been launched towards his goal. It hits the injured striker on the back and flies into the net. The attacking side celebrate wildly. Do you award a goal?

Keith Hackett

1) Tough. It's important that the player taking the kick concentrates on his game. You often see spectators standing behind the goal making every attempt to distract the penalty taker with loud whistling and arm-waving – it's up to the taker to cope with any distraction. So no, don't award a retake, it's a goal-kick.

2) Stop play and award an indirect free-kick to the opposition as the player has played the ball a second time. In nearly 50 years of participating in the game, I never wonder if any reader has ever seen this happen? In nearly 50 years of participating in the game, I never have. That is why the referee needs to have a full knowledge of the laws because it could happen.

3) Stop play and award an indirect free-kick to the defending side. The striker, although he is lying down, is still interfering with play and offside. But under the fairplay convention I would expect the referee to have stopped play before the incident unfolded, taking into account the safety of the player.

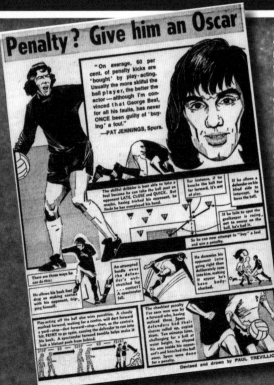

Penalty ? Give him an Oscar

"On average, 60 per cent of penalty kicks are 'bought' by play-acting. Usually the more skilful the ball player, the better the actor — although I'm convinced that George Best, for all his faults, has never ONCE been guilty of 'buying' a foul."
—PAT JENNINGS, Spurs.

Devised and drawn by PAUL TREVILLION

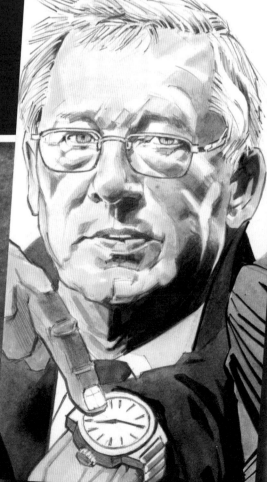

Alex Ferguson, right, drawn in familiar pose for The Guardian in 2009 – and another United icon, George Best, left, featuring with Pat Jennings in a guide to winning a penalty, published in The People in 1980

David Villa

Full name:
David Villa
Sánchez

Born:
3 December
1981, Tuilla,
Spain

Major clubs:
Sporting Gijón,
Real Zaragoza,
Valencia

International:
Spain

Position: Striker

After being turned down by Real Oviedo for being too small, Villa – now recognised as one of the finest forwards in the game – was given his chance with Sporting Gijón in Spain's second division, and scored 18 goals in his first full season, before bettering that by two in 2002-03. It was a sign of things to come. In each of his first two seasons in the top flight, with Zaragoza, he scored 16 league goals, and in his first four seasons with Valencia, 87 in 137 league games – including, in 2008-09, a club record-equalling 28 goals, a season in which he also scored 14 goals in 14 games for Spain. It had taken Spain's winning display in the 2008 European Championship for Villa to receive

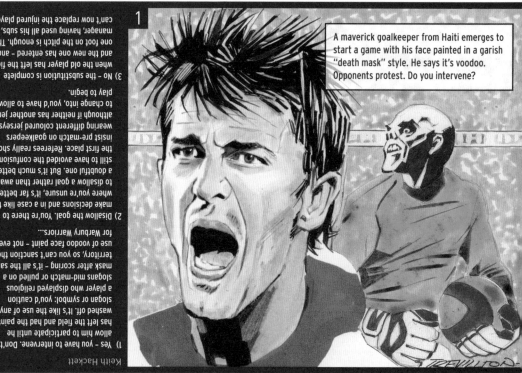

A maverick goalkeeper from Haiti emerges to start a game with his face painted in a garish "death mask" style. He says it's voodoo. Opponents protest. Do you intervene?

Keith Hackett

1) Yes – you have to intervene. Don't allow him to participate until he has left the field and had the paint washed off. It's like the use of any slogan or symbol: you'd caution a player who displayed religious slogans mid-match or pulled on a mask after scoring – it's all the same territory, so you can't sanction the use of voodoo face paint – not even for Warbury Warriors...

2) Disallow the goal. You're there to make decisions and in a case like this where you're unsure, it's far better to disallow a goal rather than award a doubtful one. But if it's much better still to have avoided the confusion in the first place. Referees really should insist pre-match on goalkeepers wearing different coloured jerseys – although if neither has another jersey to change into, you'd have to allow play to begin.

3) No – the substitution is complete when the old player has left the field and the new one has entered. The one foot on the pitch is enough. The manager, having used all his subs, can't now replace the injured player.

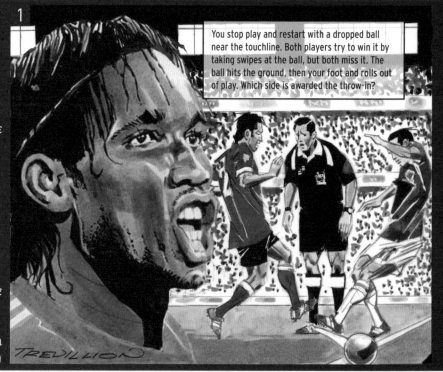

You stop play and restart with a dropped ball near the touchline. Both players try to win it by taking swipes at the ball, but both miss it. The ball hits the ground, then your foot and rolls out of play. Which side is awarded the throw-in?

Keith Hackett

1) Neither. You should have moved faster, stopping play before the ball rolled over the touchline. However, either way, you should restart play with another dropped ball.

2) The Football League regulations do not have a specific lower age limit for a first-team player, so you must allow the boys to play. However, the League do state that "child protection policies, practices and procedures will be applied to all aspects of club activities involving children", and "clubs must also abide by government legislation which applies to children under the age of 18." It's the club's responsibility, not yours, to check that they aren't contravening these regulations – so if anything isn't right it will be picked up and dealt with after the match by the game's administrators.

3) Disallow the goal, book the striker and send off the defender. The laws state that any player who intentionally lies on the ball for an unreasonable length of time should be cautioned for unsporting behaviour, with an indirect free-kick being awarded to his opponents. The defender must be sent off for serious foul play. But in practice, I'd hope a referee would stop the game quickly before this chain of events had a chance to unfold.

Among the most feared strikers in the contemporary game, Didier Drogba has two clear sides to his character. The positive – his energy and passion, powering explosively forceful, skilful performances; and the negative – regular accusations of diving and aggression towards officials. He began his career as an apprentice at Le Mans, signing his first professional contract in 1999. He moved to Guingamp in 2002 for £80,000, and scored 17 goals in 34 games in his second season there. It was eye-catching enough to attract Marseille, who paid £3.3m for him a year later – but this move was also to prove fleeting. His displays in the league, Champions League and Uefa Cup were so impressive that he

2 Both goalkeepers are wearing kits with yellow sleeves. In the last minute one of them goes up for a corner. In the confusion, you see a yellow-sleeved arm go up and deflect the ball into the goal. You have no idea which keeper pushed the ball in, and neither do your assistants. What do you do?

3 A manager makes his last substitution. The fourth official approves the swap and shows the numbers, and you allow it. The replaced player leaves the pitch, but as the new player steps on to it – one foot over the line, one behind it – he suddenly crumples to the floor clutching his hamstring. His manager demands the right to bring on a different player instead. Do you let him?

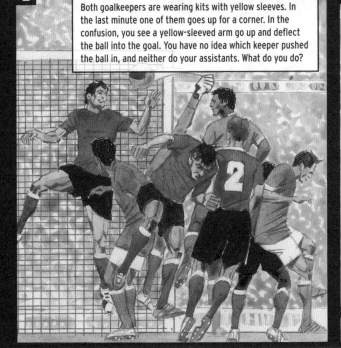

the recognition he deserved. After scoring six in qualification, he scored another four in the finals, including a hat-trick against Russia. An injury in the semi-final ruled him out of the final, but he had played a major part in Spain securing their first major title since 1964. Spain

team-mate Xabi Alonso has described him as a "born goalscorer: quick, clever and strong, superb with both feet", while Quini, a Sporting Gijón legend and five-times the top scorer in La Liga, labelled him simply "a phenomenon – the best in Europe".

2 A League Two manager makes a surprise late change to his teamsheet after two players go down with food poisoning. He wants to use two very nervous looking 14-year-old youth-team players. Do you allow it?

3 During a goalmouth melee a quick-thinking striker throws himself over the ball, shielding it from defenders with his body, and rolls with the ball over the goalline. As his team-mates appeal for a goal, a furious defender kicks the striker in the side. What do you do?

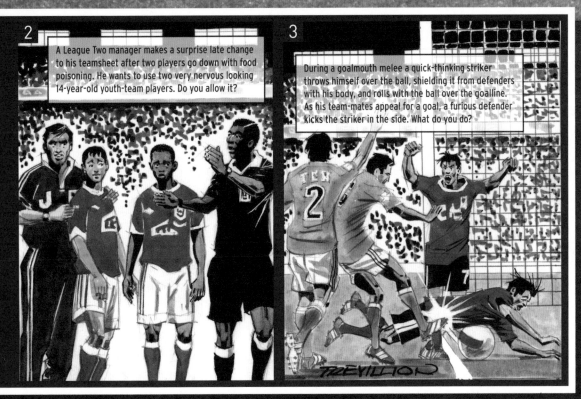

Didier Drogba

Full name: Didier Yves Drogba Tébily

Born: 11 March 1978

Major clubs: Le Mans, Guingamp, Marseille, Chelsea

International: Ivory Coast

Position: Striker

stayed just one season before his extraordinary £24m move to Chelsea. At Stamford Bridge he developed into one of the world's best forwards, and one of the most talked-about, attracting headlines for his goals, but also for regularly linking himself with transfers, and for repeated moments of indiscipline, including his infamous verbal assault on referee

Tom Henning Ovrebo after the side's 2009 Champions League semi-final defeat to Barcelona. At international level, Drogba made his Ivory Coast debut in 2002, and helped the team qualify for their first ever World Cup in 2006. Off the field he is well known for the Didier Drogba Foundation – his charity, set up to fund health projects in his home nation.

**Paul Trevillion
explains his choice:**

"Pelé was football's
Nureyev: he was made of
iron. With his incredible
balance, there was nobody
better at withstanding
a physical challenge on
the ball. That was why
defenders had to kick him
off it. But then to kick Pelé
you had to get near him,
and opponents found that
impossible. He really was
the king."

Pelé in action - drawn for an
Umbro USA 94 World Cup shirt

1

After a goalmouth scramble, the
goalkeeper and an opponent end up
behind the goalline, tangled up in the
net. As they struggle to get free, with
the ball still in play, the goalkeeper
violently lashes out at the opponent and
makes contact. What do you award?

2

You allow a substitution – and almost immediately the
sub scores with a blistering header. But after awarding
the goal and play restarting, you realise the scorer
shouldn't be on the pitch: he wasn't named among the
subs. In a panic, you stop play. What now?

1) Stop play immediately, unless there is an immediate obvious goalscoring opportunity. You must show the goalkeeper the red card. As the offence was off the field of play, you restart the game with a dropped ball from where it was in play when play was stopped. But before you restart you must make sure another player goes in goal: a team must have a goalkeeper.

2) Because play had restarted, the goal has to stand. Instruct the illegal sub – considered an outside agent – to leave the field of play. The player who has been substituted may return to the field of play or be replaced by another nominated sub. You should then continue with a dropped ball. Restart play with a dropped ball. You should then continue with the rest of the game, and later report what happened to the competition. It is so important for match officials to maintain, during the course of the game, a clear record of events. Always take a list of the subs on to the pitch with you – unless you have a fourth official, who can monitor this for you.

3) Penalise the first offence: award an indirect free-kick for offside. You could still show a yellow card if you considered the challenge reckless. At professional level match officials wear a communication system that assists the decision-making process.

Keith Hackett

PELÉ

Full name: Edson Arantes do Nascimento

Born: 23 October 1940, Três Corações, Brazil

Major clubs: Santos, New York Cosmos

Country: Brazil

Position: Forward

One of football's few undisputed geniuses, Pelé jostles with Diego Maradona at the top of all lists of greatest players. A striker and playmaker, Pelé was prolific, graceful and ruthless. He spent the bulk of his club career with Santos, scoring a phenomenal 474 goals in 438 league games, before moving to America and playing for the New York Cosmos between 1975 and 1977.

But it's for his feats with Brazil that he is best remembered. His first World Cup was in 1958 in Sweden, where he scored against Wales in the quarter-final, hit a hat-trick in the semi against France, and scored twice as Brazil beat the hosts 5-2 in the final. His first goal in the final was a masterpiece: he spun out of a challenge, controlled a pass on his chest, dinked the ball over a second defender, let the ball drop and struck a low volley past the keeper.

Four years later, in Chile, he scored against Mexico but was injured against Czechoslovakia and missed the rest of Brazil's winning campaign. In 1966 Brazil were fouled out of the competition, but in 1970 they took revenge. With a side also featuring Gerson, Rivelino and Jairzinho, they played what is still considered the most beautiful football ever produced.

Many of Pelé's most famous moments are from that 1970 campaign: his audacious attempted lob from the halfway line, the header miraculously saved by Gordon Banks, and the dummy he sold Uruguay's goalkeeper Ladislao Mazurkiewicz. Brazil met Italy in the final, with Pelé opening the scoring with a header, and went on to win 4-1. "I was born for soccer," he said. "Just as Beethoven was born for music."

Since his retirement, Pelé has been kept busy with commercial work – including being the face of Viagra – and as a Fifa ambassador.

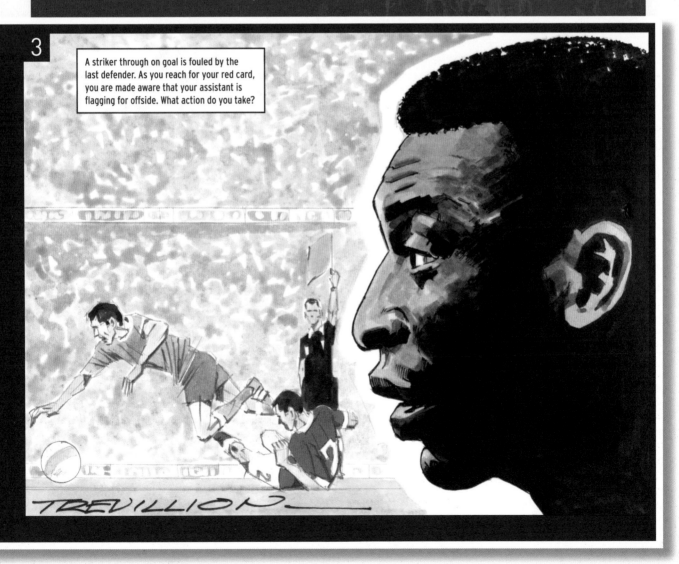

3 A striker through on goal is fouled by the last defender. As you reach for your red card, you are made aware that your assistant is flagging for offside. What action do you take?

TREVILLION

In a Premier League game, you and your colleagues are wearing yellow tops and black shorts. Before kick off the away captain approaches you to point out that the home keeper is in almost identical kit, so should change – but the home captain insists that it is their first-choice kit and they should not be penalised. He says you should change. What happens next?

Keith Hackett

TREVILLION

1) The home captain is right: you must change. You shouldn't have let it get this far. Before Premier League and Football League games the manager and the captain of both teams meet you in your dressing room. One of your tasks is to make sure there are no colour clashes: the law requires that all players wear colours that distinguish them from the officials.

2) Send the player off. He is guilty of violent conduct. After the game the player could ask for a personal hearing, claiming he did not realise what he was doing. With any head injury you must act quickly: signal for the medics to come on immediately (including, if necessary, the duty doctor and paramedics); and, where possible, keep other players away. In this situation, if you'd been able to keep other players back, the injured party would have had no-one to hit.

3) No. The substitution is complete once you have given your permission, the player has left and the sub has come on. But you must still take disciplinary action. As well as giving the departed player his second yellow card you should also consider giving the incoming sub a yellow card for delaying the restart.

Few really expected "Fat Frank" to develop into a world-class midfielder. In the youth ranks at West Ham he was in the shadow of Michael Carrick and Joe Cole, and his stocky frame earned him the nickname which has dogged him ever since. But it was Lampard who went on to become a mainstay for England and, in 2005, finish second in the Fifa World Footballer of the Year awards. Criticism has always been there, both of his fitness – despite the fact that he appeared in a record 164 consecutive Premier League matches – and of inconsistency at

Fabio Capello

Full name: Fabio Capello

Born: 18 June 1946, San Zanzian d'Isonzo, Italy

Major clubs as player: Roma, Juventus, Milan

Major sides as coach: Milan, Real Madrid, Roma, Juventus, England

Known as the Iron Sergeant, Capello arrived in England in 2008 with an intimidating image – exactly what his new squad needed. Disorganised and despondent after their failure to qualify for Euro 2008, England were dramatically rejuvenated by Capello, who led them to qualification for the World Cup in South Africa with two games to spare. His ability to discipline and unite players has been evident throughout his career. After playing in midfield for Milan and Juventus, and for Italy, he started his management career with Milan

1

A defender, by the corner flag, tries to pass the ball forward across the penalty area to a colleague standing just outside it – but he underhits the pass and an attacker tries to intercept. The keeper, seeing the danger, dashes over and picks the ball up. The attacker screams for a free-kick. What do you give?

in 1987, initially as caretaker then as an assistant to Arrigo Sacchi. The latter left to become Italy coach in 1991, and Capello led the team, including Marco van Basten, Ruud Gullit and Paolo Maldini, to an unbeaten season in 1991-92. They won four Serie A titles in five years and, in a performance

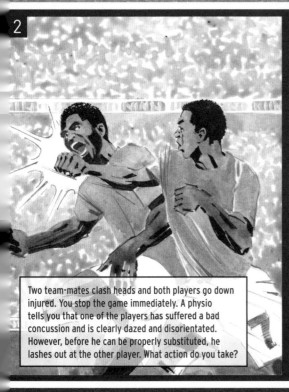

Two team-mates clash heads and both players go down injured. You stop the game immediately. A physio tells you that one of the players has suffered a bad concussion and is clearly dazed and disorientated. However, before he can be properly substituted, he lashes out at the other player. What action do you take?

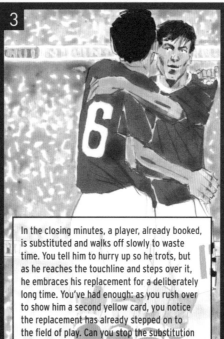

In the closing minutes, a player, already booked, is substituted and walks off slowly to waste time. You tell him to hurry up so he trots, but as he reaches the touchline and steps over it, he embraces his replacement for a deliberately long time. You've had enough: as you rush over to show him a second yellow card, you notice the replacement has already stepped on to the field of play. Can you stop the substitution retrospectively?

Frank Lampard

Full name: Frank James Lampard. Jr

Born: 20 June 1978, Romford, England

Major clubs: West Ham, Chelsea

International: England

Position: Midfielder

rnational level. Though voted England's player of the season in both 4 and 2005, he later became a scapegoat as the team underachieved n his goals grew scarce. But much of the criticism comes from unorthodox style: not especially fast or tricksy, but full of probing

passes and late runs into the box. The statistics show just how valuable he is: in August 2009 his 132nd Chelsea goal in 429 matches since his £11m move put him level with striker Jimmy Greaves in fifth on Chelsea's all-time scoring charts.

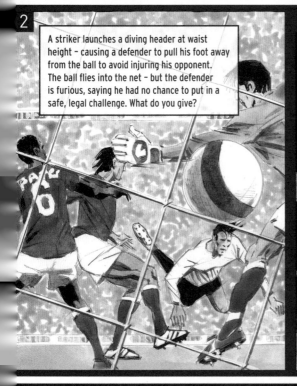

A striker launches a diving header at waist height – causing a defender to pull his foot away from the ball to avoid injuring his opponent. The ball flies into the net – but the defender is furious, saying he had no chance to put in a safe, legal challenge. What do you give?

One of two deciding World Cup group games is delayed by floodlight failure 15 minutes before full time. Waiting in the dressing room, both teams hear the result of the other game, and realise they only need a draw to qualify. When play resumes, the players pass the ball around, making no attempt to attack or score. What action do you take?

TREVILLION

Keith Hackett

1) Play on – but you may wish to take action against the attackers for dissent. The fact that the ball went forward is irrelevant. The law, often misunderstood, clearly states that the keeper must not touch the ball with his hands inside his own area after it has been deliberately kicked to him by a team-mate.

2) Give the goal. The defender is wrong; this is a normal part of open play.

3) Allow the game to proceed: there is limited action you can take during the game – but you should call the two captains together and make it very clear that their teams' actions will be reported to the authorities. The authorities, in this situation, would be likely to take significant action. Something like this happened in the 1982 World Cup in Spain when West Germany and Austria knew that a 1-0 win for the Germans would put them both through. West Germany duly went 1-0 up after 10 minutes, and the remaining 80 minutes were a non-contact farce. At the next World Cup, Fifa ensured final round kick-off times would all be simultaneous, which means that incidents like this are now exceptionally rare.

ly considered one of the finest in European ball, won the 1994 Champions League final by beating celona 4-0. Capello subsequently went on to manage Juventus Roma and had two brief spells with Real Madrid. In all he had won

seven Italian league titles, two in Spain, and a Champions League before turning his attention to international football. "England will be my last job," he said in 2009. "From now on, I wear the England shirt."

BOBBY MOORE

Full name: Sir Robert Frederick Chelsea Moore

Born: 12 April 1941, Barking, London

Major clubs: West Ham, Fulham, San Antonio Thunder, Seattle Sounders

Country: England

Position: Defence

The greatest icon in English football. Elegant, with an unparalleled ability to read the game, Moore's greatest asset was arguably his natural leadership: he captained West Ham for over a decade and, aged 22, became the youngest man to lead England. He made his England debut in 1962, in time to claim a spot for the World Cup in Chile. And by the time the tournament came to England in 1966, he had won the captaincy and, in the words of manager Alf Ramsey, become "the spirit and the heartbeat" of the trophy-lifting team. Four years later in Mexico England fell at the quarter-final stage but not before, in a match against Brazil, Moore made perhaps the most famous tackle in the sport's history – an astonishing, clinical move on Jairzinho. He went on to win 108 caps for England, the last in 1973.

After more than fifteen years as a Hammer, Moore crossed London to join rivals Fulham in 1974. He spent three years there before two brief spells in America. After his playing days ended, he had brief spells as manager of Oxford City, Eastern AA in Hong Kong and Southend. But it'll always be with England and West Ham that Moore is most linked. Franz Beckenbauer, a man who knew a thing or two about hoisting trophies, named him "the best defender in the history of the game". He died in 1993.

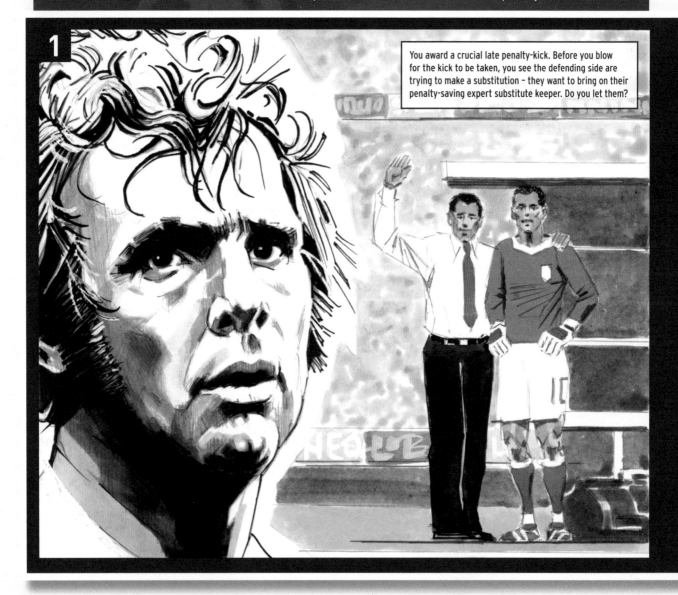

1

You award a crucial late penalty-kick. Before you blow for the kick to be taken, you see the defending side are trying to make a substitution – they want to bring on their penalty-saving expert substitute keeper. Do you let them?

Paul Trevillion explains his choice:

"A football master who did all his best work off the ball. Because Moore read the game so well, he always had time to get into position and then cut out the dangerous balls. Even more important, when Bobby had the ball, he was never guilty of giving it away. I remember him saying that keeping posession of the ball was the ultimate aim for any team: 'you can't play without it'."

Bobby Moore, drawn in 1973 (left), and with the World Cup for a limited edition of pin badges in 1994

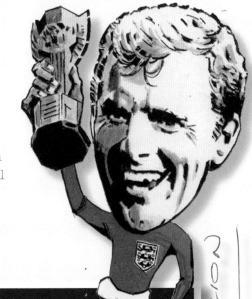

2

Breaking through a last-ditch tackle, a striker shapes to lob the goalkeeper. But as he does so, his boot flies off and hits the keeper in the face. As the keeper stumbles, the ball drops into the net. What is your decision?

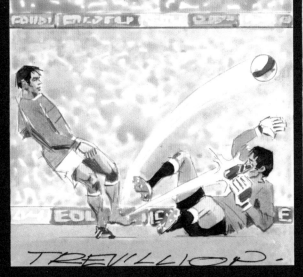

3

Towards the end of a tight game a goalkeeper and a striker challenge for a high ball. There's a horrible accidental clash of heads: both fall to the ground and both need treatment. Should you now make one player, both players or neither player leave the field for 10 seconds?

Keith Hackett

1) Yes, if the team wish to make a substitution this is allowed, provided they haven't used their allocation of substitutes.

2) If you think the boot – an outside agent – clearly interfered with the goalkeeper's ability to defend, disallow the goal and restart with a dropped ball. If you deem the boot did not interfere, and the lob beat the goalkeeper, give the goal.

3) Neither. The Laws of the game are clear in this situation. The only occasion an outfield player is allowed to remain on the field after treatment is when both he and a goalkeeper require treatment. There is no 10-second rule, as implied in the question.

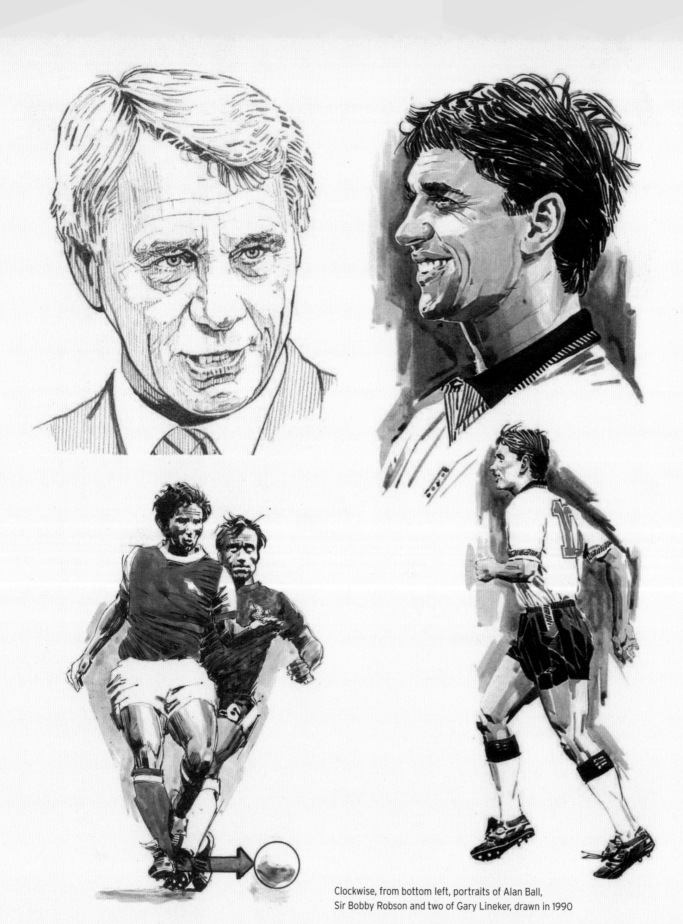

Clockwise, from bottom left, portraits of Alan Ball,
Sir Bobby Robson and two of Gary Lineker, drawn in 1990

Football's true origins are lost in time. The Chinese played a version of the sport in the second century BC – and notoriously violent forms of football were played across medieval Europe.

But the origins of the game we play today – in terms of its laws – are much easier to trace. In the mid-19th century, football in England was part mob brawl, part elitist public school pastime – but neither had a clear set of rules. Various attempts were made: schoolmasters from Eton, Harrow, Winchester, Rugby and Shrewsbury drew up the Cambridge Rules in 1848, while the founders of Sheffield Football Club created their code in 1857. These, among other codes, increased the pressure to find one, official definition of "football".

The result was the formation of the Football Association in 1863, and, later that year, the publication of the first official set of laws – 13 in total. It wasn't a smooth process: disagreements over whether the ball could be picked up or not led to the breakaway formation of the Rugby Football Union in 1871 – but for the majority, the new laws gradually stuck. Absorbing the best parts of the Sheffield rules and all the other codes, the laws were later formally ratified by the newly formed International Football Association Board (IFAB) in 1886, and began to be adopted worldwide.

Today it is the IFAB – not Fifa, as is often thought – which remain in charge of the laws. The home associations of England, Scotland, Wales and Northern Ireland have one vote each and Fifa have four votes on behalf of their members. For a change or amendment to the laws to succeed, three-quarters must agree at the IFAB annual general meeting, which is held in February or March each year.

Much has changed since the 1800s, but the spirit of today's 17 official laws is unchanged. Football is a simple game, and its laws can apply as much to the World Cup final as they do in local parks.

This is an abridged guide to all 17 modern laws – a framework for answering the You Are The Ref scenarios. In addition to these laws, the IFAB also publish additional guidance and tips for referees on a regular basis, covering, in the spirit of You Are The Ref, diverse issues from goal celebrations to pitch invasions. More at **Fifa.com**.

These abridged laws apply to male and female adult football – though certain aspects may be modified for women's competitions. Reference to individual players and officials as male is for simplification only. The laws also vary for competitions involving players aged under 16, for players older than 35 and for players with disabilities. Football measurements are traditionally given in yards, feet and inches. One yard is 0.9 metres.

LAW 1: THE FIELD OF PLAY

Defining the playing surface: this Law states that matches should be played on natural or green-coloured artificial surfaces. The field of play is rectangular and clearly marked with solid, unbroken lines which are no wider than five inches. Any commercial advertising must be kept at least one yard from the main boundary lines.

The key field markings

Rules on field markings are clearly set out. The two longer lines of the rectangular field are the touchlines (between 100 and 130 yards long), and the two shorter are the goallines (between 50 and 100 yards long). Dimensions for international matches are more tightly defined. Other important markings include:

a) **The halfway line** between the touchlines, including a centre mark with a circle 10 yards' radius around it.
b) **The goal area.** A rectangular box which extends six yards from the goalline. The lines touching the goalline are at right angles to it, and they start six yards from the inside of each post.
c) **The penalty area.** A larger rectangular box, extending 18 yards from the goalline. The lines touching the goalline are at right angles to it, and they start 18 yards from the inside of each post.
d) **The penalty mark,** commonly known as the penalty spot. This is painted 12 yards from the goalline, equidistant to both posts. An arc of a circle with a radius of 10 yards from the spot is drawn outside the penalty area, too.
e) **The corner arc.** A quarter circle with a radius of one yard (or one metre – both are allowed, despite the 3.37 inch difference) from each corner flagpost. Optional flagposts may also be placed at each end of the halfway line, not less than one yard (one metre) outside the touchline.

The field diagram is labelled with:
Corner flagpost (compulsory), Touchline, Halfway line, Goal area, Penalty area, Penalty arc, Goalline, Centre mark, Centre circle, Penalty mark, Goalline, Touchline

f) **The technical area.** This can be used to define the area within which club officials and substitutes must remain. Competition rules dictate how many people can occupy the area, but only one person at a time is allowed to convey tactical instructions to the players.

The goals

Goals are placed on the centre of each goalline. They consist of two upright white posts equidistant from the corner flagposts, joined by a horizontal white crossbar. They can be made from wood, metal or any other approved material, and can be square, rectangular, round or elliptical in shape, as long as they are not dangerous to players, and that they are the same width and depth (not more than five inches). The posts must be eight yards apart, and the crossbar eight feet from the ground. The goallines must also be the same width as the depth of the posts and crossbar. A well-secured net can also be used.

LAW 2: THE BALL

This law defines the quality of a match ball, which must be made of leather or another approved material, and have a circumference of between 27 and 28 inches. Other rules limit the weight and air pressure. If the ball bursts or deflates during a game, the referee stops the match and restarts with a (new) dropped ball from where the old ball was when play stopped (see Law 8). If the ball was not in play at the time, play restarts in the usual way.

LAW 3: THE NUMBER OF PLAYERS

The two teams have no more than 11 players, one of whom is the goalkeeper. A match cannot start if either side have fewer than seven players – and the IFAB recommend that matches should be abandoned if either side is reduced to fewer than seven during a match.

Competition rules determine how many substitutes can be named, from a minimum of three up to a maximum of seven. Non-competitive games can involve more subs, though, but only with prior agreement of the two clubs, and if the referee is informed before the match. The names of all subs must be given to the referee before the start of the match.

Making a substitution

A substitution can only happen during a stoppage in play, with the referee's approval. The substitute must enter the field of play at the halfway line when the referee signals, and after the original player has left the field. The substituted player can take no further part. If a

sub or substituted player enters the field of play without the referee's permission, he is cautioned for unsporting behaviour and ordered off. If play had to be stopped then the game is restarted with an indirect free-kick to the opposition from where the ball was when play was stopped. All substitutes are under the jurisdiction of the referee whether they come on, or not.

To change the goalkeeper

Any team-mate can change places with the goalkeeper if the referee is informed first, and the change happens during a stoppage. If this procedure is not followed, both players will be cautioned when the ball next goes out.

Players and substitutes sent off

Any player who has been dismissed before the kick-off may be replaced in the starting line-up only by one of the named substitutes. But a named sub who has been sent off, either before the kick-off or after play has started, may not be replaced.

LAW 4: THE PLAYERS' EQUIPMENT

This law details the requirements for kit (including undershirts having sleeves the same colour as the main shirt, and not containing any slogans or advertising), and the design of shinguards and other protective gear. It also stipulates that team colours must be clearly different, and not clash with the kit worn by the officials.

The goalkeepers must, if possible, wear colours that distinguish them from each other, the other players and the officials. And no one can wear jewellery or any other potentially dangerous item.

Any player told to leave the field to correct any aspect of his equipment during a game can only re-enter when the ball is out of play, when his equipment has been officially checked and when the referee signals him back on.

LAW 5: THE REFEREE

A law covering the referee's powers and responsibilities.

The referee's role is extensive: he is a timekeeper, a protector of player safety (including having the power to stop the game for any injury deemed serious, and ensuring that any player bleeding from a wound leaves the field until the bleeding has stopped), a controller of club officials, and the only person who can suspend or abandon a game.

This section also covers use by the referee of the **advantage** clause – which gives referees the power to decide whether to stop play when an offence occurs, or to play on if the innocent team are in possession and appear to have a clear chance of an immediate, dangerous attack on the opponents' goal. If the offence is so severe as to warrant a red card, though, the referee should generally stop play immediately, unless there is an obvious goalscoring opportunity.

The decisions of the referee regarding facts connected with play, including whether or not a goal is scored and the result of the match, are final. He may only change a decision (if he realises it was incorrect, or having called on the advice of a colleague) if play has not restarted.

LAW 6: ASSISTANT REFEREES

There are two assistant referees. Their principal tasks include judging when the whole of the ball is out of play, indicating corner-kicks, goal-kicks, throw-ins and offside infringements, indicating when a substitution has been requested, monitoring the goalkeeper's movement during penalty-kicks and advising the referee about other incidents or acts of misconduct. Their role is essentially to supply the referee with information upon which he can base decisions.

Some competitions also allow for a fourth official, who can take over if any of the three officials cannot continue. He also assists the referee at all times with administrative duties, substitutions and monitoring misconduct.

LAW 7: THE DURATION OF THE MATCH

A match lasts two equal periods of 45 minutes, unless otherwise agreed between the referee and the two teams, in accordance with competition rules. The half-time interval is no longer than 15 minutes.

The referee will make allowances in each half for all time lost through substitutions, assessment of player injuries, removal of injured players, deliberate time-wasting, or any other cause. If a penalty-kick has to be taken or retaken, the duration of either half is extended until the kick is complete. The fourth official, if present, will also indicate the minimum time to be added at the end of each half after being informed by the referee.

LAW 8: THE START AND RESTART OF PLAY

Before the start of a game the referee tosses a coin with both captains. The captain who wins the toss decides which goal his side will attack in the first half. The other team take the kick-off. For the second half, the teams change ends and the original toss-winning team take the kick-off.

Kick-offs are also used to restart the game after every goal (the conceding side take the kick). And goalkeepers must always be alert: a goal can be scored direct from a kick-off.

The regulations around kick-offs state that all players must be in their own half, and all opponents of the team taking the kick must be 10 yards from the ball until it is in play. The ball is in play the moment it is kicked and moves forward. The kicker can only touch the ball again after it has touched another player. If he does touch it again first, it's an indirect free-kick to the opposition. Any other kick-off procedure infringement results in a retaken kick-off.

Dropped ball

If, while the ball is in play, the referee has to stop play temporarily for any reason not mentioned elsewhere in the laws, he restarts with a dropped ball. The ball is dropped at the point where it was when play was stopped – unless it was inside the goal area. In that situation, the ball is dropped on the six-yard line parallel to the goalline at the point nearest to where the ball was when play was stopped.

Play restarts when the ball touches the ground. Any number of players, including goalkeepers, can take part, but usually the ball is dropped between two players.

LAW 9: THE BALL IN AND OUT OF PLAY

The ball is out of play when it has wholly crossed the goalline or touchline – in the air or on the ground – or when play has been stopped by the referee.

LAW 10: THE METHOD OF SCORING

For a goal to count, the whole of the ball must cross the goalline between the goalposts, below the crossbar, without any infringements having been committed previously by the scoring team.

In knockout competitions where a winner must be found and draws are no good, the IFAB allow games to be settled by the away goals rule (for home and away matches where the aggregate score is level), by extra time (two further periods not exceeding 15 minutes each)

or by kicks from the penalty mark (known as a penalty shoot-out).

The procedure for a penalty shoot-out is strict. The referee chooses which end the kicks will be taken – sometimes he will toss a coin and on some occasions the police have an input. Then he tosses a coin with the captains to decide which team kick first. If, at the end of the match and before the kicks start, one team have more players than their opponents, they must reduce their numbers so that both sides have the same number of takers. (However, if a team lose players during the kicks to injury or dismissal, the numbers do not have to be evened up.)

The teams take five kicks alternately. If, before both teams have taken five kicks, one has scored more goals than the other could score within five kicks, the game is over. But if it's level after five kicks, kicks continue until one team has scored one goal more from the same number of kicks ("sudden death").

Only players on the field at the end of the match can take part, though a goalkeeper injured during the shoot-out can be replaced by a named sub if his team haven't used all their subs. Any eligible player can change places with the goalkeeper at any point, too. All eligible players, including goalkeepers, must take a kick before any player can take a second kick.

Players not involved in each kick must remain inside the centre circle, apart from the non-facing goalkeeper, who must remain outside the active penalty area on the goalline.

One other interesting point about the penalty shoot-out: if either team are reduced to fewer than seven players during the kicks (through injury or dismissal) the match is not abandoned – play continues until the bitter end.

LAW 11: OFFSIDE

Football's most talked-about law. At its simplest, a player is in an offside position when he is nearer to his opponents' goalline than both the ball and the second last opponent. He is committing an offside offence when he then becomes involved in active play. The interpretation of "active" was defined by the IFAB in 2005. There's a lot more to it than that, though. For a full guide, see pages 114-115.

LAW 12: FOULS AND MISCONDUCT

A **direct free-kick** is awarded to the opposing team if, when the ball is in play, a player commits any of the following seven offences in a manner which the referee considers to be careless, reckless or using excessive force:

- kicks or attempts to kick an opponent
- trips or attempts to trip an opponent
- jumps at an opponent
- charges an opponent
- strikes or attempts to strike an opponent
- pushes an opponent
- tackles an opponent

A **direct free-kick** is also awarded if a player commits any of the following three offences:

- holds an opponent
- spits at an opponent
- handles the ball deliberately (except for a goalkeeper within his own penalty area)

If any of these 10 offences is committed by a player inside his own penalty area, wherever the ball is, provided it is in play, it's a penalty-kick.

An **indirect free-kick** is awarded to the opposing team from where the offence occurred if, in the opinion of the referee, a player:

- plays in a dangerous manner
- impedes the progress of an opponent
- prevents the goalkeeper from releasing the ball from his hands
- commits any other offence, not previously mentioned in this Law, for which play is stopped to caution or send off a player

An **indirect free-kick** is also awarded if a goalkeeper, inside his own penalty area, commits any of these offences:

- controls the ball with his hands for more than six seconds before releasing it
- touches the ball again with his hands after he has released it from his possession and before it has touched another player

- touches the ball with his hands after it has been deliberately kicked to him by a team-mate (the "back pass rule")
- touches the ball with his hands after he has received it directly from a throw-in taken by a team-mate

Law 13 covers free-kicks in more detail.

Disciplinary sanctions

Any player, substitute or substituted player can be shown a yellow card (cautioned or "booked") or a red card (sent off) from the moment the referee enters the field of play until he leaves it after the final whistle.

Yellow card offences:

- unsporting behaviour
- dissent by word or action
- persistent infringement of the laws
- delaying the restart of play
- failure to respect the required distance when play is restarted with a corner-kick, free-kick or throw-in
- entering or re-entering the field of play without the referee's permission
- deliberately leaving the field of play without the referee's permission

A substitute or substituted player is cautioned if he commits any of the following three offences:

- unsporting behaviour
- dissent by word or action
- delaying the restart of play

Red card offences:

- serious foul play
- violent conduct
- spitting at an opponent or any other person
- denying the opposing team a goal or an obvious goalscoring opportunity by deliberately handling the ball
- denying an obvious goalscoring opportunity to an opponent moving towards the player's goal by an offence punishable by a free-kick or a penalty
- using offensive, insulting or abusive language and/or gestures
- receiving a second caution

A player, substitute or substituted player who has been sent off must leave the vicinity of the pitch and technical area.

LAW 13: FREE-KICKS

Free-kicks are either direct or indirect (see law 12).

For direct free-kicks, it's a goal if the ball is kicked directly into the opponents' goal (though you cannot score an own goal directly from a direct free-kick: in that unlikely situation, a corner-kick is awarded to the opposition).

For indirect free-kicks (signalled by the referee holding his arm above his head until the kick is taken and the ball has touched another player or goes out of play – see page 116 for more signals), the ball must touch another player before it enters the goal for a goal to be awarded.

For all free-kicks, the ball must be stationary when the kick is taken, and the kicker must not touch the ball again until it has touched another player. If a kick-taker does play the ball again before it has touched another player, an indirect free-kick is awarded to the opposing team.

This Law also describes the correct positioning of players at free-kicks. In all cases, opponents must be 10 yards from the ball until it is in play, unless they are on their own goalline between the goalposts.

LAW 14: THE PENALTY-KICK

A penalty-kick is awarded when a player commits a direct free-kick offence inside his own penalty area while the ball is in play.

The requirements before the penalty-kick can be taken are clear: the kick is taken from the penalty mark, the taker must be clearly identified and the goalkeeper must remain on his goalline, facing the kicker, between the goalposts until the ball has been kicked. Other players must be on the field of play, but outside the penalty area, behind and at least 10 yards from the penalty mark.

The taker can only take the kick once the referee has signalled. He must kick the ball forward, and not play it again until it touches another player (punishable by an indirect free-kick to the defending side). The ball is in play once it is kicked and moves forward.

If, before the kick is taken, the penalty-taker or a team-mate encroaches, the referee will award a retake if he scores, or, if the ball does not enter the goal, an indirect free-kick to the defending side from where the infringement occurred. Likewise, if the goalkeeper or team-mate commits an offence before the kick is struck, if the ball goes in, the referee will award a goal, and if it does not, he will award a retake. If a player from both sides commits an offence before the kick, a retake is awarded.

And if, after the kick is taken, it is touched by an "outside agent" (a substituted player, person, animal or object not involved in the match) as it moves forward, the kick is retaken. However if the ball is kicked and rebounds into play via the goalkeeper or the crossbar or goalposts, and then hits an outside agent, play is restarted with a dropped ball.

LAW 15: THE THROW-IN

The whole of the ball must have crossed the touchline for a throw to be awarded. The throw-taker must face the field of play, have part of each foot either on the touchline or on the ground outside the touchline, hold the ball with both hands and deliver it from behind and over his head from the point where it left the field of play. Opponents must stand at least two yards from the point where the throw is taken. The throw-taker must not touch the ball again until it has touched another player (punishable with an indirect free-kick). A goal cannot be scored direct from a throw – and a player cannot be offside if he receives the ball direct from a throw.

LAW 16: THE GOAL-KICK

A goal-kick is given when the whole of the ball passes over the goalline, having last been touched by a member of the attacking team. The kick is taken from any point inside the goal area. Opponents must remain outside the penalty area until the ball is in play, which is not until it has been kicked directly out of the penalty area. A goal can be scored direct from a goal-kick, but an own goal cannot. A player cannot be offside if he receives the ball direct from a goal-kick.

LAW 17: THE CORNER-KICK

The other method of restarting play when the ball passes over the goalline without a goal being scored, used if it was last touched by a member of the defending team.

The ball is placed inside the quadrant nearest to the point where it went out of play. The flagpost must not be removed, and opponents must remain 10 yards from the arc until the ball is in play. The taker cannot touch the ball again until it has been touched by another player. A goal can be scored directly from a corner-kick.

For the full official laws and guidance, visit Fifa.com.

The "Did you know?" series of bubblegum cards was produced in 1958

Football's most talked-about law. At its most basic, the definition is simple: a player is in an offside position if he is nearer to his opponents' goalline than both the ball and the second last opponent. But there's a lot more to it than that.

The law changed significantly in 2005. Why?

Before 1995, an attacker in an offside position was immediately flagged offside. It was a simple system – but it led to endless stoppages, to goals being disallowed when a player not involved happened to stray offside, and it encouraged back fours to use the law to help them defend (catching attackers in the "offside trap", used famously by Tony Adams and Arsenal). It was a negative interpretation, and encouraged negative football.

So, in 1995, the International FA Board (see page 108) set about developing a more flexible but uniform interpretation. They put emphasis on the fact that it is not an offence in itself to be in an offside position. A player in an offside position is only penalised if:

> "At the moment the ball touches or is played by one of his team, he is, in the opinion of the referee, involved in active play by interfering with play, interfering with an opponent, or gaining an advantage by being in that position."

It made a big difference, but there was still real inconsistency in how officials interpreted what made an attacker "active" – what constituted interference or gaining an advantage. What makes a player actively offside, and so committing an offence, rather than just standing in an offside position? So in 2005*, the IFAB released this further clarification:

1) "Interfering with play" means playing or touching the ball passed or touched by a team-mate.

2) "Interfering with an opponent" means preventing an opponent from playing or being able to play the ball by clearly obstructing the opponent's line of vision or movements or making a gesture or movement which, in the opinion of the referee, deceives or distracts an opponent,

3) "Gaining an advantage by being in that position" means playing a ball that rebounds to him off a goalpost or the crossbar having been in an offside position or playing a ball that rebounds to him off an opponent having been in an offside position.

How does that work in practice?

Many officials remember the system by the acronym "PIG". In short, a player is only offside if he 1) Plays or touches the ball; 2) Interferes with an opponent; or 3) Gains an advantage.

Before 2005, an assistant referee, nearly every time, would flag immediately if a player was in an offside position when the ball was played by a team-mate. Now assistants are asked to wait and see. They don't flag instantly: they pause while they judge if the player fits any of the PIG categories.

It means games now flow much more smoothly. Assistants don't flag instantly, and don't flag at all if the PIG criteria are not met. Defences no longer advance to catch attackers in the old "offside trap", and attackers will ignore colleagues in offside positions and pass instead to a team-mate running from an onside position.

So how is "Interfering" – the I of PIG – judged?

There are two parts to the interference clarification: visual obstruction and distraction.

As the clarification states, a visual obstruction must be clear. So if a player clearly obstructs a goalkeeper from seeing the ball by being in his line of vision, he is declared offside. It is an easier decision if the player is close to and in front of the keeper. To be confident, the official has to be in the same line as the flight of the ball to the keeper.

To judge the second part, deception or distraction, a referee needs to be able to read the player's intentions, and to make a measured judgment on the information available to them, based on their position, what they have seen, and the reaction of players. This part of the Law most often applies to distracting a goalkeeper (for instance it would be highly controversial to disallow a goal by an onside player because a defender four yards away was deemed to have been distracted by a player in an offside position).

This part of the PIG system relies on individual officials reading a player's intentions and making good judgments.

And the "G" – "gaining an advantage"?

Much simpler. As the IFAB clarification states, a player in an offside position is only "gaining an advantage" if he plays the ball after it has rebounded from the crossbar, goalpost or an opponent. So "gaining an advantage" can only be from rebounds. If a rebound goes to another attacker in an onside position, the flag isn't raised.

Before the clarification, officials had to decide for themselves when a player was "seeking to gain an advantage". Since 1995, the word "seeking" has disappeared, and the law is now simply about "gaining an advantage" from a rebound.

What about attackers in offside positions when an own goal is scored?

Own goals are rarely disallowed. Officials still have to apply the PIG criteria to any attacking player in an offside position at an own goal, but the criteria do not often apply. The player will not have played/touched the ball, nor gained an advantage (from a rebound). He could, though, be penalised for interfering with an opponent if he had made physical contact with the opponent who scored, or was sufficiently close to that opponent to cause him to miscontrol the ball or misdirect a clearance.

Isn't the PIG system too complicated?

At first sight perhaps – but not when you apply it to real games, or to the scenarios in this book. It is positive, and officials are encouraged to use it sensibly.

For instance, there is no need for officials to be too rigid about the "wait and see" technique: a player can still be penalised for offside without fitting any of the PIG criteria if the referee decides that none of the player's team-mates in onside positions have a chance to play the ball.

So an offside attacker chasing a ball played down the wing by a team-mate can be given offside without having played the ball if the officials decide there was no other team-mate in an onside position able to take advantage of the pass. The whole stadium doesn't have to wait for him to touch the ball before play is stopped.

Officials are also advised not to be negative in their application of the law – to only penalise when the criteria are clearly met. And referees are encouraged to keep the game flowing even after a flag from an assistant if they can do so safely: when the ball runs through to the keeper or is cleared by a defender, for instance.

Overall, it works well. The system helps officials make good, informed decisions. It isn't perfect – debate about the I of PIG continues, as relying on individual judgment can threaten consistency – but it is the best version of the offside law in the sport's history.

* For uniformity, the IFAB also clarified in 2005 that: "nearer to his opponents' goalline" means that any part of a player's head, body or feet is nearer to his opponents' goalline than both the ball and the second-last opponent. The arms are not included in this definition.

Offside – or not?

Goalkeeper ● Attacker ● ⟶ Movement of the Ball
Defender ● Official ● ⤑ Movement of the player

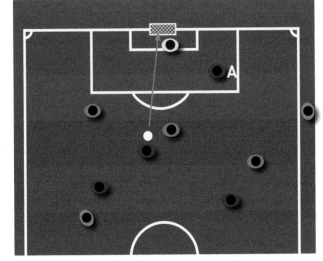

Not offside. There is clearly an attacker in an offside position (A), but he does not fit any of the PIG criteria: he hasn't played the ball, interfered, is not in the goalkeeper's line of sight) or gained any advantage. It's a good goal.

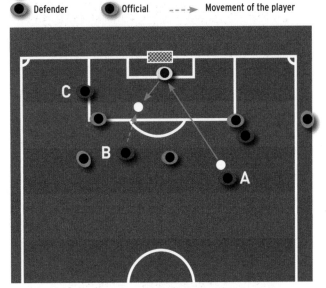

Also not offside. Player B has benefited from a rebound, but he was running from an onside position. Player C is in an offside position, but has neither played the ball. Gained an advantage or interfered.

Clear, crisp accurate signals are essential at any level of football. At the highest level you will have communication systems and fourth officials to help, but you still need to use the full range of signals to communicate with players and colleagues. Keith Hackett explains how the signals work, and how best to use them:

REFEREE SIGNALS

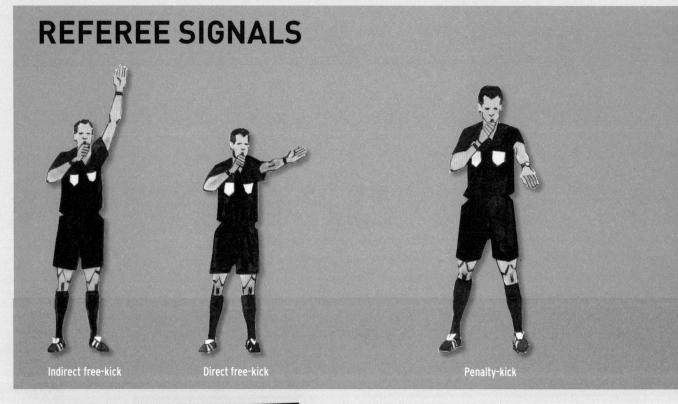

Indirect free-kick Direct free-kick Penalty-kick

Free-kicks

With all these signals, you need to be clear, confident and decisive, and show authority through your body language, backing up your signals with firm verbal instructions. The two most obvious signals are these: use them to show players, managers and the crowd whether a free-kick you have awarded is direct or indirect (see page 112). For an indirect free-kick, hold your arm straight up, and keep it there until the kick has been taken, to avoid any confusion. For a direct free-kick, point your arm in the direction of the offending side's goal.

Penalty-kick

Often the toughest calls you will ever have to make: you must be confident and stand by your decision. To award a penalty, blow your whistle and point with your whole arm towards the penalty mark, as shown. In awarding a penalty, you may also take advice from your assistant, who has his own penalty signal (see page 119).

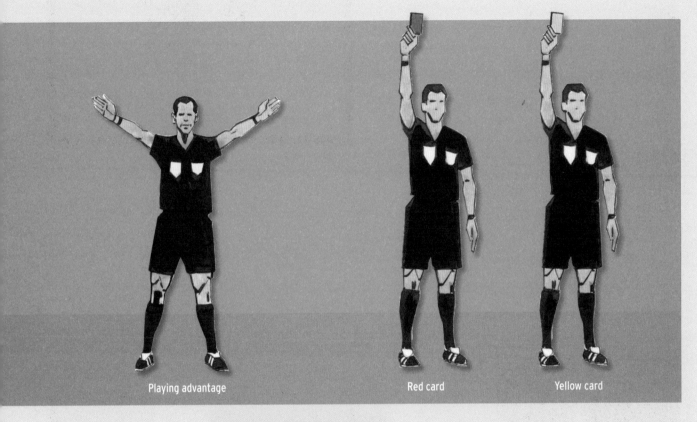

Playing advantage Red card Yellow card

Advantage

Hold both hands up and forward towards the defending side's goal, and shout "play on". Your timing needs to be perfect, and your reactions fast: failing to make the signal instantly and subsequently bringing play back to the original offence will look like indecision. You need to be able to recognise quickly the difference between true advantage and what is simply continued possession.

Left, Howard Webb in action, and right, England's Wayne Rooney is sent off at the 2006 World Cup

Yellow/red cards

Two clear, easy-to-read signals. The story behind the red and yellow card system dates back to 1966, before it existed, and the World Cup quarter-final between Argentina and England. Argentina's Antonio Rattin was sent off by German referee Rudolf Kreitlin, but either didn't understand, or refused to understand the referee's instruction. Fifa official Ken Aston had to escort Rattin off the field. It then emerged that the referee had booked Jack and Bobby Charlton during the game – but no one had realised because he hadn't indicated it publicly. Aston resolved to improve communication, and came up with the solution while in his car: "As I drove down Kensington High Street, the traffic light turned red. I thought 'Yellow, take it easy, red, stop, you're off'." His brainwave led to the new cards being used for the first time during the 1970 World Cup finals in Mexico, and in the Football League from 1976.

ASSISTANT REFEREE

As an assistant you are there to advise the referee – to give him good, solid, clear information. You need to treat the flag like an extension of your arm: make sure it is always visible to the referee, keep it unfurled and still while running, and make your signals clear, deliberate and neat. To make any of the signals shown in this section, stop, face the field, make eye contact with the referee and then follow the procedures shown here.

You should always raise the flag using whichever hand will be used for the next signal in a sequence – and only swap the flag between hands, below waist level, if circumstances change. At professional level you will also have a "signal beep" at your disposal, operated via a button on the flag. The beep gives you an additional way to gain the referee's attention, when, for instance, awarding offside, a foul out of the referee's view, if the ball has gone out of play and the referee hasn't noticed, or for other tight calls.

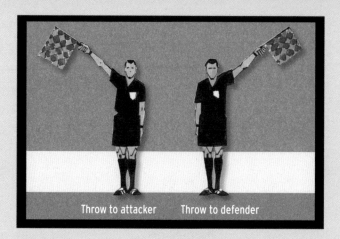

Throw to attacker Throw to defender

Throw-ins

For a throw-in to the attacking side, raise the flag with your right hand then hold it in the position shown. For the defending side, use your left hand. If the ball goes out and you're not sure which side touched it last, raise your flag to indicate the ball is out, make eye contact with the referee and follow his decision. The referee will confirm your decisions too by mirroring your signal with his arm, held out horizontally either left or right. If the ball goes out of play near the corner, he may also indicate with his spare arm whether he has awarded a throw-in rather than a corner-kick.

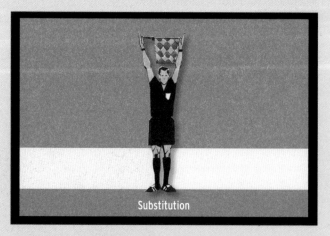

Substitution

Substitutions

When the fourth official has been asked to oversee a substitution, it is your job to inform the referee at the next stoppage. Do so by holding the flag in this horizontal position. The fourth official will oversee the substitution process itself, aided by the communication system, so there is no need for you to move up to the halfway line to manage the process (unless there is no fourth official).

Assistant referee Wendy Toms - the first female official to reach the higher levels of the game in England

An assistant's initial alert for any offence, before giving the precise signal

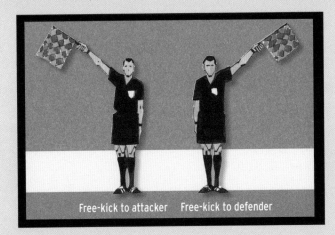

Free-kick to attacker Free-kick to defender

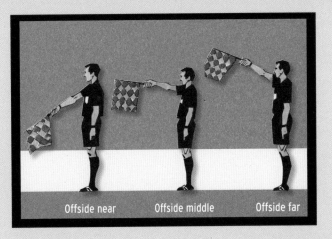

Offside near Offside middle Offside far

Free-kicks

You should only signal for a foul or misconduct if it is committed in your immediate vicinity, or the incident happens outside the referee's vision. In all other situations, wait and offer your opinion if it is required. If you do need to signal, use the same flag position as you would for a throw-in, indicating which side you believe should be awarded the free-kick.

Offside

First, flag to attract the referee's attention, then use it to indicate both that you have identified an offside offence, and where on the field of play the offence took place. Point the flag down to indicate that the offence was on the side of the field of play nearest to you, point it up to indicate it was on the far side, or hold it level to show it was in the middle. You should use your right hand to raise the flag, which gives you a better field of vision. See pages 114-115 for more on the offside law.

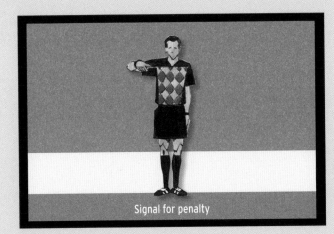

Signal for penalty

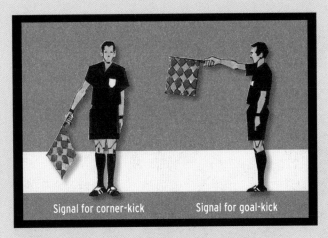

Signal for corner-kick Signal for goal-kick

Penalty kick

If you have clearly seen a penalty-kick offence take place inside the penalty area, you must bring it to the referee's attention. First raise your flag for the offence in the normal way, then place it across your chest as shown. That is the process in England – in some other countries the assistant will signal the offence, then run towards the goalline to indicate he believes a penalty kick should be awarded.

Corner-kick/goal-kick

To indicate a corner-kick, flag for the ball going out of play, then point your flag towards the corner arc – be clear and deliberate about your gestures so that there is no confusion. If the ball has crossed the goalline for a goal-kick, move level with the six-yard line and hold the flag out horizontally – the same signal as if you were awarding offside in the middle of the field of play.

BECOMING A REFEREE TODAY

What does it take to be a referee? Commitment, good levels of fitness and eyesight, confidence in decision-making and a real passion for football. It's a tough process: but the rewards are real.

The path to the top is clearly mapped out. The first stage is to contact your local or national FA, then to pass your first test: learning and understand the 17 laws (tougher than it sounds – see pages 108-115). If you succeed, in the English structure, you're immediately a Level 7 or 8 referee (depending on your age).

As you progress, your ability is constantly measured. At the earliest stages, a club official from both teams in games you referee will issue a report card to the league and mark your performance out of 10. It's a form of talent scouting as well as quality control: they're looking to assess your application of the laws, recognition of offences, your body language and communication, management of people and situations, your fitness and your character.

If you do well enough regularly enough, your marks will reflect that, and you'll climb up the league's merit table. The ultimate goal for every referee is to be promoted to International Level. For a young official in the English structure, these are the levels you'll have to pass to get there.

The pre-match routine: officials go through their final checks ahead of a Premier League game

THE KEY LEVELS

8 Youth referees aged between 14-16 (you must be at least 14 to begin refereeing matches). At this age you'll often officiate games in schools, or at the ever-growing Referee Academies.

7 Junior referees aged 16 or more. A chance to move into the many junior leagues nationwide.

6 County referees. Park level refereeing – the first experience of the often challenging rival pub matches...

5 Senior county referees. Having picked up good marks at Level 6, progress to this level puts you in line for more senior games, and for further progress.

4 Supply league referees. This is the first step into semi-professional football. If you reach this stage you are among the top 2,000 referees in the country.

3 Contributory referees. At this level you are under more intense scrutiny, receiving regular assessment reports to determine your position on a merit table. The table determines your chances of going further. This level is where it gets really serious in terms of dedication, commitment and physical and personal demands. It is probably the biggest step in any referee's career – and only the very best progress beyond it.

2 Panel list referees. You are now eligible to officiate at Conference level and below, which includes Premier League reserve level. You can also act as an assistant referee in the Football League and Premier League – and the very best win Fifa recognition, assisting at international games worldwide.

1 National list. Referees selected by the Football Association. You are now eligible for appointment to games in the FA Premier League, the Football League and other top level matches.

And above Level 1 is the ultimate: **International Level**. This top level contains the very best referees – a group of elite Fifa referees who are rated the best in the world, and who officiate the sport's biggest matches.

How long does it take to get there? The very best young referees can complete this rise from Level 7 to International Level in 10 years. Stuart Attwell, who began refereeing aged 15 years and 6 months in 1998, was appointed to the Fifa international panel in 2009. Mark Clattenburg did the same – and before them, Graham Poll was also a fast riser. But however long it takes, you need patience and commitment – one level at a time.

KEITH HACKETT: My Route to the Top

Back in 1960, a pub landlord changed my life. Pulling a pint for my dad, he told him all about his time as a qualified referee – and how he thought I might like to give it a go. I was nonplussed: I was enjoying life in midfield for Fulwood Amateurs. But my dad had a way of being right about these things. So, aged 16, I turned up at the Sheffield and Hallamshire County Football Association HQ – a room above the Bull and Mouth pub in Sheffield.

Over six evening sessions in that room I was taught football's 17 laws – the intricacies and meanings – and the more I learned and understood, the more I was hooked.

Once you've started down this road, passed the first exam and picked up your first whistle, it's so easy to get the bug. I remember my first match as a junior referee in second-by-second detail. It was Sheffield United Juniors v Hillsborough Boys Club in September that year. The school field where it all happened is still there – it brings back vivid memories every time I drive past. Wearing outsized XXL borrowed kit, I walked out, swallowed my nerves and got stuck in.

The biggest rush was at half-time when the United coach offered me a large piece of orange and said how well I was doing. And the following Monday the County FA secretary phoned to say the same. He suggested I forget about playing, and focus entirely on refereeing. I didn't need to think twice.

What followed was hard work. I was also starting out with Hallamshire Steel in their drawing office, so was trying to learn two trades at once. But I did make progress. First into the Yorkshire League, then into the new Northern Premier League, aged 24. It was my first experience of refereeing players who were paid to play: a tough crowd, where a wrong decision could cost them bonuses. It definitely toughened me up.

In all, it took me 13 years of big and small steps before I made it on to the Football League list in 1973 – a long apprenticeship, and hundreds of games to get to the top.

It's not an easy journey. And it's no great revelation that referees need a thick skin. They're closely scrutinised, there are all sorts of challenges to overcome, miles to travel, long hours – and, at adult level, you need a tolerant employer, too (my boss at the Essex-based company I worked for when I was a league referee was fantastically accommodating – until, that is, I was appointed to New Zealand v Australia...)

But it is also a fantastically rewarding journey. In all, I was a referee for 37 years, then head of PGMOL (see page 122). Working with football's greats, travelling the world, refereeing the FA Cup final – it was all a long, long way from that room at the Bull and Mouth. But it shows what you can achieve – and the route to the top today is much the same as it was for me.

This section will tell you all you need to know.

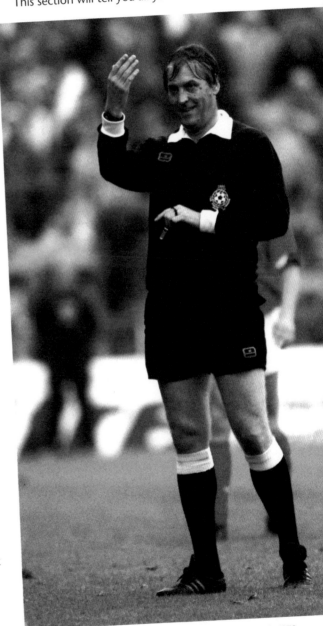

Man in black: Keith Hackett joined the Football League list in 1973

Making it to Level 1 in England means you are available for selection to the Professional Game Match Officials Ltd (PGMOL) list. PGMOL, formed in 2001 when full-time professional referees were introduced, is responsible for recruiting, training and developing top officials, and appointing their officials to Premier League and Football League competitions every week. For the 2009-10 season there were 78 Level 1 referees, 18 of them in the Select Group (Premier League level), and 246 assistant referees (44 in the Select Group).

Reaching the top of the refereeing profession will earn you a good living. In 2010 Premier League professional referees earned a basic salary of between £41,400 and £57,500 depending on experience, and in addition a match fee of £325 per game. That's still less than many top players earn in a week, but by national standards it is a well-paid job. Football League referees receive £285 per game, and average 35 games per season.

Assistant referees are also well rewarded: in the Premier League they receive £375 per game, and in the Football League, £145 per game.

Every referee is constantly assessed, and at Premier League level the scrutiny is intense. There are three ways in which PGMOL rank and manage their officials.

1) Match Assessors The Assessors are a panel of former referees and assistant referees who attend games and produce written reviews, with a mark out of 100. They base their assessments on the live action, and on studying footage of big decisions afterwards. Was that penalty decision correct? How well was discipline maintained?

2) Separately, the Premier League appoint match delegates (former players, managers and top football administrators), who also attend games to assess officials. They consult with the team managers before issuing their report, and award a mark out of 30. The two marks are then used on a merit league table, which helps PGMOL monitor officials. Referees in the bottom quarter of the table are used less often, and can be dropped completely. The tables are confidential.

3) On top of that, PGMOL use ProZone technology, which looks at every decision made by officials in fine detail, to assess a range of statistics – everything from a referee's average distance from the ball during a match, to their speed and positioning at corners. It is also used to assess all offside decisions, with an accurate overhead animation to analyse every call.

Fitness

Referees have to be fit at any level – but at the highest level, where the game is fastest and most intense, they are true athletes. In an average game, a referee will cover a distance of 11,500 metres – at an average of 19.4m away from the ball.

Premier League referees train four times a week under the supervision of PGMOL's sports scientist and vision scientist. They must also follow nutritional advice, avoid alcohol and undergo medical screening. They also cannot officiate unless they pass the Fifa tests – which involve strict standards for sprinting and high-intensity running.

Kit

Kit has changed a lot over the years – and continues to evolve. Post-war, referees still wore smart blazers. In the 60s shirts were made of black terylene with removable white collar and cuffs – chic by comparison. But today's kit requirements are rather more advanced.

Match officials at the top level need all the following items – plus spares:
a) Official shirt with appropriate badges – there are various different colour options to avoid clashes with club shirts – plus shorts and socks.
b) Boots – most referees carry three pairs to allow for different conditions.
c) A set of electronic flags.
d) An arm strap to hold the buzzer which assistant referees use to attract the referee's attention (by pushing a button on their flag stick).
e) A waist band to hold the communication kit receiver/transmitter, plus an earpiece. Each earpiece is specifically moulded to suit individual officials.
f) A whistle – various options depending on crowd size – typically made by Fox 40 or Acme.
g) Red and yellow cards, plus pencils and pens. Most referees put the yellow card in their shorts pocket, and the red in their shirt pocket, to avoid confusion in the heat of the moment.
h) A heart monitor which measures fitness.

Female referees

There are a growing number of female officials in the English system, and the future for women referees looks bright. Up to now very few women have reached the higher levels of the structure – Wendy Toms made history by reaching the assistant referees panel of PGMOL, but she was an exception. But this will change – and around Europe, notably Germany and Switzerland, women are officiating at the top level on a regular basis.

The future

Refereeing today has access to more technology and scrutiny than ever before. So what does the future hold?

Keith Hackett: "I firmly believe that the introduction of additional technology is inevitable – it's just a matter of time. The use of Hawk-Eye technology in cricket and tennis, and the video ref in both codes of rugby, shows football the way forward. Goalline technology is a must. And other aids – those that explicitly do not interfere with the flow of the game – are also on the agenda.

"I've also long been impressed with Refcom – used in rugby union to allow fans to hear the referee. Again, it's something I believe has a place in football.

"And technology available to clubs will keep expanding too. A live analysis system, tracking players' movements, passing, tackling, heart rates and other factors, all supplied to the managers in real time, cannot be far off."

THE REFEREES' ASSOCIATION

If you want to be part of the refereeing world, you'll need plenty of support. Referees in England are part of the Referees' Asso ciation (footballreferee.org). Formed on 9 May 1908 in Nottingham, it has branches in most cities.

Keith Hackett: "Back in 1960, after my basic training, I signed up as a member of the Sheffield and District RA – it was one of my first decisions as a referee, and certainly one of my best. I'll always remember that first meeting for the people I met, the welcome – and for the speaker, Ken Aston, who six years later invented the red and yellow card system while stuck in traffic at a set of traffic lights. It was also through the RA that I met Mal Davies, whose knowledge and advice on the laws has been invaluable throughout my time at PGMOL, and in the development of You Are The Ref. He is recognised as a world authority on the laws. If Mal doesn't know the answer, there isn't one."

Keith Hackett's top five referees

The best referees I have worked with or watched during my time in football are these five. Between them they represent all the key qualities a top official needs.

1 Pierluigi Collina.
Italy. Born 13 February 1960.
Instantly recognisable, Pierluigi was the outstanding referee of his generation. His preparation for a game was legendary among officials: he would study every player in minute detail, and watch film of each side's tactics. He also did wonders for the image of refereeing: liked and appreciated by both fans and players worldwide.

2 Jack Taylor. England. Born 21 May 1930.
This butcher from Wolverhampton rose to the top of the game and is best remembered for 1974 and his World Cup final. Never before had a penalty been awarded in any of the previous nine World Cup finals, but in this one, between West Germany and Holland, he gave the sides one each. Taylor said of the match: "I literally did swap my butcher's apron for the whistle to take charge of the World Cup final, but it was the norm. I had a job to pay the mortgage and another life refereeing around the world. It was a schoolboy dream to referee an FA Cup final [which he did in 1966] – but the World Cup final, there's only one referee every four years that does that, it was the ultimate." West Germany won 2-1.

3 George Courtney. England. Born 4 June 1941.
George was an outstanding referee, who also officiated World Cup games and every honours match in the English game. I had the pleasure of running the line for him, and for Jack Taylor. George was firm and fair in his decision making and adopted a very professional approach with his fitness and diet.

4 Lubos Michel. Slovakia. Born 16 May 1968.
I had the pleasure of watching Lubos in my role as a Uefa referee observer. He went about his task in a quiet and unassuming manner. His quality of decision making was terrific and a joy to watch.

5 Graham Poll. England. Born 29 July 1963.
I was as disappointed as he was when he showed three yellow cards to the same player in the 2006 World Cup. I was watching the game on TV with George Courtney and we were both amazed that neither of his colleagues had spotted the error before the restart. But I was really pleased that after that incident he came back and officiated another season rather than walking away. He wasn't the easiest of people to manage, but his preparation was second to none.

Paul Trevillion explains how he created one of the new portraits for You Are The Ref – and the simple rules that will help you produce your own comic art realism

There's a great old showbusiness saying: "eyes and teeth". They're the two parts of the face that everybody can move, and bright eyes and a big smile light up the stage and draw audience attention. The same thinking applies to this style of art. I don't draw portraits, I draw the personality: bright eyes and expressive mouths – a real challenge.

One of the best subjects in modern football is Fabio Capello: he's distinctive, full of character, intelligence and emotion. He's a man of extremes.

1. First, the basics. These lines are your building blocks: everyone can draw reasonably straight lines and curves like these. That's why everyone's an artist, in the same way that everyone who can kick a football is a footballer. However, it does take a natural talent and feel to be able to use them to full effect, which is as hard to teach as a Messi step-over. You either have that bit extra or you don't – follow these steps and you'll find out...

2. Try these three rapid, cartoony pencil sketches of Capello's face. They don't require any drawing, they're technical, created with the building blocks in point 1. So there are curves for the smiling face, straight downward lines for angry, and straight upward lines for disappointed. Practise this, enjoy it, apply the basic rules to other personalities, and see where you get to. It's all about technique – master this, then you can move up a gear.

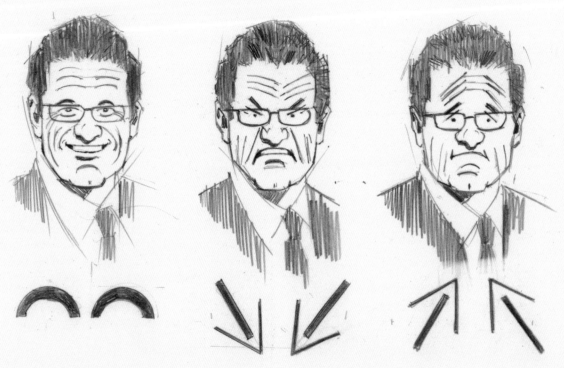

4. Now carefully rub out the pencil box shape and guide lines. That's the hard bit over. This is where you can enjoy yourself by starting to add extra round lines to complete the hair, eyebrows, shadow under the nose, shadow at the bottom of the chin and the shadow under the chin. Always remember: don't lose concentration and allow downward and upward lines to creep into your drawing. Stick to curves or you'll lose the Capello smile.

3. Clearly there's a big difference between those cartoons and a finished, full colour portrait, but keep those basic principles in mind as you move on to the main piece. First, and most fundamental, think again about the shape of Capello's face, as you did in stage two. It's not a long, thin shaped face like Arsène Wenger, or a rounded face like Carlo Ancelotti. Capello is square shaped, with a very powerful jawline. So start with that shape, a square, then split it into these relevant zones which will keep the features in proportion.

We're aiming for a smiling Capello here, so remember to work with curves, not hard straight lines. First, in the bottom zone, add the curves to produce the powerful jawline. In the middle zone, the top of the ears are on the same line as the eyebrows, the bottom of the ears on the same line as the bottom of the nose. The mouth, again made of simple round shapes, sits comfortably underneath. In the top zone, make sure you get the hairline right, again using those simple curves.

5. Keep building the depth by adding more layers of curves – note how few straight lines there are on the face. Here you can really see the portrait coming to life, the character coming out. Every line you add does a job, adds substance to your portrait, taking it way beyond the cartoons we produced in stage 2. Keep Capello – his personality and style – in your mind as you draw.

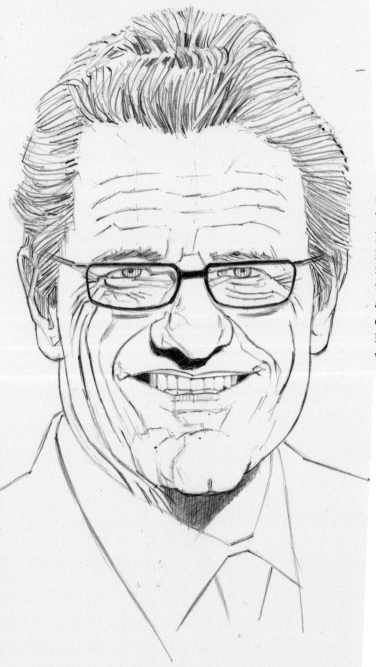

6. The pencil work done, it's time to start painting. Take a step back before you start and remember what you're aiming for. It'd be a mistake to just apply flat paint to the whole of the portrait: you need to decide first where the light is going to hit the face. I've chosen the right side of Capello's face – the left as you look at the portrait - which allows me to leave some white down almost a quarter of the width to give it shape. Remember, you're not painting a mask, this is a real face with depth and contours.

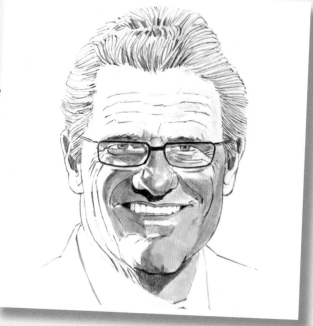

7. Another key point to consider as you add paint: the glasses. You need to avoid them looking like they're part of his face, somehow surgically attached – so place a shadow below the rims and leave a little bit of white inside the frame to help lift them off the face. A simple device, but again it makes a world of difference to the quality of the portrait you end up with.

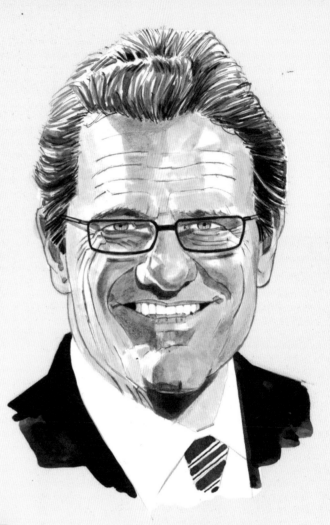

8. And there you have it. Adding shade and depth and following the contours, stop when you can feel the personality. Imagine Capello on the touchline smiling, or grinning in a press conference, and don't stop until that's what you can see looking back at you from the page. This is my finished effort – you can see him in his strip on page 102.

TREVILLION

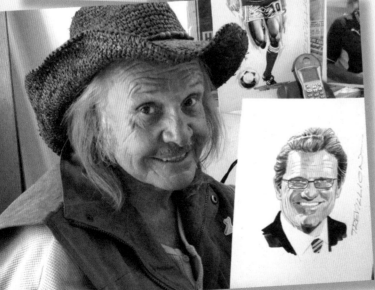

If you'd like to send your finished portraits to Paul, please email your scanned image to you.are.the.ref@observer.co.uk. We'll publish the best on the official You Are The Ref website: guardian.co.uk/football/you-are-the-ref

Own goals

1) In 2000, which player scored an own goal on his Wembley debut, and on his England debut, in different games in the same week?

2) In 1987, which Tottenham player's own goal won the FA Cup for Coventry City?

3) In 2006 against Croatia, which England player, winning his 84th cap, scored his first goal – in the wrong net?

4) Which Liverpool player scored Chelsea's equaliser in the 2005 League Cup final?

5) In 1981, which Manchester City player scored for both teams in the FA Cup final?

Famous officials

1) The national stadium of Azerbaijan is named after a former official called Tofik Bakhramov. For what was he most famous?

2) Which English referee had the idea for red and yellow cards – first used at the 1970 World Cup – from looking at traffic lights?

3) Which official retired after receiving death threats from Chelsea fans after a controversial match with Barcelona in 2006?

4) Which referee is still remembered by Leeds fans for allowing a West Brom goal to stand, despite offside appeals, which cost Leeds the 1971 league title?

5) Which referee blew for full-time as a corner came across, denying Brazil a winning goal in a 1978 World Cup finals match against Sweden?

...yet went to the High Court in 1983, unsuccessfully trying to overturn a ban imposed for a booking in a league game which meant he missed the FA Cup final?

3) Who was banned for 11 matches for pushing over referee Paul Alcock in 1998?

4) Portugal's João Pinto was banned for four months for striking the referee during his team's match against which side at the 2002 World Cup finals?

5) Which Manchester United player received a five-match ban in 2002 for admitting in his autobiography that he had tried to injure an opponent?

Handballs

1) Diego Maradona's infamous handball goal in the 1986 World Cup quarter-final came from a ball deflected in his direction by which England player?

2) Which Liverpool defender made an unpunished goalline save from Arsenal's Thierry Henry in the 2001 FA Cup final?

3) Which Manchester United player was sent off for handling on the line in the 1994 League Cup final defeat to Aston Villa?

4) Which Argentina player handled the ball on the goalline, unseen by the referee, during their 1990 World Cup game against the Soviet Union?

5) Which England player's handball in the penalty area allowed Switzerland to equalise in the opening game of Euro 96?

Sendings-off

1) Which Italian player's World Cup finals career consisted of 10 minutes against Nigeria in 1994, after he was sent off having come on as a substitute?

2) Which team was the only one to finish the World Cup final with 9 men?

3) Who was the second player to be sent off in an FA Cup final?

4) Four England players were sent off between June 1998 and September 1999. Name them.

5) In 1998, which Cameroon player became the first man to be sent off in two World Cups?

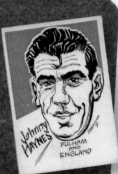

Victims of famous fouls

1) When Eric Cantona was sent off against Crystal Palace in 1995, leading to his famous kung-fu kick, whom had he fouled?

2) Which former Coventry player was brought down by Phil Neville for the Romania penalty that eliminated England from Euro 2000?

3) Tottenham's Paul Gascoigne ruptured knee ligaments fouling which Nottingham Forest player in the 1991 FA Cup final?

4) Wayne Rooney was sent off for stamping on which Portugal player in England's 2006 World Cup quarter-final?

5) France's Zinedine Zidane was sent off for headbutting which Italy player in the 2006 World Cup final?

Portraits are from a series of 50 Master Vending bubblegum cards, produced in 1958

England and the World Cup

1) Which England player appealed for a goal rather than attempting to turn the ball in after Geoff Hurst's shot hit the bar and bounced down in the 1966 World Cup final?

2) Which player scored with a penalty on his England debut during the 1970 finals?

3) Which player scored with a penalty when England failed to beat Poland at Wembley, meaning that they did not reach the 1974 finals?

4) Which future FA official scored a famous goal that left the ball stuck in the frame of the goal, in a qualifying win in Hungary in 1981?

5) Which player scored the only England goal of his first 38 international appearances against Colombia in the 1998 finals?

England and the World Cup
1) Roger Hunt
2) Allan Clarke
3) Also Allan Clarke
4) Trevor Brooking
5) David Beckham

Sendings-off
1) Gianfranco Zola
2) Argentina in 1990. Pedro Monzon and Gustavo Dezotti were dismissed
3) Arsenal's José Antonio Reyes, against Manchester United in 2005
4) David Beckham (v Argentina), Paul Ince (in Sweden), Paul Scholes (at home to Sweden), David Batty (in Poland)
5) Rigobert Song

Bans
1) Kevin Keegan of Liverpool, sent off with Leeds' Billy Bremner
2) Steve Foster, who missed the 2-2 draw with Manchester United. He returned for the final, lost 4-0
3) Paolo Di Canio of Sheffield Wednesday
4) South Korea
5) Roy Keane (Manchester City's Alf Inge Haaland)

Famous officials
1) He was the so-called Russian linesman at the 1966 World Cup final
2) Ken Aston, who was in charge of all officials at the 1966, 1970 and 1974 World Cups
3) Anders Frisk
4) Eric Tinkler
5) Clive Thomas

Victims of famous fouls
1) Richard Shaw
2) Viorel Moldovan
3) Gary Charles
4) Ricardo Carvalho
5) Marco Materazzi

Handballs
1) Steve Hodge
2) Stephane Henchoz
3) Andrei Kanchelskis
4) Maradona. Again
5) Stuart Pearce

Own goals
1) Richard Wright (playing for Ipswich in a play-off final and England in Malta)
2) Gary Mabbutt
3) Gary Neville
4) Steven Gerrard
5) Tommy Hutchison